EMPIRES RESTORED ELYSIUM REVISITED

THE ART OF
SIR LAWRENCE ALMA-TADEMA

JENNIFER GORDON LOVETT
WILLIAM R. JOHNSTON

WITH CONTRIBUTIONS BY
PATRICIA R. IVINSKI
KATHRYN L. CALLEY
VERN G. SWANSON

STERLING AND FRANCINE CLARK ART INSTITUTE

WILLIAMSTOWN, MASSACHUSETTS

Published in conjunction with the exhibition *Empires Restored, Elysium Revisited: The Art of Sir Lawrence Alma-Tadema*, organized by the Sterling and Francine Clark Art Institute in collaboration with the Walters Art Gallery and held at the Sterling and Francine Clark Art Institute, Williamstown, Massachusetts, September 21, 1991–January 5, 1992; Walters Art Gallery, Baltimore, Maryland, February 5–March 31, 1992; Taft Museum, Cincinnati, Ohio, April 23–June 11, 1992; Dixon Gallery and Gardens, Memphis, Tennessee, July 12–September 6, 1992.

Edited by Jacolyn A. Mott
Designed by Elizabeth Woll
Typeset by Pagesetters
Printed in the United States by W. E. Andrews Co.

LIBRARY OF CONGRESS CATALOGING-IN-PUBLICATION DATA

Lovett, Jennifer Gordon.
 Empires restored, Elysium Revisited : the Art of Sir Lawrence Alma-Tadema / by Jennifer Gordon Lovett and William R. Johnston ; with Patricia R. Ivinski, Kathryn L. Calley and Vern G. Swanson.
 p. cm.
 Exhibition schedule: Sterling and Francine Clark Art Institute, Williamstown, Mass., Sept. 21, 1991–Jan. 5, 1992; Walters Art Gallery, Baltimore, Md., Feb. 5–Mar. 31, 1992; Taft Museum, Cincinnati, Ohio, Apr. 23–June 11, 1992; Dixon Gallery and Gardens, Memphis, Tenn., July 12–Sept. 6, 1992.
 Includes bibliographical references.
 ISBN 0–931102–30–8 (pbk.)
 1. Alma-Tadema, Lawrence, Sir, 1836–1912—Exhibitions. I. Alma-Tadema, Lawrence, Sir, 1836–1912. II. Johnston, William R.
III. Sterling and Francine Clark Art Institute. IV. Title.
ND497.A4A4 1991
759.2—dc20 91–27468
 CIP

COVER: *The Women of Amphissa* (detail), cat. no. 37

CONTENTS

LENDERS TO THE EXHIBITION

AKRON ART MUSEUM
Akron, Ohio

STEVEN AND PEGGY BARSHOP

MUSEUM OF FINE ARTS, BRIGHAM YOUNG UNIVERSITY
Provo, Utah

MICHAEL D. AND SOPHIE D. COE

CAROLYN FARB
Houston, Texas

FOGG ART MUSEUM, HARVARD UNIVERSITY
Cambridge, Massachusetts

FORBES MAGAZINE
New York, New York

SCOTT AND LUISA HASKINS
Santa Barbara, California

HAUSSNER FAMILY LIMITED PARTNERSHIP

MADISON ART CENTER
Madison, Wisconsin

MEMORIAL ART GALLERY, UNIVERSITY OF ROCHESTER
Rochester, New York

MONTREAL MUSEUM OF FINE ARTS
Montreal, Canada

MUSEUM OF FINE ARTS
Boston, Massachusetts

J. NICHOLSON
Beverly Hills, California

PHILADELPHIA MUSEUM OF FINE ARTS
Philadelphia, Pennsylvania

FRED AND SHERRY ROSS

STERLING AND FRANCINE CLARK ART INSTITUTE
Williamstown, Massachusetts

TAFT MUSEUM
Cincinnati, Ohio

VASSAR COLLEGE ART GALLERY
Poughkeepsie, New York

WALTERS ART GALLERY
Baltimore, Maryland

MARCIA AND MARTIN WERNER

ZANESVILLE ART CENTER
Zanesville, Ohio

AND SEVERAL PRIVATE COLLECTIONS

THE IDEA OF organizing an Alma-Tadema exhibition at the Clark Art Institute surfaced nearly ten years ago with the purchase of *The Women of Amphissa* and the gift of *Preparations for the Festivities*. Mr. Clark had earlier acquired *Hopeful*, and the three paintings gave us a range of over four decades of the artist's work. The Walters Art Gallery has a fine and more extensive representation of his paintings and watercolors, and its associate director, William Johnston, had long been interested in an Alma-Tadema show.

It is therefore a great pleasure to share this exhibition with the Walters Art Gallery and I would like to thank Bill Johnston for his support and for contributing his essay, "Antiquitas Aperta: The Past Revealed." Vern Swanson, who has published a recent catalogue raisonné of the artist's paintings, has always been generous in sharing his wide knowledge of him and has kindly contributed an introduction to Alma-Tadema as a personality. Finally, the real credit for getting the whole project off the ground must go to Jennifer Lovett, associate curator of paintings and sculpture at the Clark, who has pursued Tadema with affection and enthusiasm. I am grateful to her and to other members of the curatorial staff at the Clark who have helped to make this exhibition a success.

DAVID S. BROOKE
Director

THIS CATALOGUE AND the exhibition could not have been realized without the support and cooperation of many people within the Sterling and Francine Clark Art Institute and the Walters Art Gallery and the numerous lenders and research facilities that generously made paintings and resources available to us. David Brooke, director of the Clark Art Institute, deserves special thanks for his encouragement of the project; the idea for an Alma-Tadema exhibition was conceived in 1978 when he purchased *The Women of Amphissa* for the Institute. Mary Jo Carpenter, director of public relations and membership, was a relentless editor and oversaw the production of the catalogue efficiently and enthusiastically. Martha Asher, registrar, diligently and expertly orchestrated all details associated with the loans and their travel to and from the exhibition venues. Beth Wees, curator of decorative arts, also deserves recognition for her helpful and insightful critique of the manuscript. Dr. Ellen D. Reeder, curator of ancient art at the Walters Art Gallery, helped identify many of Alma-Tadema's classical sources, as did Guy Hedreen and Elizabeth McGowan of the Williams College Art Department. Jacolyn Mott, editor, skillfully blended five distinct writing styles to produce a cohesive publication that was enhanced by Elizabeth Woll's sensitive and harmonious book design.

Many members of the Clark Art Institute staff participated in the production of this exhibition. I would like to thank Steven Kern, curator of paintings; Rafael Fernandez, curator of prints and drawings; Lisa Jolin and Maribeth Bernardy, curatorial secretaries; Anna Gado, curatorial assistant; Paul Dion, preparator; Alan Chamberland, superintendent; Peter Erickson and Paige Carter of the Clark Art Institute library; Arthur Evans and Merry Armata, photographers; Harry Blake and Robert Gageant of buildings and grounds.

Several individuals gave generously of their time and expertise. In particular I would like to acknowledge Gary Vikan, curator of medieval art at the Walters Art Gallery; Carla Grosse and Susan Foster, curatorial interns from the Williams College Graduate Program in the History of Art; Elizabeth Kieffer, lecturer in German at Williams College; Thomas Branchick and Michael Heslip of the Williamstown Regional Art Conservation Laboratory; Barry Goldfarb at the University of Pennsylvania; Margaret Moore and Elaine Kilmurray from the John Singer Sargent catalogue raisonné; and B. S. Benedikz, librarian at the University of Birmingham Library.

While organizing the exhibition, we encountered many private collectors who shared their knowledge and love of Alma-Tadema's paintings. Several of them are lending to the exhibition and we are indebted to these individuals for their generous support of this project.

The authors are extremely grateful to Vern Swanson who wrote *The Biography and Catalogue Raisonné of the Paintings of Sir Lawrence Alma-Tadema.* Throughout the months of research and preparation for the exhibition, he was an enthusiastic ally. Extremely generous with his own files on the artist, he was helpful in all stages of our investigation into Alma-Tadema's oeuvre.

This endeavor could not have been accomplished without the positive and productive collaboration of the authors. I have enjoyed working with my colleagues and cannot imagine undertaking this project alone. My sincere thanks go to William Johnston, associate director of the Walters Art Gallery; Patricia Ivinski, curatorial assistant at the Clark Art Institute; and Kathryn Calley, Clark curatorial intern and student in the Williams College Graduate Program in the History of Art. Finally, I would like to thank my husband, Chip, and my sons, Justin, David, and Daniel, who have patiently endured my hectic schedule and cheerfully supported my efforts.

JENNIFER GORDON LOVETT

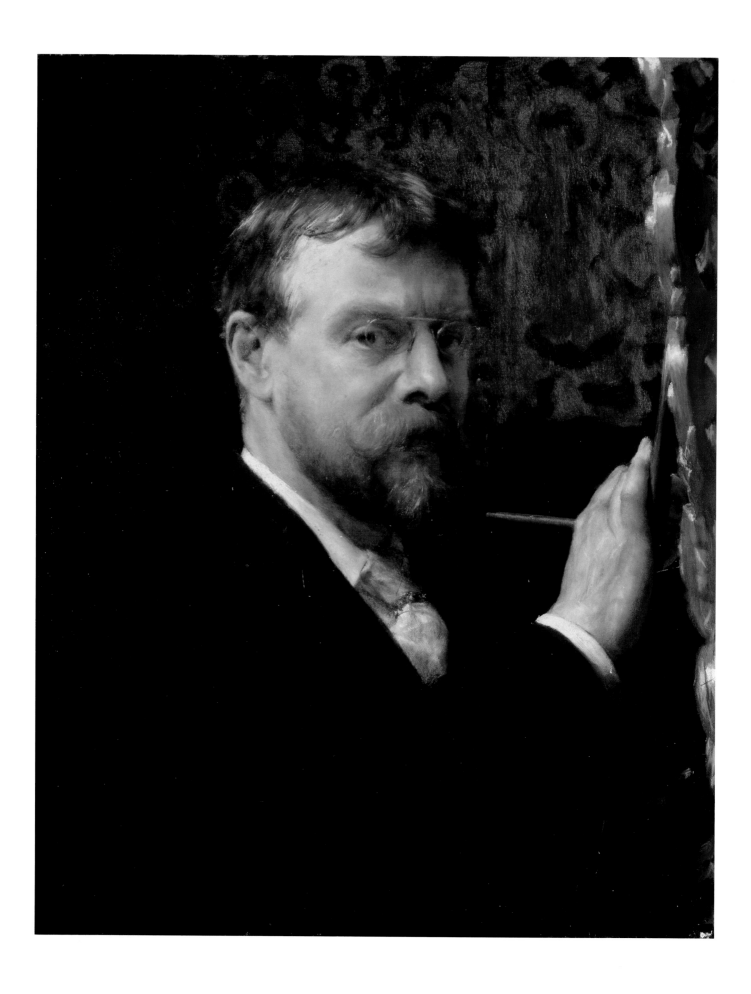

L AWRENCE ALMA-TADEMA (1836–1912) was one of the most successful painters in Britain in the latter years of the nineteenth century. Renowned for highly detailed views of domestic life set in ancient Rome, he was universally admired for his careful technique, skillful draftsmanship, and superb sense of color. His unique style was eclectic: it combined classical objects (Greek and Roman art, architecture, and costume) with the light and detail that are characteristic of traditional Dutch genre painting. Aesthetically, Alma-Tadema was poised between the academic establishment and the growing avant-garde. Paradoxically, his meticulously imagined glimpses of antiquity provide an instructive view of Victorian society. The carefully researched settings are peopled with contemporary Britons. His paintings were therefore reassuring to a bourgeois public that enjoyed seeing its lifestyle mirrored by citizens of ancient Rome. Criticism, at times severe, was directed at his often vapid figures and the materialistic orientation of his unorthodox brand of classicism. Nevertheless, Alma-Tadema's style appealed to the taste of the middle class that sprang up in England and the United States in the wake of the Industrial Revolution.

This exhibition—the most comprehensive show of Alma-Tadema's work to be held in this country—demonstrates the importance of American patronage. The paintings come primarily from American collections, and many of them have been in this country since they were purchased from the artist or his agents. American collectors were not as thoroughly schooled in classical literature or history as were their European contemporaries. Consequently, Alma-Tadema's scenes of objects and places that they could recognize had more appeal for them than the more esoteric works of other British classicists.

Alma-Tadema's art was intimately connected to the Victorian era; with the demise of the British Empire at the turn of the century, his pictures fell quickly into disfavor. By his death in 1912, his reputation had greatly diminished. His work then languished in obscurity for half a century. Alma-Tadema's sentimental visions of a tranquil past were lost in the turbulent early years of the twentieth century much as his beloved Pompeii had disappeared in clouds of volcanic ash in the first century.

The artist was born Lourens Alma Tadema[1] on January 8, 1836, in the village of Dronrijp in Friesland, northern Holland. His father, Pieter, was the village notary. He was also well known locally for his talents as an organist and composer. Pieter's second wife, Hinke Dirks Brouwer, bore him two children, Lourens and a daughter, Artje, and raised three sons from Pieter's first marriage to her half-sister. In 1837 the Tadema family moved to nearby Leeuwarden, the provincial capital, where Pieter died in 1840. Hinke Tadema was left with five young children and meager financial resources. Fortunately, she had the assistance of her two brothers-in-law, Lourens and Adrianus Alma, both apothecaries in Amsterdam. Godfathers to young Lourens, they helped Hinke manage and educate her family.

Hinke Tadema was devoted to her children and made provisions for their thorough education, which included training in art and music. Shortly after their father's death, the three older boys began to study drawing. Lourens, then four or five, was fascinated with the classes and soon joined in. Reputedly, he corrected the perspective in his teacher's drawings when he was only five years old.

Alma-Tadema had an early interest in ancient history and civilization, as evidenced by the margins of his schoolbooks, which were decorated with doodles and small sketches. In 1848, at the age of twelve, he made several drawings illustrating scenes from Greek mythology.[2] Pieter Tadema had wanted his youngest son to become a lawyer and, in his will, charged the boy's godfathers with the responsibility of ensuring the achievement of this goal. The family did not consider painting a viable or secure profession, and Lourens was

FIG. 1: *Self-Portrait*, 1896 (opposite).

strongly discouraged from pursuing an artistic career. He was allowed to study music, perhaps out of respect for his father, but was forced to relegate drawing and painting to his spare time.

In 1849 Alma-Tadema, then thirteen, received his first commission. Three local children ordered an oil painting as a gift for their parents. The children's father, Watse Hamstra, was the director of the Society for the Promotion of Painting and Drawing in Leeuwarden. He was impressed with the portrait of his children and recommended to Alma-Tadema's family that he be allowed to study art. In spite of his obvious talent, his guardians would not relent. The boy was forced to devote his day to the academic subjects necessary for a law degree.

Alma-Tadema was determined, however, to continue drawing and painting. Long before he had to be up for school each day, he would have his mother wake him by pulling a string tied to his toe, and he would spend the early morning sketching. He acquired a copy of Leonardo da Vinci's *Treatise on Painting* and a Dutch book on perspective. Endless hours were devoted to reading and copying from these publications, and the latter was instrumental in directing his interest toward the accurate rendering of architecture.

All of Alma-Tadema's free time was devoted to the study and practice of his art. The strain of this exhausting schedule eventually resulted in physical and emotional collapse. When he was diagnosed as consumptive, his mother and his godfathers relaxed their dictum that he continue legal training. Assuming that he would not survive adolescence, they allowed him to spend his remaining days happily engaged in drawing, painting, and studying art. The result was a rapid recovery of physical and mental health.

In 1852 when he was sixteen years old, Alma-Tadema moved to Antwerp to enroll in the Academy of Fine Arts. This was done only after obtaining the blessing of his strict Mennonite mother, who had great reservations about her son's living in the Catholic city of Antwerp. Several years later, Alma-Tadema persuaded his mother and his sister, Artje, to join him.

The academy was under the direction of Gustave Wappers (1803–1874). His self-imposed mission was to foster a return to romantic realism based on the Dutch and Belgian masters in place of the rigid neo-classicism of Jacques-Louis David (1748–1825), who had lived in Brussels from 1816 until his death. William Gaunt describes the stranglehold that David's style still retained at about the time Alma-Tadema arrived: "The classic régime was so firmly established that it is said a sculptor, commissioned to make the model of a wolf, could only conceive the animal as the she-wolf of Rome, and without being asked included Romulus and Remus with it."[3]

Wappers, who had led the Belgian romantic school in the 1830s, was the teacher of the English painter Ford Madox Brown (1821–1893), a Pre-Raphaelite sympathizer. Wappers particularly admired the rich colors and impastos of Richard Parkes Bonington (1801–1828), Théodore Géricault (1791–1824), and Eugène Delacroix (1798–1863) and used these techniques to depict events from Netherlandish history. Within this academic context, Alma-Tadema was immediately oriented toward early Dutch and Flemish history rather than classical antiquity.

Alma-Tadema was extremely critical of his own work. He destroyed much of it and painted over many pictures that he deemed unsatisfactory. Consequently, relatively little remains from his early years in Antwerp. *The Massacre of the Monks of Tamond* (cat. no. 3), completed in 1855, shows the influence of Wappers and of his successor as head of the Academy, Joseph Laurent Dyckmanns (1811–1888).

In 1856 Alma-Tadema received his first important commission, *The Declaration of Love*, or *The Alm* (location unknown). It was painted for Klaas Tigler Wybrandi of Leeuwarden, the husband of Alma-Tadema's aunt, Sjoukje Brouwer. The painting was probably a memorial to Sjoukje, who had died the year before. Because Alma-Tadema left the Academy of Fine Arts to work on the

painting, he was expelled by the current director, the history painter Nicaise de Keyser (1813–1887).[4]

While still a student at the Antwerp academy, Alma-Tadema had met Louis de Taeye (1822–1890), an influential professor of archaeology. His stand midway between the classicism of David and romanticism had a critical influence on Alma-Tadema. After being expelled, the young artist lived in de Taeye's house from 1857 until late 1858. De Taeye introduced him to early French and Belgian history, encouraged him to explore classical subjects as well, and emphasized the importance of portraying historical scenes with archaeological accuracy. It was during this time that he became aware of the Merovingians, a savage and violent people who dominated central Europe between the fall of the Roman Empire and the tenth century.[5] The anecdotal quality of Merovingian legends appealed to him; and these somber subjects, which allowed the exploitation of history and archaeology as sources for paintings, occupied him into the 1860s.

Clotilde at the Tomb of Her Grandchildren, 1858 (location unknown), was Alma-Tadema's first Merovingian painting. A year later, his first surviving Egyptian scene, *Death of the First-Born*, 1859 (Johannesburg Art Gallery), was completed. At that time, he also produced a watercolor entitled *Marius on the Ruins of Carthage* (location unknown), the first Roman subject. Apparently de Taeye's eclecticism, interest in archaeology, and impressive library enabled Alma-Tadema to broaden his own focus.

It was while living with de Taeye that Alma-Tadema became aware of the aesthetic properties inherent in marble, the material with which his name would ultimately be closely connected. Years later, he recalled the experience that inspired him to paint marble:

> I was first attracted to the artistic possibilities of marble when visiting Ghent in 1858. A friend happened to take me into a certain club-house—I forget for the moment the name of the club—which had a marble smoking-room. I don't suppose the room was of any exceptional magnificence, but it was the finest marble room I had then seen, and its wonderful whiteness and atmosphere made an extraordinary impression upon me.[6]

Another important connection established in Antwerp was with the famous Egyptologist Georg Ebers (1837–1898). Ebers's interest in the everyday life of ancient Egypt probably influenced Alma-Tadema, who preferred to focus on genre rather than history in his scenes of life in ancient Rome. The two men became lifelong friends, and Ebers wrote a particularly sympathetic biography of Alma-Tadema in 1886.

In 1858 Alma-Tadema was introduced by de Taeye to Baron Hendrik Leys (1815–1869), a successful history painter (see fig. 2) living in Antwerp. The following year, Leys invited Alma-Tadema to join his studio as an assistant. Leys did not usually take students, but he was impressed by Alma-Tadema's ability and knowledge of architectural perspective. The collaboration lasted for approximately three years and involved many large projects. Leys's style combined academic technique with romantic subjects. The work was strenuous and exacting, but it provided Alma-Tadema with a solid foundation in the craft of painting. While working on six frescoes of events from the history of Antwerp for the town hall, the artists undertook extensive research to help them achieve historical accuracy. They frequently consulted Louis de Taeye for his expertise in Netherlandish archaeology. This intensive experience taught Alma-Tadema the techniques of the archaeologist and the practical application of this science to art. Leys repeatedly encouraged his apprentice to paint realistically with exact detail: "When Alma-Tadema had to paint . . . a table for Leys' *Luther* the master observed in criticism, 'it is not my idea of a table. I want one that everybody would knock their knees against.' "[7]

By 1861 Alma-Tadema was enjoying considerable success: he was elected a

FIG. 2: *The Edict of Charles V*, c. 1861, by Baron Hendrik Leys.

member of the Academy of Fine Arts in Antwerp; and his painting, *Education of the Children of Clovis* (location unknown), another Merovingian subject, was exhibited to great acclaim. Ebers called it "the magnificent painting destined to instantly raise Tadema to the ranks of the first artists of his time and make his name famous."[8] The composition was applauded for its clarity, historical accuracy, and pathos; but it was also strongly criticized by Baron Leys who commented, "That marble is cheese and those children are not studied from nature."[9] In spite of the predominantly positive reaction to the painting, Alma-Tadema was most affected by the terse criticism from his mentor. It reinforced his commitment to become the best painter of marble in the world.

The following year, the twenty-six-year-old Alma-Tadema ventured to London for the first time to visit the International Exhibition. There he encountered two influences that were to have significant effect on his developing style: the Japanese prints at the exhibition and the impressive collections of the British Museum, specifically the Elgin Marbles from the Parthenon in Athens and the numerous Egyptian antiquities.

The year 1863 proved to be a watershed. The events of his personal life were momentous but were, in retrospect, eclipsed by his professional achievements. Georg Ebers referred to 1863 as "the portal as it were of his road through antiquity."[10] In January, Alma-Tadema's mother died. The following September, he married Marie Pauline Gressin, the daughter of a French journalist of royal descent living outside Brussels. The couple embarked on a two-month honeymoon to Florence, Rome, Naples, and Pompeii. Alma-Tadema was overwhelmed by the ruins of Pompeii. He obsessively measured and sketched the architecture, wall paintings, mosaics, marbles, and numerous other relics of this ancient culture. The radiant colors of Italy and the warmth of the Mediterranean sun motivated him to abandon the dark and gloomy Merovingians and begin the exploration of ancient Rome that would occupy him for the rest of his life.

His first excursions into Mediterranean subjects were Egyptian. Because he did not visit Egypt until the end of his life, it is possible that the Egyptologist Ebers influenced his choice of subjects. Alma-Tadema's Egyptian pictures of the early 1860s were extremely popular. Precisely rendered, they were among his most emotionally expressive scenes to date. He created a total of twenty-six Egyptian scenes and, when asked by Ebers why he painted Egypt, replied:

> Where else should I have commenced when I first began to make myself familiar with the life of the ancients? The first thing the child learns of ancient times leads it to the court of the Pharaohs . . . and when we go back to the source of the art and science of the other nations of antiquity how often we reach your Egypt![11]

Alma-Tadema's *Pastimes in Ancient Egypt 3,000 Years Ago*, 1863 (Harris Museum and Art Gallery, Preston, England), won the gold medal at the 1864 Paris Salon and enjoyed critical acclaim. This important success motivated the artist to embark upon his first trip to Paris. Among the many artists he encountered there were Alfred Stevens (1823–1906), Jean-Léon Gérôme (1824–1904), and Rosa Bonheur (1822–1899).

During the summer of 1864, Alma-Tadema met Ernest Gambart (1814–1902), an influential Belgian art dealer with offices in many European cities. The story differs according to the source, but apparently Gambart was intentionally misdirected so that he would arrive at Alma-Tadema's studio. The artist was working on *Leaving Church in the Fifteenth Century* (location unknown), and the picture attracted the dealer's attention. Gambart immediately commissioned twenty-four oil paintings, three of which were shown at his French Gallery in London in an exhibition of French and Flemish paintings. This was the first time Alma-Tadema's work had been seen in London, and the reception was lukewarm. More and more of his paintings had Greco-Roman genre subjects and Gambart was skeptical about the success that these scenes would have in England. He encouraged Alma-Tadema to continue with Egyptian and Merovingian themes but the artist chose to persevere with his particular form of classicism. Gambart soon realized that scenes of ancient Rome were indeed salable and that they, in fact, complemented the work of two English artists whom he represented—Frederick Leighton (1830–1896) and Edward Poynter (1836–1919).

Alma-Tadema's pictures from the mid-1860s reveal the high finish, technical precision, and historical accuracy that were to become his trademarks. During the years from 1865 through 1870, his prolific Pompeian period, he executed forty-five Greco-Roman subjects.[12] Typically, Alma-Tadema's compositions at this time contained full-length figures in the foregrounds of interiors closely based on actual Pompeian villas. The frescoed walls are predominantly red, the overall palette earthy. The scenes are packed with antiquities: fine arts, decorative arts, and utilitarian objects (many of them now in museum collections). Characteristically, a distant view of the sea or a sweeping landscape is visible through an open window or door. The paint is thicker, the overall effect is brighter, and the subjects are less dramatic than in his earlier works.

By the end of May, 1865, Alma-Tadema had moved his family to Brussels. The city was larger than Antwerp and more cosmopolitan. Gambart had offices there, and Pauline's family was close by. Eugène, Alma-Tadema's first child and only son, had been born in July of 1864 but died three months later of smallpox. Pauline also contracted the disease; but she recovered and, although frail and sickly, had two more children before her premature death in 1869. The artist's daughters, Laurense and Anna, were born in 1865 and 1867, respectively.[13]

Catullus at Lesbia's, 1865 (location unknown), was the first painting to be completed in Brussels. As Alma-Tadema's first full-scale Roman composition, it was the initial embodiment of his Pompeian style. The events depicted are trivial; the painting is genre rather than history. Its appeal lay in precise detail and archaeological accuracy. Its popularity reflected the general interest in the ongoing excavations at Pompeii and Herculaneum.

Alma-Tadema decorated his Brussels studio by painting Roman motifs on walls of Pompeian reds and black. This warm and dusky atmosphere was reflected in his art. Later, in 1868, the color of the studio was changed to light green, and his paintings became brighter, more luminous and harmonious—less apt to echo the earthy colors of the earlier studio walls. By changing his surroundings, Alma-Tadema was attempting to cool down his compositions, which he felt were overpowered by the intense Pompeian reds. He changed the color of his studio several times during his career, and each change was reflected dramatically in his paintings. Late in life, he commented on this phenomenon:

I have always found that the light and color in a studio had a great influence upon me in my work. I first painted in a studio with panels of black decoration. Then in my studio in Brussels I was surrounded by bright red, and in London—at Townshend House, Regent's Park—I worked under the influence of a light green tint. During the winter I spent in Rome in 1875–76—when I was obliged to leave my London house by the destructive effect of the Regent's Canal explosion—I tried the effect of a white studio. Now, as you see, the prevailing hue is a silvery white, and that, I think, best agrees with my present temperament, artistically speaking.[14]

Alma-Tadema always painted his figures from life. From 1865 on, his initial sketch was done on a cream ground in blue crayon. This light ground, preferred by the Pre-Raphaelites, was unusual; most Victorian painters started with a dark ground.[15] Next, a rough sketch was painted in a thin layer of a neutral color, over which the pigment would be applied. This method allowed Alma-Tadema to build up the darker tones of his composition from a light base. Consequently, his colors are more luminous and appear at times to be translucent. To the consternation of many of his friends—who felt that he destroyed too much of his work—Alma-Tadema frequently painted over areas of compositions that he disliked. He never varnished his pictures and would sometimes return to them years after they were painted to revise the composition.

Alma-Tadema had an extremely sociable and gregarious character. Throughout his life, he enjoyed entertaining his many friends. In the mid-sixties, he began regularly to host evenings at home in which he received guests for lively conversation and musical entertainment. "His artist friends . . . often chaffed him about his archaeological art, and on one occasion defied him to paint a Roman picture gallery. This put him on his metal, and he painted one. Then his picture-dealer commissioned him to paint a shop of sculpture. The original [*The Collector of Pictures at the Time of Augustus*, 1867 (private collection, London)] was sold the other day in New York."[16]

Following the enormous success at the Exposition Général des Beaux-Arts in Brussels in October, 1866, of the Roman scene *Preparations for the Festivities* (cat. no. 5), Alma-Tadema was named a knight of the Order of Leopold. This public recognition of his achievements meant a great deal to him. At this point in his career, he was already extremely popular. By 1868 he had earned a reputation in England as one of the most important Continental artists. The following year, he was made a knight of the Order of the Dutch Lion by King Willem III of the Netherlands. However, Alma-Tadema's pictures were never as popular in his native country as they were in England and the United States. Dutch collectors purchased very few of his paintings, and he never received an official commission from the state or the crown.

In May of 1866, the Alma-Tademas traveled to England to attend a ball at Gambart's London home. The party never took place because a huge gas explosion the night before destroyed much of the house. Alma-Tadema and his wife, who were staying with Gambart, were not physically injured, but Pauline was traumatized by the incident and never fully recovered from the shock. Almost exactly three years later, in May of 1869, she died after years of chronic illness. Alma-Tadema was left with his two small daughters and his sister, Artje, who lived with her brother until her marriage in 1873 and helped care for his children.

Gambart's commission for twenty-four paintings took almost forty-two months to complete. The final picture, *Tarquinius Superbus* (cat. no. 10), illustrates a story from Livy. The composition reflects Alma-Tadema's Pompeian style. However, its evocation of looming tragedy is unusual in the artist's work. The painting was a critical success and enhanced his stature. Although his pictures were selling well in Brussels, he was frequently the target of strong

criticism. Gambart was, by now, confident that there was a market for Alma-Tadema's pictures; and in 1869 he initiated a second commission for forty-eight paintings.

A Roman Lover of Art, 1868 (Yale University Art Gallery, New Haven), and *The Pyrrhic Dance*, 1869 (Guildhall Art Gallery, London), were entered in the summer exhibition at the Royal Academy in London in 1869. Submitted as works by a foreigner, they were met with severe criticism from the vociferous John Ruskin, who stated that "the most dastardly of all these representations of classic life, was the little picture called the *Pyrrhic Dance,* of which the general effect was exactly like a microscopic view of a small detachment of black-beetles, in search of a dead rat."[17]

Ruskin, whose importance to the development of Victorian taste should not be underestimated, disliked Alma-Tadema's classicist orientation and for many years targeted his work for bitter attack. Considering historical subjects to be boring, Ruskin felt strongly that art should reflect contemporary life and that it should be instructive and morally uplifting. He championed Gothic art and the work of the Pre-Raphaelites during his notorious "reign of terror" as a critic.

In the summer of 1869, Alma-Tadema began to suffer from an ailment that his doctors in Brussels were not able to treat. He went to London in December to consult a physician about his condition, which ultimately resulted in surgery. During this sojourn, he met Ford Madox Brown who introduced him to a young woman named Laura Epps who would become his second wife. Alma-Tadema's biographers agree that the thirty-three-year-old painter fell in love with the seventeen-year-old art and music student the first time they met. Laura was described by Nathaniel Hawthorne's son Julian as "one of the London beauties, of good stature, auburn-haired, with the warm body of a milkmaid, and a gentle, Greek face."[18]

The Franco-Prussian War broke out in July, 1870; and many artists, including Claude Monet (1840–1926), James Tissot (1836–1902), Henri Fantin-Latour (1836–1904), Alfred Sisley (1839–1899), and Jules Dalou (1838–1902), took refuge in England. Alma-Tadema, already popular there and eager to pursue his relationship with Laura Epps, decided to join his colleagues in London. Before leaving Brussels in September, he was honored by Gambart at a large dinner. As gifts he received a silver goblet and a check for one hundred pounds.

Alma-Tadema's unique form of classicism—archaeologically oriented domestic genre—did not threaten other classicists, so he blended easily into the stylistic maelstrom that characterized the British art world in the late nineteenth century. He gleaned techniques and compositional approaches from both the avant-garde and the traditionalists of the Royal Academy and was soon welcomed into the ranks of the "Victorian Olympians" as someone who would contribute to their success and popularity.

The major protagonists of classical painting in England at this time were Frederick Leighton, Edward Poynter, George Frederick Watts (1817–1904), and Albert Moore (1841–1893). Each had his own distinct approach. Poynter's morally imbued reconstructions of antiquity were the closest in style to Alma-Tadema's. Watts preferred allegory, and Moore explored the formal qualities of pattern and color.

By the mid-1860s, Frederick Leighton had become the champion of the classical revival in England. Of the many manifestations of Victorian classicism, Leighton epitomized the academic style. Whereas Alma-Tadema targeted a bourgeois audience with his domestic genre, Leighton had an Olympian view of antiquity. His aesthetic focus was Greece, not Rome; and, through predominantly mythological subjects based closely on antique sculpture, he represented what he felt was archetypal beauty. His refined Hellenic classicism with its emphasis on the ideal was aimed at ennobling and elevating the British public, whom Leighton envisioned as the natural inheritors of the Periclean age.

British interest in ancient Greece and Rome grew substantially during the nineteenth century. It began with the arrival of the Elgin Marbles in 1803 and their subsequent exhibition to the public in 1807. During Queen Victoria's reign, from 1837 to 1901, the number of people who embarked on the Grand Tour of the Continent grew dramatically, and Greece was often included in the itinerary. The construction of the Suez Canal from 1854 to 1860 focused public attention on Egypt and the exotic Arab culture. Many artists, among them Gérôme, Leighton, Frederick Goodall (1822–1904), and Charles Gleyre (1806–1874), visited Egypt in the middle of the century; and their evocative depictions of that mysterious land were extremely popular.

The romantic classicism of the eighteenth century celebrated the ruins of the ancient world. The revival that took place in the 1860s focused on a complete reconstruction of the glory of Rome. Within classical settings, the leading artists of the late nineteenth century celebrated the sensuality of the human form. This new approach to portraying antiquity met with strong criticism. Ruskin and others found such attention to pagan times to be anti-Christian and severely immoral. He preferred the work of the Pre-Raphaelite Brotherhood who, within a medieval format, concentrated on spiritual concerns. Ruskin, together with Thomas Carlyle, frequently expressed outrage at the preoccupation of classicists with the physical body.

The new middle class in England, made up of industrialists and merchants, were thrilled to encounter Alma-Tadema's art, contemptuously termed "five-o'clock-tea-antiquity" by the American expatriate artist James Abbott McNeill Whistler (1834–1903).[19] Many of these nouveau riche had taken the Grand Tour, knew of the discoveries in Pompeii, and had read Edward Bulwer-Lytton's popular novel *The Last Days of Pompeii*, published in 1834. Because Alma-Tadema's literary sources were not obscure (with the exception of a few pictures like *The Women of Amphissa*, cat. no. 37), his art appealed to collectors who may not have comprehended the more sophisticated symbolism and erudite compositions of painters such as Leighton, Watts, and Poynter. Such collectors felt that Alma-Tadema's pictures on their walls created a connection to the literary and artistic traditions of the aristocracy.

Alma-Tadema's style smoothly combined genre with classicism. The quiet domesticity of many of his subjects from the 1870s and 1880s reflected a trend in British taste that predated his arrival in England. Genre subjects were extremely popular in the 1850s and 1860s. The preoccupation with domesticity coincided with the rise of the Pre-Raphaelites and the height of the success of the Victorian novel. The Exposition Universelle in Paris in 1855 included the largest exhibition of British art yet shown on the Continent. Noting the abundance of quiet domestic scenes, one reviewer commented: "To pass from the grand salons appropriated in the Palais des Beaux Arts to French and Continental works, into the long gallery of British pictures, was to pass at once from the midst of warfare and its incidents, from passion, strife, bloodshed, from martyrdoms and suffering, to the peaceful scenes of home."[20]

Classicism veiled in domesticity was especially attractive to the Victorian public, troubled by the serious social problems that accompanied industrialization. Indeed, Victorian art can be characterized according to the various methods through which it escaped that reality. The "isms" of the time—classicism, medievalism, and orientalism—all provided an inviting view of distant and exotic places. As Gaunt states, "Alma-Tadema made the ancient world as bourgeois as a Dutch kitchen. He domesticated Greece and Rome and extracted from the distant classic spectacle the moral that even amid Corinthian columns there was no place like home."[21]

It is obvious that the people depicted in Alma-Tadema's pictures are Victorians and not ancient Greeks, Romans, or Egyptians. Although he may have used some Italian models, his favorite sitters were family and friends. Laura's auburn hair and wholesome figure are easily recognized in many compositions.

Although she did not reflect the traditional "classic ideal," Alma-Tadema did not consider this to be inconsistent with his archaeologically correct approach to antiquity. He firmly believed that, while history changes, human nature remains constant:

> It has been said, I know, that some of my Greeks and Romans are too English in their appearance. But, after all, there is not such a great difference between the ancients and the moderns as we are apt to suppose. This is the truth that I have always endeavoured to express in my pictures, that the old Romans were human flesh and blood, like ourselves, moved by much the same passions and emotions.[22]

This attitude reinforced the Victorian notion that imperial Britain was a contemporary reflection of the great Roman Empire. Through images of glorious antiquity peopled with everyday Londoners, the viewer was not only connected to a literary and artistic tradition but to the grandeur of the Roman Empire itself. Alma-Tadema commented on what he felt was the persistence of classicism in a lecture to the Royal Institute of British Architects in 1907: "Its reign has never really ended, for the influence of the Roman civilization lives still, and we are benefited by it more than we are aware of, and the dream of the great rulers has ever since been the reconstruction of the Roman Empire."[23]

The vehicle for this seduction of the viewer was classical subject matter skillfully rendered with precise detail and archaeological veracity and infused with a modicum of sentimentality. It invited the viewer to become involved in the narrative, for Victorian audiences reveled in mystery and ambiguity. They enjoyed "reading" pictures and interpreting their hidden but suggested meanings. Alma-Tadema's style matured in England; and its most popular phase consisted of his least crowded, most sentimental and enigmatic subjects. The move to London and subsequent marriage to Laura coincided with a change in style. Free of Belgian influences, Alma-Tadema's palette became brighter and more delicate. His female figures grew more solid and wholesome—taller and more robust—resembling his young British wife. He gradually became less preoccupied with narrative subjects and more interested in the formal aspects of his compositions. During his first decade in London, his style matured, his self-confidence increased, and he enjoyed greater independence.

In 1871 the Alma-Tademas purchased Townshend House in London and lavished a great deal of time, money, and effort on refurbishing it. Each room was decorated to represent a different culture or style—among them, Byzantine, Roman, Egyptian, and Japanese. Luxurious furnishings and fixtures were imported from the world over, and extreme care was taken to make each room architecturally correct. The eclectic taste of the owners was reflected in their diverse selection of materials: Spanish leather, Mexican onyx, German glass, Dutch woodwork, and exotic marbles (see fig. 3).

Alma-Tadema instituted a system for organizing his oeuvre by opus number in 1872. He began, retroactively, to assign numbers, which were inscribed on the pictures in roman numerals. A portrait of his sister, Artje, was designated opus I. Painted in 1850, it was the first picture to have been exhibited publicly, at a gallery in Leeuwarden. Altogether, Alma-Tadema created 408 of these numbered works. The opus numbers and dates of completion were recorded separately; and, until this list was published in 1910 by Rudolf Dircks,[24] only Alma-Tadema himself could verify a date or authenticate a painting. This system protected against forgeries and pleased Gambart, who thought the pictures seemed more current without dates on them.[25]

By 1872 Alma-Tadema was well ensconced in London. *Death of the First-Born*, 1872 (Rijksmuseum, Amsterdam), was named Picture of the Year by Pall Mall Magazine. The artist was immensely popular with his buying public as well as his artistic colleagues. His desire for complete assimilation into British society was fulfilled when he was granted citizenship on January 25, 1873, through the receipt of letters of denization from Queen Victoria.

Alma-Tadema was elected to the Royal Society of Painters in Watercolor the same year. Unlike most of his classicist colleagues, he was quite interested in this medium and prolific. The several examples in the exhibition prove that he was skillful at achieving a delicate luminosity and clarity in his watercolors. Technically, the finished watercolors are similar to his oils; and, in fact, he complained to Georg Ebers that the medium required as much time and energy as oil but resulted in much smaller profits.[26]

In December, 1870, the French dealer Durand-Ruel opened a gallery in London and began exhibiting impressionist works. Alma-Tadema admired the paintings of Edouard Manet (1832–1883) and the impressionists, but their influence on his technique was minimal. During the 1870s, more and more of his compositions had outdoor settings, suggesting an awareness of contemporary plein-air painting. Although interested in the effects of light and spontaneous motion, he painted all of his pictures in the studio.

Alma-Tadema was not immune to the influence of his contemporaries. Instead of following one particular philosophy or style, however, he gleaned techniques from a variety of sources and integrated them into his own method, which remained unique. A recognizable influence was that of the Pre-Raphaelites, with whom Alma-Tadema's name was erroneously connected on several occasions because of his classical subjects, detailed naturalism, and bright palette. His exposure to Pre-Raphaelite painting did serve to lighten his palette and free it from the formal heaviness acquired in Belgium. Nonetheless, although he admired the work of the Pre-Raphaelites and was friendly with several of them, he did not share their fundamental philosophy that art should reinforce morality.

Even Whistler, the proponent of "art for art's sake," influenced Alma-Tadema's style. Both artists had a respect for the innate beauty of natural forms, and it is likely that the sense of immediacy, which became a very important feature of Alma-Tadema's later work, was suggested by Whistler's style. Like Whistler, Alma-Tadema was detached from subject matter; his pictures frequently have several interchangeable titles, and he is known to have literally cut canvases or panels into smaller autonomous compositions. The anecdotal qual-

ity of his pictures became diluted as he matured stylistically and formal considerations grew stronger. In 1886 Alma-Tadema sounded quite modern when he stated that the subject was not his primary focus when composing a picture:

> One of the greatest difficulties in Art is to find a subject that is really pictorial, plastic. . . . Of course, the subject is an interesting point in a picture, but the subject is merely the pretext under which the picture is made, therefore it is wrong to judge the picture according to the subject.[27]

By 1875 Alma-Tadema had completed well over forty paintings for Gambart. His new English style was received with mixed reviews in the spring of 1875 when *A Sculpture Gallery*, 1874 (Hood Museum of Art, Dartmouth College, Hanover, N.H.), was exhibited at the Royal Academy. In his *Academy Notes*, Ruskin expressed cautious praise for the picture:

> This, I suppose, we must assume to be the principal historical piece of the year; a work showing artistic skill and classic learning, both in a high degree. . . . The artistic skill has succeeded with all its objects in the degree of their unimportance. . . . The execution is dexterous but more with mechanical steadiness of practice than innate fineness of nerve.[28]

Together with its pendant, *A Picture Gallery in Rome*, 1874 (Towneley Hall Art Gallery and Museum, Burnley, Lancashire), *A Sculpture Gallery* was exhibited at the Royal Academy summer exhibition in 1875. Critical reaction was much more favorable, and the immense popularity of these two pictures was probably responsible for Alma-Tadema's election to the academy. Although nominated for membership in 1876, Alma-Tadema did not become an academician until 1879 because there was no vacancy in the membership, which was limited to forty.

In October, 1875, Alma-Tadema and his family embarked on a trip through Europe of five and a half months. The artist, suffering from exhaustion, wished to escape the stresses of London. His house had been nearly destroyed the previous year, when a barge loaded with gunpowder exploded on nearby Regent's Canal. Much of his energy had been directed toward the extensive repairs. In addition, Laura's sister Nellie and her new husband, Edmund Gosse, were living with them in Townshend House. The Alma-Tademas must have looked forward to a respite from crowded quarters and workmen.

The family toured Florence, Bologna, Verona, Venice, and Rome, where Alma-Tadema collected photographs of architectural sites and antiquities. For the first time, he sought out and studied works of art of the Italian Renaissance. He visited the Villa Borghese and made many small oil sketches in the surrounding gardens. These, as well as sketches of other Roman sites, became the basis for several later pictures, for example, *Spring in the Gardens of the Villa Borghese* (cat. no. 20). Another picture in this exhibition, *On the Road to the Temple of Ceres: A Spring Festival* (cat. no. 21), was started on this trip and completed in 1879 in the artist's London studio.

In May of 1877, the Grosvenor Gallery, which was organized by the painters Sir Coutts Lindsay (1824–1913) and Charles Hallé (1846–1914), was opened as an alternative exhibition space to the Royal Academy. The gallery showed the works of artists who had been rejected by the academy and those who resented its restrictive policies. This somewhat controversial stance was enthusiastically received by the artistic community. The first exhibition included pictures by Alma-Tadema, Leighton, Poynter, Whistler, Dante Gabriel Rossetti (1828–1882), Edward Burne-Jones (1833–1898), and Gustave Moreau (1826–1898). Alma-Tadema entered a total of seven pictures, among them *Tarquinius Superbus* (cat. no. 10). "Joining the gallery was an act of courage and foresight for Alma-Tadema," according to Vern Swanson, "as this partial defection placed

in jeopardy his wish to become a full Royal Academician."[29] The opening of the exhibition was met by a loud outcry of criticism. Oscar Wilde, an acquaintance of Alma-Tadema's, commented: "I and Lord Ronald Gower and Mr. Ruskin, and all the artists of my acquaintance, hold that Alma-Tadema's drawing of men and women is disgraceful. I could not let an article signed in my name say he was a powerful drawer."[30]

Alma-Tadema was often criticized for the way he painted figures. Although his technical skill, knowledge of antiquity, and keen sense of color and light were always highly praised, his handling of the human form was condemned as lifeless, stiff, and lacking "soul." Helen Zimmern felt that frequently the people in Alma-Tadema's pictures were not really the subject of the work but rather served as accessories, not unlike a statue on a table or a painting on a wall. In her description of *The Oleander* (cat. no. 30), she states:

> Near the oleander sits a woman . . . and in this case the charge of giving less soul to his human beings than to his stones . . . is not unfounded. In fact, we hardly notice, certainly do not remember this woman, while the pink blossoms, the yellow columns of the corridor, the sunlit water, all stand out clear and distinct. Of this Alma Tadema seems himself to have been conscious to a certain degree, for he has called his picture 'An Oleander,' thus tacitly admitting that the woman has more or less been thrown in as an accessory to the flowers.[31]

In the spring of 1878, Alma-Tadema returned to Pompeii. He was impressed with the amount of archaeological research that had been accomplished since his earlier visit and eagerly set to work sketching, measuring, and investigating the ruins. He was delighted when the director of the excavations conducted an official dig in his honor: the excavation of a room in an ancient house. Although nothing of consequence was discovered, the experience was a thrill for Alma-Tadema.

Frederick Leighton became president of the Royal Academy in 1878, the year of the famous libel suit by Whistler against Ruskin.[32] Leighton had a strong and influential character and proved to be a talented administrator. The academy benefited immensely from his eighteen-year tenure as director. In June of 1879, Alma-Tadema was elected an academician—an honor that meant more to him than any of his previous accomplishments.

Perhaps the most significant achievement of the years immediately following his membership in the Royal Academy was the picture *Sappho and Alcaeus* (cat. no. 26). Completed in 1881, the painting proved to be one of Alma-Tadema's most important and successful works. From the very beginning, he planned to exhibit it not only at the Royal Academy in London but also at the one in Berlin. He thus took considerable pains to ensure that the details of the composition were historically correct. Nevertheless, the picture was condemned for inaccuracy by a critic writing for the *Nation* in 1886.[33] The artist sought to vindicate himself and was able to provide the sources for the disputed elements of the composition. The picture was extremely popular with most other critics and with the public, and it remains one of the best known examples of Alma-Tadema's oeuvre.

The decades of the 1870s and 1880s were productive and fulfilling for Alma-Tadema who, in 1874 alone, completed a total of twenty-one pictures. Many of these comprise his best efforts. As the years progressed and his style matured, he became more interested in investigating the subtleties of color and the formal structure of composition. His early preoccupation with narrative waned, as did his reliance on easily recognizable antique settings. He became more selective in his choice of archaeological detail, and his compositions grew more spacious and less crowded. His manipulation of light and color could at times be spectacular and, in the later years, often overwhelmed any anecdote or narrative. Throughout his career, Alma-Tadema was above all a colorist; and in the last

years of the century, he attained a crescendo of luminosity and clarity. Anne Goodchild aptly summarizes his ability as a colorist:

> His colour schemes fully complemented his magnificent lighting, ranging from the Pompeian reds of the canvases of the 1860's and 70's to the palest mauves and greys and clear greens and blues of the later works. The effect of these shimmering colour schemes is one of an irridescence, which appears to emanate from within the object. It is interesting to note that these effects were achieved without the aid of varnishes.[34]

Unlike many of his colleagues, Alma-Tadema was not religious, spiritual, or deeply intellectual. He was straightforward, uncomplicated, gregarious, optimistic, hard-working, and shrewd. His aesthetic concerns were simple: he devoted his life to celebrating the beauty that he saw around him. Helen Zimmern labeled him "the painter of gladness, of the joy of life."[35] This sentiment is embodied in his pictures of the 1880s and 1890s. They rarely contain recognizable architecture, and action is minimal. The compositions are tightly orchestrated presentations of harmonious colors, luxurious textures, vivid flowers, luminous marble, water, and creamy flesh—all bathed by strong radiant sunlight.

In 1879, Alma-Tadema was invited by the actor Sir Henry Irving to design the sets for his production of Shakespeare's *Coriolanus*. Alma-Tadema's eight watercolors were significant for placing the drama in the Etruscan era, closer to the traditional period of this legendary hero than the usually employed classical setting. The drawings greatly impressed the members of the Royal Institute of British Architects who, many years later, made him an honorary member because of his impressive skill in rendering architecture. During the 1880s, Alma-Tadema continued to design sets, scenery, and costumes for the theater. His influence even affected the world of fashion; dresses inspired by his costume designs became extremely popular and gave rise to the term "Tadema togas." Furthermore, his sweeping views and convincing recreations of ancient Rome reputedly influenced the films of D. W. Griffith and Cecil B. deMille.

In 1882, the Grosvenor Gallery held a show of Alma-Tadema's work from 1840 to 1882. The largest exhibition of his pictures to date, it included 185 paintings and drawings. Alma-Tadema diligently tracked down many of his most important works for the exhibition. He was able to borrow from most of the Continental owners but could obtain only two works from American collectors. This was a great disappointment, because many of his best paintings were in the United States. Ultimately, however, he was satisfied that his oeuvre was well represented by the exhibition. The show received mixed reviews, consistent with past critiques of the artist's work. The accurate archaeology and vivid color were highly acclaimed; and the stiff, lifeless figures were censured. According to Vern Swanson: "He was praised for his brushwork, colour, detail and perspective, but condemned for saying more about the Romans than anyone would want to know."[36]

The retrospective was extremely important to Alma-Tadema's career. It gave his art great visibility and established him as one of the most successful and sought-after painters in Britain in the 1880s. After the show closed, his production of pictures slowed dramatically from about twelve to about five a year. This was primarily due to the greater demands on his time from his administrative responsibilities at the Royal Academy, teaching duties, and the alterations to his home.

In addition to an extremely busy social calendar—Alma-Tadema was friendly with much of London's artistic and intellectual community—by 1882 he had memberships in numerous art societies that claimed his time.[37] He took these affiliations seriously and devoted himself to as many of them as he could. The unfortunate result of his hectic schedule was exhaustion and chronic physical complaints.

Formal portraiture had never been an important element in Alma-Tadema's oeuvre. Although he frequently included members of his family and friends in his compositions, he rarely painted portraits before the 1880s. After the Grosvenor Gallery show, they became much more common; in fact, in 1883 he painted seven. This may, in part, reflect a reaction to the criticism of his figures. Alma-Tadema's portraits are intimate and vital. His portrait of young Alice Lewis (cat. no. 33) is an extremely sensitive image of a shy young woman. By employing a somewhat unorthodox oblique pose, he reinforces the very private nature of her character.

In April of 1883, Alma-Tadema embarked on a three-month trip to Italy. This was his last important trip to Italy, and much of his time was spent in Pompeii. A great deal of progress had been made in the excavations since his visit in 1878, and he devoted himself to learning as much as possible about the city and its history. In a letter to his brother-in-law Edmund Gosse, Alma-Tadema described his feelings about the ancient city of Pompeii:

> Pompeii is still the great attraction. We go there daily, I study it thoroughly. It is so quaint, so interesting, so sad, so terrible, so poetical, so bewitching, that really I dread to come to an end with it. Every day one loves the place better as every day one knows a little more of it.[38]

This trip to Italy had a direct effect on Alma-Tadema's art. After he returned to London, his pictures were less crowded with details. He seemed to have gained enough knowledge and understanding of the life of ancient Rome to no longer need to make his scenes encyclopedic.

In 1884 Alma-Tadema began renovating another house in London. He had bought it from the painter James Tissot when the latter returned to his native France in 1882. This house at 17 Grove End Road, Saint John's Wood, became the focus of much of Alma-Tadema's creative energy from 1884 to 1886 (fig. 4). It was the ultimate expression of his character. He designed and supervised elaborate building plans that doubled its size. No expense was spared in creating a Roman villa that, for nearly three decades, would be the center of his life.

The bronze front door was a reconstruction of a door in Pompeii. Carved into the wood above it was the Latin greeting SALVE (Welcome). The rooms were identified with Roman names: the dining room was called the *triclinium*;

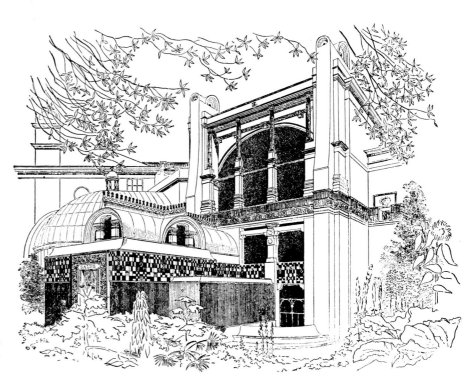

FIG. 4: Alma-Tadema's house at 17 Grove End Road, showing the entrance to the studio, c. 1886, drawn by J. Elmsly Inglis.

the library, the *atrium*; and the studio, the *conclave*. The library housed Alma-Tadema's vast collection of books, which at his death consisted of over four thousand volumes, mostly related to art, archaeology, ancient history, and antiquities. It also contained a large collection of photographs, which were bound in 165 portfolios, numbered, and arranged alphabetically by subject.[39] A brass staircase led to the studio, which, together with the library, was the most important space in the house. Alma-Tadema's favorite motto, "As the sun colours flowers so art colours life," was inscribed in the wall over the studio door. This room, where he spent most of his time, had marble walls, cedar doors, and a marble fireplace with a chimney in the shape of a silver column with a gilt capital and base. There was a piano with a vellum-lined lid inscribed with autographs of the many celebrated musicians who had performed there. Several easels held pictures in various stages of completion because Alma-Tadema preferred to work on more than one at a time. The domed ceiling of the studio was covered with polished aluminum, which reflected a cool, silvery light. The effect of this light, together with the creamy marble walls, dramatically affected the pictures painted there. They had a luminous quality that can be seen in *A Reading from Homer* (cat. no. 34).

Many of the exotic and precious materials that had been used at Townshend House were also employed at Grove End Road. There were Tunisian embroideries, Moorish panels, and a window made of Mexican onyx that appears in several paintings. A series of connecting rooms, among them Laura's studio, was inspired by seventeenth-century Dutch interiors. The entrance hall contained numerous painted panels, each done by an artist friend of the family. The many contributors included Leighton, Sargent, Collier, and Poynter.

This extraordinary building allowed Alma-Tadema to live as if in one of his own paintings. It supplied settings and props for his pictures, as well as the background for displaying them. It also nurtured him by providing an environment that was conducive to creating the sensuous and harmonious works of his most creative years. And it was the scene of the lavish social gatherings that delighted him. Cosmo Monkhouse, writing in *Scribner's Magazine* in 1895, felt that the house was such an integral part of Alma-Tadema that "its future occupant, whatever his merit or ability, will be nothing but a hermit-crab."[40]

Because Saint John's Wood was fashionable for artists and writers, Alma-Tadema's move greatly enhanced his ability to climb the social ladder. He quickly immersed himself in the active social life of the area. His Monday afternoons "at home" and frequent parties and concerts were popular events. They eventually became so grand that they affected the entire neighborhood:

> The once demure "picture Sundays," when studios were opened to the patrons, dealers, critics and friends to view artists' newly finished work before sending-in day at the Royal Academy, began to acquire a pretentious vulgarity. Parties became unwieldy affairs, with admittance cards and rows of carriages, altering forever the hidden Bohemian ambiance.[41]

Although Alma-Tadema enjoyed his complicated social life, he worried about the negative impact of a busy schedule on his art. Lamenting this disturbing situation, he told a friend, the pianist George Henschel, "Only the daylight can be utilized and people will not understand that I must remain at the wheel when the light to work is there. Today again I had to refuse a lunch. I cannot accept these invitations and produce pictures as well."[42]

In the mid-1880s, Alma-Tadema complained of difficulty in finishing pictures.[43] *The Triumph of Titus: The Flavians* (cat. no. 35), painted for William T. Walters in 1885, took more than a year to complete. Many letters excusing the delay were sent to Walters. On the other hand, *A Reading from Homer* (cat. no. 34), also dating from 1885, was completed within two months. The size of the picture, 36 × 72³/₈ inches, made this accomplishment noteworthy.

A Reading from Homer, perhaps the most famous of all Alma-Tadema's

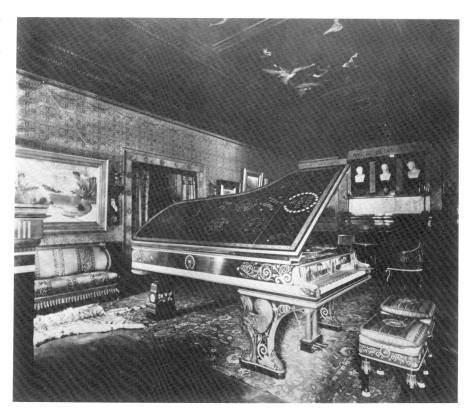

paintings, was executed for Henry G. Marquand, an American entrepreneur and art patron. Around the same time, he commissioned Alma-Tadema to design a music room (fig. 5) for his New York townhouse. The classical scheme for the room included all the furnishings, a ceiling painted by Leighton, and an elegant grand piano with a panel painted by Poynter. *A Reading from Homer* was originally installed in the room, as was another picture by Alma-Tadema, *Amo Te, Ama Me*, 1881 (location unknown).

Laura and her sisters, Nellie Gosse and Emily Williams, who were also painters, began summering in the quaint village of Broadway in the Cotswolds around 1886. They were guests in the home of the American artist Frank D. Millet (1846–1912) and his wife, Lily, where they were joined by Alma-Tadema, who sought relaxation and refuge from the demands of the construction on his London house. The families became close friends and shared many holidays throughout the years. Alma-Tadema painted two portraits for the Millets: one of Lily (cat. no. 36) and the other of the couple's infant son, John Alfred Parsons Millet (cat. no. 40). The picturesque village of Broadway attracted many artists and intellectuals. Alma-Tadema's relationship with John Singer Sargent (1856–1925) bears mention for, although the two painters represented stylistic extremes, they were friendly and encouraged each other's efforts. Sargent was strongly influenced by the impressionist style of Claude Monet at this point in his career. He felt that Alma-Tadema's technique lacked spontaneity and that his compositions were contrived and artificial. Edmund Gosse, always a supporter of Alma-Tadema, discussed Sargent's disdain for Alma-Tadema's work:

> Most revolutionary, for me, was his serene and complete refusal to see anything at all in the works of Alma Tadema, then in the zenith of his fame. "I suppose it's clever," he said, "of course it *is* clever . . . but of course it's not art in any sense whatever," with which cryptic pronouncement I was left awed and shaken. . . . Sargent's dislike of Alma Tadema's painting here expressed was accompanied with the highest deference to his knowledge and opinion. There were few artists for whose artistic judgement Sargent entertained such cordial respect, none that he was more ready to consult as a critic.[44]

It is likely that the time shared by Sargent and Alma-Tadema at Broadway proved to be mutually beneficial. Exposure to Sargent's impressionist technique made Alma-Tadema more sensitive to the subtle and changing effect of light on surfaces. Sargent benefited directly from commissions that were sent his way by Alma-Tadema.[45]

In 1888 George Eastman invented the Kodak camera, and Alma-Tadema was one of his first customers. From early in his career, photography had played an important role in Alma-Tadema's working method. He incorporated it in a variety of ways: for developing compositions, recording antiquities, reinforcing his memory, and studying movement and light. He began using photographic prints in 1866 when, together with the photographer J. Dupont, he took pictures of his paintings in progress to study tonal properties. The photographs were taken at several stages and compared against the painting as it evolved.[46]

Alma-Tadema was particularly intrigued by the ability to stop action through photography. Because of the criticism of his figures as stiff and lifeless, he desired to instill motion into them. He studied Eadweard Muybridge's research on animal and human motion and was instrumental in arranging for him to lecture at the Royal Academy in 1889. Much of Alma-Tadema's late work appears to incorporate photographic effects. Images are frequently cropped, vantage points are high or panoramic, and there is the sense of spontaneity that exists in a snapshot.

In 1889 *The Women of Amphissa* (cat. no. 37) was awarded a medal of honor at the Exposition Universelle in Paris. This particular prize meant a great deal to Alma-Tadema because it was decided by an international jury. The picture was extremely popular and inspired Cosmo Monkhouse to write that with *The Women of Amphissa* "the artist has become the master of the archaeologist."[47] The composition, a Greek subject and one of the last works to represent an event from history or literature, is daring and complex. Carefully orchestrated and extremely detailed, the monumental scene includes approximately forty figures set among an encyclopedic array of antiquities.

In the last twenty years of his life, the pace of Alma-Tadema's production slowed considerably. Fewer pictures were produced each year—he averaged only four or five paintings a year from 1898 to 1912—but they were often of higher technical and formal quality. By 1890 his figures were more lifelike and vivacious. His compositions were simpler with emphasis on carefully selected, frequently enigmatic, accessories. The action or anecdotal quality is often trivial and secondary to the sentimental ambience. Several pictures in the current exhibition reveal this new sensibility, for instance, *Promise of Spring* (cat. no. 41), *Unwelcome Confidence* (cat. no. 42), and *Whispering Noon* (cat. no. 44). Alma-Tadema's brushwork, color, tonal harmony, and sensual lighting are exceptional in his late pictures. Unusual perspectives and compositions were a dramatic change from the traditional focus of members of the Royal Academy.

In January of 1892, Alma-Tadema became a charter member of the Japan Society, founded to promote the appreciation of Japanese culture and art. Actively involved with the group, he enthusiastically helped prepare exhibitions of Japanese art. Alma-Tadema had first encountered Japanese prints on his visit to London in 1862 and again in Paris at the 1867 Exposition Universelle. He eventually amassed a large collection of Japanese art that included porcelain, bronzes, lacquer, screens, prints, and pottery. He shared this interest with several contemporaries, in particular Whistler and Moore. Japanese influence is manifest in the strong formal rhythms, subtle color schemes, and simplified subject matter in their art. It is evident also in the dramatic perspective and oblique viewing angle in works like Alma-Tadema's *A Coign of Vantage* (cat. no. 43).

Several of the paintings submitted by Alma-Tadema to the World's Columbian Exposition in Chicago in 1893 won prizes. *A Sculpture Garden* (cat. no. 17) was the most highly acclaimed British entry. The exhibition enhanced Alma-

Fig. 6: Alma-Tadema and his wife, Laura, c. 1905.

Tadema's fame in the United States, where he remained very popular until well after his death.

Although his greatest following was in the United States, Alma-Tadema was an Anglophile through and through. He was deeply honored when on May 24, 1899, the day of her eightieth birthday, Queen Victoria made him a knight. He was only the eighth artist born on the Continent to be so honored.[48] The event was celebrated with a banquet attended by 180 men, including most of the important artists of the late nineteenth century.[49] By this high point in his career, Alma-Tadema had completed 273 works to which opus numbers had been assigned.

In the spring of 1900, the artist traveled once more to Italy, this time to research the Etruscan sites north of Rome for his ongoing theatrical designs for *Coriolanus*. The project, which had been postponed since 1880, finally got underway and the play was performed in 1901. Alma-Tadema's set designs received more attention from the critics than did the play itself.

In the winter of 1902–1903, Alma-Tadema was invited by Sir John Aird to attend the dedication of the Assiut and Aswan dams in Egypt. The trip lasted six weeks. When it ended, the artist painted *The Finding of Moses*, 1904 (private collection), as a gift for Aird. It took almost two years to complete and provoked Laura Alma-Tadema to remark that Moses was by now "two years old and need no longer be carried."[50]

While the picture was being painted, King Edward VII paid a visit to Alma-Tadema's studio. He was extremely impressed with *The Finding of Moses* and bestowed the Order of Merit on the artist very soon after the painting was finished. In the same year, Alma-Tadema was asked to serve on the British Committee for the 1904 Saint Louis World's Fair. His three entries—*At the Shrine of Venus*, 1888 (New Orleans Museum of Art), *The Coliseum*, 1896 (private collection), and *Caracalla: A.D. 211*, 1902 (location unknown)—were all very popular.

By then, Alma-Tadema's world was growing smaller. Many of his friends and colleagues had died; and his health, as well as that of his family, was chronically poor. His ability to paint and the quality of his work remained high, although in the last decade he produced few paintings. In 1905 he completed only one work that bears an opus number, *A World of Their Own* (cat. no. 47). It was commissioned by Scott and Fowles of New York and sold to the Taft family of Cincinnati.

Until the end of his life, Alma-Tadema (fig. 6) continued to amass personal honors. In 1906 he was made an honorary member of the Royal Institute of British Architects and was asked to give a lecture on ancient architecture. The following year, he spoke on marble:

> Marble is beautiful stuff to deal with. . . . When used for interior work I know nothing finer, nothing more precious, nothing more wonderful, than a well-adjusted and well-disposed marble decoration. It is so clean and bright, so solid, and never harsh or unpleasant, provided it be applied by a man of taste.[51]

On August 15, 1909, Alma-Tadema's beloved wife Laura died unexpectedly. This was a loss from which he never fully recovered. As his own health deteriorated, he felt forced to relinquish many of his official positions and in 1911 resigned from his responsibilities at the Royal Academy. The melancholy painting *Summer Offering* (cat. no. 49) may reflect the artist's temperament at this time. Several of Alma-Tadema's late works possess a sense of introspection that suggests he was no longer solely interested in the outward appearance of the world.

In regard to the artist's late style, Cosmo Monkhouse wrote, "he gets more modern as well as more human, using art only as a drapery for nature, and the

past as a cloak for the present."[52] Alma-Tadema's last major oil, *Preparation in the Coliseum* (private collection), was unfinished at his death in 1912. This remarkable painting, over sixty by thirty inches in size, embodies the strength of his late compositions but adds a dimension not present in previous works. The anxiety in the face of the bacchante seems to anticipate twentieth-century concerns about alienation.

Alma-Tadema felt strongly that his art addressed contemporary issues:

Remember . . . we are after all the descendants of antiquity. The times change, but human nature does not change with them. And so, whether it is Pharaoh weeping over his dead son's body in an Egyptian temple, or a Roman lady chaffering with a Tiber boatman over his fare for ferrying her across the river, or a Greek youth reading Homer by the shore of the much-roaring sea, I endeavor to throw into each something of that life which I best know—the ever-throbbing life of the great city which lies around us.[53]

Suffering from ill health, Alma-Tadema, accompanied by his daughter Anna, traveled to a spa in Wiesbaden in the spring of 1912 to rest and recuperate. His condition worsened, and on July 28th the seventy-six-year-old artist died. Anna brought his body back to London, where he was buried in Saint Paul's Cathedral.

Soon after his death, Alma-Tadema became the target of a great deal of negative criticism. His figures were condemned as insipid and lifeless, his settings as overcrowded and contrived. His style was singled out as the embodiment of Victorian elitism, materialism, and artificiality. A particularly vicious attack was made in the *Nation* in 1913 by the champion of impressionism, Roger Fry:

Sir Lawrence's products are typical of the purely commercial ideals of the age in which he grew up. His art . . . demands nothing from the spectator beyond the almost unavoidable knowledge that there was such a thing as the Roman Empire, whose people were very rich, very luxurious, and, in retrospect at least, agreeably wicked. . . . He does, however, add the information that all the people of that interesting and remote period, all their furniture, clothes, even their splendid marble divans, were made of highly scented soap. . . . the case of Sir Lawrence Alma-Tadema is only an extreme instance of the commercial materialism of our civilization. . . . How long will it take to disinfect the Order of Merit of Tadema's scented soap?[54]

Philip Burne-Jones, speaking in defense of Alma-Tadema, voiced a somewhat lonely opinion in the same year:

The collected works of Sir Lawrence Alma-Tadema . . . form as impressive an example as is likely to be found of what human industry combined with consummate draughtsmanship, impeccable technique, and an exquisite sense of the beauty of the material world is able to achieve. The hand of man has never surpassed, if it has ever even equalled, the skill displayed in some of these pictures. There is more real sunlight and *joie-de-vivre* in a single square inch of [his] painting . . . than in the entire output of the Impressionist School.[55]

Now that nearly a century separates us from Alma-Tadema's most prolific period, interest in his work has been rekindled. Alma-Tadema's oeuvre provides insight into the complex and multifaceted art world that, at the end of the last century, battled over issues of style, patronage, aesthetics, technique, and artistic autonomy. His pictures are fascinating examples of tireless research into antiquity, of an individualistic technique and working method, and of the merging of disparate artistic traditions into a unique style. The sensual light and endless

variations of texture and color harmonies are impressive; the extensive archaeological detail alone is often overwhelming. Neither philosophically nor allegorically profound, Alma-Tadema's work is appealing for its simple clarity, rich colors, and occasional touches of endearing humor. He provided his audience with an escape from gritty reality into a fantasy world, similar in shape and content to the "glory that was Rome" but inhabited by familiar faces. Now that the distance of years has allowed us to recognize his talent once more, Alma-Tadema's expansive oeuvre provides us with a pleasant vehicle with which to explore the often maligned and unappreciated Victorian era.

JENNIFER GORDON LOVETT

1. Named for one of his godfathers, Lourens Alma, the artist changed his name when he moved to England in 1870. He had been spelling his first name Laurens for some time, but in England he anglicized it to Lawrence. He also connected his middle name and surname. There is much debate about the reason for this. Most biographers agree that the hyphenation was done in order to have his name entered, in exhibitions and catalogues, at the front of the alphabet. For the sake of consistency, the name Lawrence Alma-Tadema will be used in this catalogue.
2. Vern G. Swanson, *The Biography and Catalogue Raisonné of the Paintings of Sir Lawrence Alma-Tadema* (London: Garton and Co., 1990), p. 20.
3. William Gaunt, *Victorian Olympus*, rev. ed. (London: Jonathan Cape, 1975), p. 58.
4. Swanson, *Biography and Catalogue Raisonné*, p. 24.
5. Two invaluable sources for Merovingian subjects for Alma-Tadema in de Taeye's library were Augustin Thierry, *Récits des temps mérovingiens* (1840), and Gregory of Tours, *Historia Francorum* (590).
6. Quoted in Frederick Dolman, "Sir Lawrence Alma-Tadema, R.A.," *Strand Magazine* 18, (Jan., 1900), p. 605.
7. Quoted in Gaunt, *Victorian Olympus*, p. 59.
8. Georg Ebers, *Lorenz Alma Tadema: His Life and Works*, trans. Mary J. Safford (New York: William S. Gottsberger, 1886), p. 21.
9. Quoted in Gaunt, *Victorian Olympus*, p. 59.
10. Ebers, *Lorenz Alma Tadema: His Life and Works*, p. 35.
11. Quoted ibid., pp. 35–36.
12. Some of the important literary sources that Alma-Tadema used for his Pompeian pictures were Edward Bulwer-Lytton, *The Last Days of Pompeii* (1834); Guiseppe Fiorelli, *Journals of the Excavations at Pompeii* (1861–62); and Henri Roux, *Herculaneum et Pompeii* (1840).
13. Alma-Tadema's daughters were devoted to their father and lived most of their lives with their parents. Laurense (1865–1940) became a somewhat successful author of fiction and poetry. Anna (1867–1943) was a talented painter who exhibited several works at the Royal Academy and Grosvenor Gallery. Plagued by emotional problems, she was dependent on her family for much of her life. Neither daughter married, they were not well provided for in their father's will, and both died in relative poverty.
14. Quoted in Dolman, "Sir Lawrence Alma-Tadema, R.A.," p. 612.
15. Alma-Tadema may have learned this technique from the Pre-Raphaelites.
16. "The Royal Gold Medallist and his Pictures," *Journal of the Royal Institute of British Architects*, 3rd ser., 13 (June 30, 1906), p. 444. See cat. nos. 9, 15, and 17 for a discussion of Alma-Tadema's art gallery/connoisseur pictures.
17. John Ruskin, *Mornings in Florence, Time and Tide, The Art of England, Notes on the Construction of Sheepfolds* (Boston: Dana Estes and Co., n.d.), p. 295.

18. Quoted in Jeremy Maas, *Gambart, Prince of the Victorian Art World* (London: Barrie and Jenkins, 1975), p. 234.
19. Quoted in Swanson, *Biography and Catalogue Raisonné*, p. 40.
20. Quoted in Graham Reynolds, *Victorian Painting* (London: Studio Vista, 1966), p. 94.
21. Gaunt, *Victorian Olympus*, p. 99.
22. Quoted in Dolman, "Sir Lawrence Alma-Tadema, R.A.," p. 607.
23. Lawrence Alma-Tadema, "Marbles: Their Ancient Application," *Journal of the Royal Institute of British Architects*, 3rd ser., 14 (Jan. 26, 1907), p. 169.
24. Rudolf Dircks, "The Later Work of Sir Lawrence Alma-Tadema, O.M., R.A., R.W.S.," *Art Journal*, Christmas suppl. (1910), pp. 1–32.
25. Swanson, *Biography and Catalogue Raisonné*, p. 42.
26. Alma-Tadema to Ebers, Dec. 27, 1883, quoted ibid., p. 62.
27. Quoted in Helen Zimmern, "The Life and Works of Alma Tadema," *Art Journal* (London), n.s., special no. (1886), p. 28.
28. John Ruskin, *The Works of John Ruskin*, ed. E. T. Cook and A. Wedderburn, vol. 14 (London: George Allen, 1904), pp. 271–72.
29. Swanson, *Biography and Catalogue Raisonné*, p. 52.
30. Oscar Wilde, *Letters of Oscar Wilde*, ed. R. Hart-Davis (London: Rupert Hart-Davis, 1962), p. 39.
31. Zimmern, "Life and Works of Alma Tadema," p. 23.
32. Concerning one of Whistler's paintings in the 1877 Grosvenor Gallery exhibition, Ruskin had written, "I have seen, and heard, much of Cockney impudence before now; but never expected to hear a coxcomb ask two hundred guineas for flinging a pot of paint in the public's face" (*Works of John Ruskin* vol. 29 [1907], p. 160). Whistler won the suit but was only awarded a token sum in damages, and the negative publicity from the trial ruined him. The case also ended Ruskin's powerful influence over the art world.
33. W. S. Gottsberger, "The Archaeologist of Artists," *Nation* 43, no. 1107 (Sept. 16, 1886), pp. 237–38.
34. Mappin Art Gallery, Sheffield, England, *Sir Lawrence Alma-Tadema, O. M., R. A., 1836–1912*, exhib. cat., 1976, unpaged.
35. Zimmern, "Life and Works of Alma Tadema," p. 45.
36. Swanson, *Biography and Catalogue Raisonné*, p. 59.
37. By 1882 Alma-Tadema had joined the Council of the Royal Academy, the Royal Institute of British Architects, the Society of British Artists, the Royal Society of Painters and Etchers, Society of Cabinet Pictures in Oil, the Costume Society, and the Society of Oil Painters.
38. Quoted in Swanson, *Biography and Catalogue Raisonné*, p. 61.
39. The photographs and the books are now housed in the Birmingham University Library in England.
40. Cosmo Monkhouse, "Laurens Alma-Tadema, R.A.," *Scribner's Magazine* 18 (Dec., 1895), p. 681.
41. Swanson, *Biography and Catalogue Raisonné*, p. 67.
42. Quoted in Mario Amaya, "The Roman World of Alma-Tadema," *Apollo*, n.s., 76 (Dec., 1962), p. 778.
43. Swanson, *Biography and Catalogue Raisonné*, p. 64.
44. Quoted in Evan Charteris, *John Sargent* (London: William Heinemann, 1927), p. 77.
45. Swanson, *Biography and Catalogue Raisonné*, p. 68. Alma-Tadema introduced Sargent to Henry G. Marquand, who commissioned a portrait of himself and other family members.
46. Ibid., p. 33.
47. Monkhouse, "Laurens Alma-Tadema, R.A.," p. 675.
48. The others were Peter Paul Rubens (1577–1640), Anthony van Dyck (1599–1641), Balthasar Gerbier (c. 1592–1667), Robert Peake (c. 1551–1619), Peter Lely (1618–1680), Nicolas Dorigny (1658–1746), and Godfrey Kneller (1646–1723).
49. A poem in honor of the artist was composed by Comyns Carr and set to music by George Henschel; see Gaunt, *Victorian Olympus*, p. 149. The entire evening, including a summary of Alma-Tadema's remarks, was chronicled in M. H. Spielmann, "The Alma-Tadema Celebration," *Magazine of Art* 24 (Jan., 1900), pp. 136–40.
50. Quoted in Gaunt, *Victorian Olympus*, p. 149.
51. Alma-Tadema, "Marbles," p. 180.
52. Monkhouse, "Laurens Alma-Tadema, R.A.," p. 678.
53. Quoted in "Six Popular Painters of The Royal Academy," *Review of Reviews* (New York) 9 (June, 1894), p. 693.
54. Roger Fry, "The Case of the Late Sir Lawrence Alma Tadema, O.M.," *Nation* 12 (Jan. 18, 1913), p. 667.
55. Philip Burne-Jones to the editor, *London Times*, Jan. 7, 1913, p. 9.

ANTIQUITAS APERTA:

The Past Revealed

VISITING THE DISINTERRED remains of Pompeii inspired the English novelist E. G. Bulwer-Lytton with "a keen desire to people once more those deserted streets, to repair those graceful ruins, to reanimate the bones which were yet spared to his survey; to traverse the gulph of eighteen centuries and to wake to a second existence—the City of the Dead!"[1] Much the same response was felt by Lawrence Alma-Tadema a generation later in the autumn of 1863. While spending his honeymoon in Italy with his first wife, Pauline, the young artist took time to become familiar with Rome's early Christian churches.[2] Then, finding the city too modern for their taste, the couple continued to Naples where they were enthralled by the archaeological treasures in the Museo Archeologico Nazionale and by the ongoing excavations at nearby Pompeii. These experiences served as a turning point in the career of the artist, who was subsequently to win international acclaim with his pictorial interpretations of the ancient world.

Previously, Alma-Tadema had portrayed incidents from Netherlandish history of the Merovingian era and the fifteenth and sixteenth centuries (see cat. nos. 3, 4, and 16). These subjects were calculated to appeal to nationalistic sentiments. Although he characterized them as "a sorry lot to be sure," Alma-Tadema thought the Merovingians to be "picturesque and interesting."[3] For information about their murky and sanguinary history, he turned to the *Historia Francorum*, compiled in the sixth century by Gregory of Tours, and to the *Récits des temps mérovingiens* by the nineteenth-century historian Augustin Thierry.

A pronounced imprint was left on his technique and style by an apprenticeship with Hendrik Leys (1815–1869), a romantic artist who had won acclaim at various international exhibitions with monumental pictures illustrating Flemish history. From 1859 to 1862, Alma-Tadema assisted Leys with murals for the town hall in Antwerp. These murals, depicting the nation's travails in the sixteenth century, were executed in an archaizing style derived from the study of sixteenth-century Flemish and German painting. Antecedents for the physiognomies and costumes of the figures, for the subdued, uniform lighting, and for the avoidance of linear perspective can be seen in the art of Albrecht Dürer, Hans Holbein the Younger, and the Cranachs. The ability to impart a sense of verisimilitude to his paintings by slavish attention to descriptive detail was a skill that Alma-Tadema learned from Leys and exploited effectively for the remainder of his career.

Returning from Italy early in 1864, the Alma-Tademas stopped in Paris, where a classical tradition far more firmly rooted than in either Belgium or the Netherlands had withstood the onslaught of romanticism in the first half of the century. It had been nurtured by such influential artists as Jean-Auguste-Dominique Ingres (1780–1867) and Charles Gleyre (1806–1874). Ingres's *Antiochus and Stratonice*, 1840 (Musée Condé, Chantilly), and Gleyre's *Hercules and Omphale*, 1863 (Musée des Beaux-Arts, Lausanne), for example, anticipated Alma-Tadema's dramatic scenes in settings inspired by Pompeian interiors. He must have taken particular interest in the paintings of the *néo-Grecs*, a coterie of Gleyre's former pupils who, in the 1850s, worked in a piquant, lighthearted manner, depicting trivial incidents from daily life in antiquity rather than recreating events of historical significance.[4] Among them were Jean-Louis Hamon (1821–1874), whose work was familiar to Alma-Tadema (see cat. no. 22), and, for a while, Jean-Léon Gérôme (1824–1904), then in the process of developing a more ambitious, archaeologically exact style that was to culminate in his Colosseum subjects. The latter's masterly compositions such as *Ave Caesar, Moritur Te Salutant*, 1859 (Yale University Art Gallery, New Haven), and *The Christian Martyrs' Last Prayer*, 1863–83 (Walters Art Gallery, Baltimore), would be indelibly impressed in the consciousness of British and American viewers through engraved reproductions.

It is unlikely that, while in Paris, the Alma-Tademas could have resisted the

opportunity to visit the Maison Pompéienne, a replica of a Pompeian villa built on the Avenue Montaigne for Prince Louis Napoleon.[5] When he was not there, giving "toga parties" for his companions, the fantasy house served as one of the city's most popular attractions. Strolling through its atrium, decorated in red and black with illusionistic Third Style wall paintings, Alma-Tadema may have imagined himself an ancient Roman touring the Villa of Diomedes or the House of the Tragic Poet in pre-eruption Pompeii.

Parallel classicizing trends could be discerned in Parisian sculpture and decorative arts. The display at the Exposition Universelle of 1855 of a chrys-elephantine replica of Phidias's colossal *Athena Parthenos* of the fifth century B.C. had piqued an interest, later shared by Alma-Tadema, in the media and coloration of ancient statuary.[6] Judging from the attention he lavished in his pictures on earrings and necklaces, Alma-Tadema was a keen observer of jewelry. Therefore, he must also have been aware of the impact of the French government's purchase in 1859–60 of the celebrated Campana collection of ancient art (Musée du Louvre, Paris). The Italian agent for the sale, Alessandro Castellani, remained in Paris for several years popularizing "archaeological jewelry," a revivalist style that was adopted by the distinguished French jewelers Alexis Falize and Eugène Fontenay.[7]

London, which became Alma-Tadema's permanent residence after 1870, provided the cultural climate most suited to his antiquarian pursuits. It was not simply that self-assured Englishmen recognized the affinities between Britain's imperial aspirations in the late nineteenth century and the glory of the Roman Empire nor that the great public schools in which the English upper classes were educated valued proficiency in Greek and Latin as second only to prowess in sports.[8] Businessmen, many of whom were self-made industrialists and finan-ciers with limited formal education, were strongly attracted to Alma-Tadema's classical paintings for the veneer of intellectual sophistication that they believed to come from displaying them on their parlor walls.

With the growth of travel on the Continent, people were becoming more familiar with the world of antiquity. They went to Italy armed with John Murray's indispensable *Handbooks for Travellers* on journeys expedited by Thomas Cook's recently established travel agency. For those who stayed home, an intimation of the ancient world could be gleaned through museum reproduc-tions. The collection of plaster casts compiled for Somerset House in 1837 was transferred to the South Kensington Museum (after 1899, the Victoria and Albert Museum, London) and became the basis of the great Cast Court. In 1868, a convention signed by the princes of the reigning houses of Europe encouraged the international exchange of reproductions and the proliferation of cast collec-tions in museums across Europe and in the United States.[9] In addition, com-mercial galleries, such as the one opened by D. Brucciani at Covent Garden in 1864, were established to exploit this growing market for reproductions. Al-though Alma-Tadema does not appear to have been interested in plasters, he acquired a replica, presumably an electrotype made by Christofle of Auteuil, of a silver krater from Hildesheim (Staatliche Museum, Berlin), which he intro-duced into a number of paintings (see, for example, *The Women of Amphissa*, cat. no. 37).

The popular excitement generated by ongoing archaeological triumphs in the second half of the century can be regarded as corresponding to our genera-tion's enthusiasm for the conquest of space. Alma-Tadema's classical themes undoubtedly capitalized on the widespread interest in archaeology that had been stimulated by recent discoveries: the *Demeter* from Cnidus, c. 340 B.C. (British Museum, London), had been found in 1858. The *Winged Victory of Samothrace*, c. 200 B.C. (Musée du Louvre), and the *Augustus of Primaporta*, c. 20 B.C. (Musei Vaticani), were both found in 1863. The Hildesheim silver hoard was found in 1868, the Treasury of Priam at Troy (present location unknown) in 1873. The Tomb of Agamemnon was found at Mycenae in 1876,

and the Ludovisi Throne (Museo Nazionale Romano, Rome) in 1877. In the instances of the Hildesheim and Primaporta finds, Alma-Tadema quickly exploited them in such compositions as *The Women of Amphissa* (cat. no. 37) and *An Audience at Agrippa's*, 1875 (Dick Institute, Kilmarnock, Scotland).

A Victorian classical movement was already in progress in literature when Alma-Tadema settled in London. Bulwer-Lytton's *The Last Days of Pompeii*, published in 1834, has frequently been cited as the literary counterpart to the works of Alma-Tadema.[10] This melodrama is set in Pompeii and tells of the unrequited love of a blind flower girl, Nydia, for an Athenian noble, Glaucus, who in turn is besotted with Ione. The book shares with the artist's visual recreation of antiquity an emphasis on archaeologically accurate descriptive detail. Historical romances treating the ancient world remained in vogue throughout the second half of the century. Examples of the genre that have proved enduring include Charles Kingsley's *Hypatia* (1853), Cardinal Newman's *Callista, a Sketch of the Third Century* (1855), and Walter Pater's *Marius the Epicurean* (1885). Also widely read in translation were Gustave Flaubert's *Salammbô* (1862), as well as the romances by Alma-Tadema's friend and adviser for archaeology, Georg Ebers.[11] This distinguished Egyptologist's first novel, *The Egyptian King's Daughter*, written in a manner resembling Bulwer-Lytton's, appeared in 1862. Ebers subsequently published a number of works, mostly set in Egypt at the time of the Roman Empire, including *Homo Sum* (1877), which was dedicated to Alma-Tadema, and *The Question* (1881), a novella inspired by the painting *A Question*, 1877 (location unknown).

When Alma-Tadema arrived in London, he also found the first generation of Victorian classical painters already flourishing.[12] Their guiding spirit was Frederick Leighton (1830–1896), who was to become Baron Leighton of Stretton. A Jovian figure himself—aloof, strikingly handsome, and cosmopolitan—this energetic, moderately gifted artist presided over the Royal Academy for eighteen years. Abandoning Gothicism in the early 1860s, he turned to ancient subjects and developed a decorative, harmonious style derived in part from the study of ancient statuary. His principal disciple, Edward Poynter (1836–1919), who had trained in Paris with Charles Gleyre, occasionally approached Alma-Tadema's archaeological verisimilitude in such paintings as *Faithful unto Death*, 1865 (Walker Art Gallery, Liverpool), which illustrated an episode from *The Last Days of Pompeii*. More aesthetic interpretations of the ancient world were offered by George Frederick Watts (1817–1904), who saw the past from a decidedly Renaissance perspective, and by Albert Joseph Moore (1841–1893), an artist remembered for his formally arranged friezes of figures with Japanese accoutrements. Unlike Alma-Tadema's rather prosaic attempts at reconstructing bourgeois life in ancient Rome, the English classical painters tended toward idealized, ethereal, or emotionally charged views of antiquity. They had a decidedly Hellenic cast, with subjects drawn from Greek mythology. As is borne out by the diaphanous, billowing draperies in the paintings of these artists, the presence in London of the Elgin Marbles from the Parthenon, acquired from Lord Elgin by the British Museum in 1818, was a factor contributing to this Greek bias. Another, undoubtedly, was the sympathy aroused by the Greek wars for independence, as reflected in the poetry of Lord Byron.

Following his initial visit to Naples in 1863, Alma-Tadema enjoyed a productive career of almost five decades during which he completed 388 pictures bearing opus numbers. Approximately sixty-three percent of the works dealt with antiquity; the remainder were recreations of medieval history (all painted before 1879), portraits, landscapes, and miscellaneous genres. Most of the scenes from antiquity were set in Rome or Pompeii. A few were identifiably Greek, and others were Egyptian or Egypto-Roman.

Although his mastery of Latin and Greek at the Leeuwarden gymnasium has been questioned,[13] Alma-Tadema had no trouble retrieving subjects from a range of literary sources. For the pictures in the current exhibition, he drew on

Livy, Josephus, Dio Cassius, Plutarch, and Catullus, among others, either directly or through translation. In addition, he was not averse to using more recent texts, including Shakespeare's plays, English romantic poetry, and the novels of Bulwer-Lytton, Georg Ebers, and Carel Vosmaer.[14]

The scope of Alma-Tadema's knowledge of archaeology, particularly of Rome and Pompeii, was generally esteemed by his contemporaries. It seems to have been acquired not through systematic study but from repeated visits to sites and museums and from years of random reading. In addition to a library of over four thousand books, Alma-Tadema had at his disposal an encyclopedic collection of photographs, prints, and drawings filed under various headings: Greek headdresses, bronzes, armor, furniture, and so forth.[15] Drawing upon these resources, which would eventually exceed five thousand items, he composed settings for his pictures. Though sometimes questioned by carping critics, his paintings struck most viewers as plausible. So convincing were they, in fact, that the occasional deliberate incongruities inserted by the artist, an irrepressible prankster, were seldom detected. These included the basalt rattlesnake of Aztec origin placed on a Roman altar in *A Roman Emperor—Claudius* (cat. no. 14), the skin of a polar bear thrown over a Roman *lectus* (couch) in *A Listener*, 1899 (private collection), and his own portrait as a herm in *The Departure*, 1880 (destroyed).

Unlike other Victorian classical artists, Alma-Tadema was more a painter of genre than of history. The antics of pagan deities were of little interest; and, on those rare occasions when he tackled a specific historical event, he tended to trivialize or domesticate it rather than emphasize its drama. *Tarquinius Superbus* (cat. no. 10), for example, served as an excuse for the artist to indulge a taste for painting flowers. *The Triumph of Titus: The Flavians* (cat. no. 35) shows not the actual ceremonies but a family procession led by the patriarch, returning home from the temple. Even a particularly gruesome assassination, as in *Ave, Caesar! Io, Saturnalia!* (cat. no. 23), has been expunged of most of its horror and overshadowed by a colorful, boisterous acclamation of the new emperor.

Alma-Tadema chose anecdotal, genre subjects with which his viewers could readily identify. Often, despite the ancient trappings, they were themes encountered in current exhibitions in London and Paris. For example, *Flowers* (cat. no. 12) is a costume piece in the manner of the Belgian artist Alfred Stevens (1823–1906). *A Soldier of Marathon*, 1865 (location unknown), takes up the theme of the returned warrior, a common motif after the political upheavals of 1848; and *A Picture Gallery* (cat. no. 15) follows the longstanding Flemish tradition of paintings of *cabinets d'amateur* (small rooms devoted to the display of a collector's treasures).

The individuals in Alma-Tadema's pictures were those to whom his wealthy patrons could relate: an upper bourgeoisie in an era of affluence. His Romans shared Caligula's preference for costly silks over the woolen garb of Republican times. Indeed, as Richard Muther observed, Alma-Tadema's subjects were essentially contemporary English women, whom the German critic described as "among the most beautiful things in the world," of "lofty and noble figure" and with "forms made for sculpture."[16] He might also have noted that these women, judging from the angularity of their poses, predated the Anti-Tight-Lacing Society championed by Alma-Tadema's colleague George Frederick Watts.[17]

Scenes of courtship and flirtation abound in Alma-Tadema's paintings, although there is seldom the titillation or suggestion of sexual tension characteristic of the works of many of his British contemporaries. Alma-Tadema was as much a devotee of Bacchus as of Venus. Sometimes he showed revelers left somnolent by a *symposium*, or drinking party, as in *The Siesta* (cat. no. 11). More often he portrayed thyrsus-bearing attendants and frenetic maenads clanging tambourines in the service of Bacchus or a related chthonian cult (see for example, *On the Road to the Temple of Ceres: A Spring Festival*, cat. no. 21).

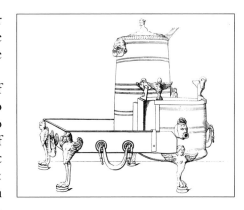

FIG. 7: Bronze stove, c. first century A.D. Reprinted from *A Guide in the National Museum of Naples and its Principal Monuments Illustrated* (Naples, n.d.), pl. 82.

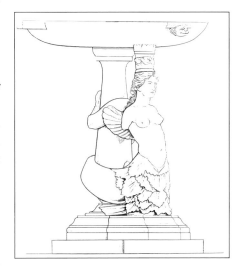

FIG. 8: *Mermaid Tazza*, porphyry, Museo Archeologico Nazionale, Naples. Reprinted from *Collection of the Most Remarkable Monuments of the National Museum* (Naples: Raphael Gargiulo, 1873), vol. 1, pl. 59.

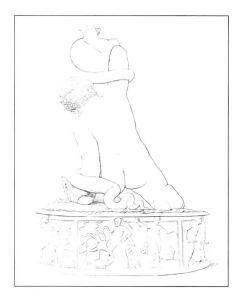

FIG. 9: *Infant Hercules Strangling Serpents*, bronze, Palazzo Reale di Capodimonte, Naples. Reprinted from *Raccoltà de' più belli ed interessanti Dipinti, Musaici, ed altri monumenti rivenuti negli scavi di Ercolano Pompei di Stabia* (Naples, 1871), pl. 34.

Over the years, Alma-Tadema varied the intent and methods of his archaeological reconstructions. Domestic settings predominated in his early, Pompeian phase. Its principal features were walls painted in warm colors and decorated in the Third Style with linear and grotesque motifs, together with bronze tables, lamps, and other household furnishings based on examples in the Museo Archeologico Nazionale, Naples, such as the stove (fig. 7) depicted in *Tibullus at Delia's House* (cat. no. 7).

Later, he undertook works that displayed his own erudition while flattering those perspicacious viewers who could identify the historical sources. Most remarkable were the paintings of cabinets d'amateur. In the earliest, *A Sculpture Gallery in Rome at the Time of Augustus* (cat. no. 9), a bronze *Sophocles* (Musei Vaticani) is surrounded by statuary from the collections of the Musei Capitolini in Rome and the Musei Vaticani. Featured in a later version, *A Sculpture Garden* (cat. no. 17), are a *Mermaid Tazza* from Pompeii (fig. 8), a marble statue based on the bronze *Infant Hercules Strangling Serpents* (fig. 9), and a number of other highlights of the Museo Archeologico Nazionale in Naples that he knew either firsthand or through publications. Given the lack of physical evidence, picture galleries posed a greater challenge. By drawing compositions from wall paintings and mosaics found in Pompeii and Herculaneum, he invented a gallery of panel paintings such as might have been seen in the collections cited in Pliny's *Natural History* (bk. 35, chap. 4). Most readily recognizable in *A Picture Gallery* (cat. no. 15) is the life-size *Medea* said to replicate Timomachus's masterpiece of the first century B.C., which was acquired by Julius Caesar for the Temple of Venus Genetrix in Rome.

With early Greek subjects, the scarcity of supporting archaeological data forced the artist to supplement erudition with inventiveness. In *Sappho and Alcaeus* (cat. no. 26), for example, he concocted the various antique accessories in the painting from disparate sources. In doing so, he inevitably exposed himself to the criticism of caviling scholars, although he later avoided this hazard by presenting more generalized settings, as in *A Reading from Homer* (cat. no. 34).

The Women of Amphissa (cat. no. 37) shows the Amphissans, with Victorian high-mindedness, protecting their Phocian sisters who have collapsed, exhausted by religious frenzy similar to that of the bacchantes of the celebrated stamnos (vase, see fig. 10) by the Dinos Painter in the Museo Archeologico Nazionale. The setting is rich in detail, but the artist has successfully manipulated the ancient motifs to avoid a studied appearance and prevent the paraphernalia from assuming undue prominence.

In subsequent works, the classical elements grew increasingly diffuse as the artist turned to his favorite theme, languorous women reclining in marble settings amid flowers and blooming shrubs. In these later paintings, as one biographer observed, Alma-Tadema "teaches less but he pleases more."[18] Then, toward the end of his career, perhaps as a consequence of his designing sets for the London stage, Alma-Tadema occasionally returned to specific historical subjects. The later paintings set in Roman baths and in the Colosseum are tours de force in archaeological reconstruction, rivaling those of Jean-Léon Gérôme a generation earlier.

WILLIAM R. JOHNSTON

1. Edward George Bulwer-Lytton, *The Last Days of Pompeii*, Baudry's European Edition (Paris, 1839), p. vii.

2. For the artist's biography, the author has relied on Vern G. Swanson, *Alma-Tadema: The Painter of the Victorian Vision of the Ancient World* (New York: Charles Scribner's Sons, 1977), and *The Biography and Catalogue Raisonné of the Paintings of Sir Lawrence Alma-Tadema* (London: Garton and Co., 1990).

3. Quoted in Georg Ebers, *Lorenz Alma Tadema: His Life and Works*, trans. Mary J. Safford (New York: William S. Gottsberger, 1886), p. 14.

4. C. H. Stranahan, *A History of French Painting* (New York: Charles Scribner's Sons, 1893), pp. 329–35.

5. The villa, completed by Alfred Nicolas Normand in 1860, was sold by the prince in 1866 and demolished in 1891. It was recorded by Gustave Boulanger in the painting *Rehearsal of "The Flute Player" in the Atrium of the House of H.I.H. the Prince Napoleon*, 1861 (Musée National du Château de Versailles).

6. The replica of the *Athena Parthenos*, commissioned from Pierre-Charles Simart and Henri Duponchel by the Duke of Luynes for the château of Dampierre, is discussed by Henri Bouilhet, *L'Orfèvrerie française aux XVIIᵉ et XIXᵉ siècles*, vol. 2 (Paris: H. Laurens, 1910), p. 251.

7. Geoffrey C. Munn, *Castellani and Giuliano, Revivalist Jewellers of the 19th Century* (New York: Rizzoli, 1984), p. 85, fig. 87.

8. Hippolyte-Adolphe Taine, *Notes on England*, trans. W. F. Rae (London: Strahan and Co., 1873), pp. 121–36, based his observations on visits to Harrow, Eton, and Rugby.

9. The convention of princes is discussed in a letter from the Prince of Wales to the Duke of Marlborough, published in *Catalogues of Reproductions of Objects of Art . . .* (London: George E. Eyre and William Spottiswoode, 1870), pp. iii and iv.

10. Mario Amaya, "The Roman World of Alma-Tadema," *Apollo*, n.s., 76 (Dec., 1962), p. 772.

11. Among other authors who distinguished themselves in the genre of historical novels set in antiquity were the English prelate N. P. S. Wiseman, the American Lew Wallace, the Pole Henryk Sienkiewicz, and the Germans Felix Dahn and Ernst Eckstein. Ebers is discussed by Rykle Borger in *Drei Klassizisten Alma-Tadema, Ebers, Vosmaer* (Leiden: Ex Oriente Lux, 1978), pp. 30–36.

12. Major studies of these Victorian painters include William Gaunt's *Victorian Olympus*, rev. ed. (London: Jonathan Cape, 1975); Richard Jenkyns's *The Victorians and Ancient Greece* (Cambridge, Mass.: Harvard University Press, 1980); and Christopher Wood's *Olympian Dreamers: Victorian Classical Painters, 1860–1914* (London: Constable, 1983).

13. Ebers, *Alma-Tadema*, p. 7, spoke of the pleasure Alma-Tadema derived from the classics; whereas Swanson, *Biography and Catalogue Raisonné*, p. 20, concluded that the artist disliked ancient languages.

14. The Shakespearian subject is *Portia*, 1887 (location unknown). English poetry themes include *Watching and Waiting*, 1897 (location unknown), based on Tennyson; *Her Eyes and Her Thoughts Are Far Away*, 1897 (location unknown), from Byron; *The Year's at the Spring, All's Right with the World*, 1902 (private collection), from Browning; and *Under the Roof of the Blue Ionian Weather*, 1901 (location unknown), from Shelley. Bulwer-Lytton inspired *Glaucus and Nydia*, 1867 (private collection); Vosmaer, *Amo Te, Ama Me*, 1881 (private collection); and Ebers, *Xanthe and Phaon*, 1883 (cat. no. 32), *A Question*, 1877 (location unknown), and *Hadrian in England*, 1884 (cut into three pieces by the artist; parts are in the Stedelijk Museum, Amsterdam, and the Musée d'Orsay, Paris).

15. The artist bequeathed this collection to the Victoria and Albert Museum (Gerald C. Horsley, "The Alma-Tadema Memorial Library," *Architectural Review* [London] 39 [Jan.–June, 1916], pp. 34–35). In 1947, it was transferred to the Birmingham University Library.

16. Richard Muther, *The History of Modern Painting*, vol. 3 (London and New York: E. P. Dutton and Co., 1907), p. 350.

17. Gaunt, *Victorian Olympus*, p. 125.

18. Cosmo Monkhouse, *British Contemporary Artists* (New York: Charles Scribner's Sons, 1899), p. 221.

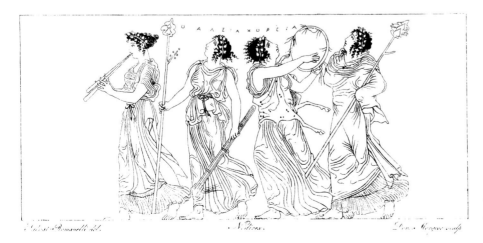

FIG. 10: Detail of red figure stamnos of the Dinos Painter, c. 420 B.C., showing bacchantes. One wears a leopard skin; two carry thyrsi. Reprinted from *A Guide in the Naples Museum*, pl. 98.

35

ALMA–TADEMA: CONTRASTS & SIMILARITIES

WHAT WAS Sir Lawrence Alma-Tadema really like? Much has been written about his art and his personality. "It was hard to recognize in this immense child," wrote Helen Henschel, "the painter of those pictures!"[1] Indeed, a study in contrasts is provided by the restrained, dainty paintings and the rambunctious bear of a man who painted them. For all the quiet charm and erudition displayed in his work, the artist

retained throughout his life some of the simple impulses and attributes of a veritable child. He had the wondering delight of a child in each new experience as it came within the range of his vision and there were times when some passing ebullition of temper would betray something also of a child's wayward petulance. It was characteristic of this side of his nature, which for the rest ranked among the most masculine and virile I have known, that he preserved to the last a child's abiding delight in all forms of mechanical toys. This was a weakness well known to his intimate friends, who, on the annual occasion of his birthday, would vie with one another in presenting him with the most admired achievements of the toy-maker's art.[2]

He also loved atrocious puns and jokes and was an inveterate storyteller. But he sometimes misunderstood a joke and would spoil the punch line. Often his strong Frisian accent rendered the story incomprehensible. "Tadema spoke four languages fluently," wrote G. W. Smalley, "and not one of them quite correctly."[3] Actually, he spoke Frisian, Dutch, French, German, English, and some Italian and Latin. He also read a little Greek. A visitor to his home in Saint John's Wood, London, remembered that his conversation "was marked by deep conviction and entire sincerity. He never acquired complete mastery over our language, but he could always find the word or phrase that reached the heart of what he wanted to say."[4]

Alma-Tadema loved the swirl of society. He had the ability to remove himself from the pressures of his profession and lose himself among his friends. His work was so intense and demanding that frequent periods of "letting go" insured his mental and physical stability. Endowed with the wealth to sponsor immensely popular parties, dances, and banquets, the Tademas entertained often. The artist made many friends and kept them steadfastly throughout his long life. Their importance to him is reflected in one of his favorite quotations, from Shakespeare's *Richard II* (act II, sc. iii, lines 46–47): "I count myself in nothing else so happy as in a soul rememb'ring my good friends." Unlike those who shed old friends for more influential ones as their star rises, Alma-Tadema treated all alike. He was tolerant of deviant behavior in friends like Algernon Swinburne, Oscar Wilde, William Morris, and James McNeill Whistler. It was boorishness and unconviviality that offended Alma-Tadema. The foundation of his life was friendship, family, mirth, and a zest for living, combined with productive hard work and honesty.

He always rose at 6 A.M. to begin work at first light. Often he would stay up very late at night, partying with friends until three or four in the morning. Although robust, he consumed his own energies at an alarming rate. Thus there were cycles of strenuous activity followed by exhaustion, which resulted in sickness and convalescence of the most pampered sort. The family was obsessed with health and in the later years one or the other was absent, recuperating at some prestigious European spa.

Alma-Tadema tolerated no error when it came to his profession. He washed his own brushes and would not let anyone tidy up his studio. "His library is catalogued and classified by himself. The whole of his correspondence—a big slice out of the working day—is conducted by himself unaided. And woe betide the unwary visitor who calls in the morning hours whilst Alma-Tadema is working! Every hour of the precious daylight is dedicated to his

calling when he is at work upon a picture."[5] In spite of his devotion to his work, he would not abstain from participation in his club and social activities. He did, however, have to moderate his involvement in one of his family's favorite pastimes:

> All the family are ardent lovers of the drama, but it is an enjoyment in which Mr. Tadema can indulge but sparingly. For when he goes to the theatre he throws his whole soul into the play, as he does into everything that interests him, and he finds that the excitement, the bright lights, and brilliant colors combine to affect his eyes and to render him unfit for work next day.[6]

A harsh taskmaster, Alma-Tadema demanded that those in his employ meet the same stringent standards that he set for himself. "He was too much of a perfectionist and always demanded extra work of father," said the daughter of Leopold Lowenstam (the artist's engraver). "He was hot tempered and could become excessively angry if details didn't run smoothly."[7] Alma-Tadema shepherded each engraving through to completion.

His love of hard work and detail was evidenced by the presence of a large magnifying glass at his easel. He often used the glass while painting his meticulously rendered flowers. He would continually rework parts of his paintings to satisfy his own high standards. It was written by one visitor to the studio that "Tadema *fights* with his [painting]—he thinks it out, he throws it aside, and takes it up again; he alters, he corrects it—and all that before he even starts."[8]

Thanks to the high quality of his work and to his business acumen, Alma-Tadema became one of the richest artists of the nineteenth century. Though lavish in spending for his home, travel, and entertainment, he carefully assessed the costs against the potential benefits before making any expenditure.

Alma-Tadema had a strong strain of possessiveness, and, even after giving things away, seems to have felt that they still belonged to him. His generosity lay more in his concern for others than in material gestures. He was compassionate with those who needed his help and had a special willingness to make time for young struggling artists.

At home he behaved like a patriarch, dominating every facet of life. Though a strict husband and father, he was truly loved by his wife and daughters. He provided excellent opportunities for his children to develop educationally and culturally, though the "hot house" atmosphere perhaps created some emotional imbalances in his younger daughter, Anna. At his death, the misses Alma-Tadema were sparingly provided for, while the bulk of his estate was presented to his beloved Royal Academy.

Although his mother had been a strict Mennonite and he was on the rolls of the Dutch Reformed Church of the Austin Friars of London, Alma-Tadema was not very religious in the organized sense. Perhaps "liberal Christian" would best describe him. The letters written in his old age mention faith, spirit, and prayer fairly often.

Throughout his life, Alma-Tadema remained a diligent, if somewhat obsessive, and pedantic worker. At the same time, he was an extrovert with a remarkably warm personality. He had most of the characteristics of a child, coupled with the admirable traits of a consummate professional. "Unspoiled by success," as Hamerton aptly described him, "Alma-Tadema works still in the spirit of a student, always simply endeavoring to do his best."[9]

VERN G. SWANSON

1. Helen Henschel, *When Soft Voices Die* (London: John Westhouse Ltd., 1944), p. 85.
2. Comyns Carr, *Coasting Bohemia* (London: MacMillan and Company, 1914), pp. 27–28.
3. G. W. Smalley, "Alma-Tadema: His Friendships, His Family, His Art, His Career and His Fame," *New York Tribune* (July 12, 1912).
4. Carr, *Coasting Bohemia*, p. 32.
5. Percy Cross Standing, *Sir Lawrence Alma-Tadema, O.M., R.A.* (London: Cassell and Company, 1905), p. 120.
6. Ethel Mackenzie McKenna, "Alma-Tadema and his home and pictures," *New McClure's Magazine* 8 (Nov., 1896), p. 41.
7. Interview by author with Millie Lowenstam, London, 1976.
8. A. L., "The Art of Sir L. Alma-Tadema, R.A.," *Pearson's Magazine*, no. 116 (August, 1905), p. 124.
9. Philip Gilbert Hamerton, *Man in Art* (London and New York: Macmillan and Co., 1892), p. 11.

CATALOGUE

Dimensions are given first in inches and then in centimeters. Height precedes width. The initials of the author appear at the end of each entry.

1.

TETE-A-TETE
1850
Pencil on paper
3³/₄ × 6¹/₂ in. (9.6 × 16.4 cm)
Collection of Scott and Luisa Haskins
Santa Barbara

Alma-Tadema used contour drawing throughout his life. Sculptural in its effect, the technique silhouettes the forms against the background. This quick sketch, done when the artist was about fourteen, represents his mother and his aunt, Agatha Van Ringh, chatting over tea. The bold, animated lines efficiently capture the likenesses of the two women; but there is no attempt to depict the texture, surface detail, and chiaroscuro that would have been incorporated into one of his finished drawings.

With a minimal use of line, the artist has described spatial relationships between the sitters, as well as the objects surrounding them. *Tête-à-Tête* demonstrates the high level of technical control, design, and draftsmanship that Alma-Tadema possessed at an early age, before he acquired formal training.

JGL

2.

G. N. VAN DER KOOP
1851
Colored chalk on paper
10 1/4 × 8 in. (26 × 18.3 cm)
Collection of Fred and Sherry Ross

This portrait may have been done for Alma-Tadema's first exhibition, in Leeuwarden in 1851. It remained in his collection until 1887, at which time it came into the possession of Edmund Gosse, his brother-in-law. The fact that the artist kept the drawing suggests that the sitter was a fellow art student or a family friend, but nothing is known about him.

In this highly finished, traditional bust-length portrait, Alma-Tadema has captured a personable young man with a ruddy complexion and chubby cheeks. He is apparently self-confident and dap-per, but his character is only superficially explored. Although the technique is somewhat stiff and labored, the young artist has successfully described a variety of textures: the thick fabric of the young man's coat, his fine feathery hair, and his soft skin. This early drawing is well executed but it does not possess the clarity of form and skillful draftsmanship that would characterize Alma-Tadema's later work.

JGL

The Clarks

One of the heirs to the Singer sewing machine fortune (his grandfather had been Isaac Singer's business partner), Robert Sterling Clark (1877-1956) also inherited from his father a lively interest in art collecting. After graduating from Yale's Sheffield Scientific School in 1899, he served in the army until 1905, winning a silver star in action against the Boxer forces at Tientsin, China, in 1900. In 1908-09 he led a scientific expedition to northern China whose results were published in 1912. In 1911 he settled in Paris to the life of an enthusiastic collector, serving again in the army from 1917 to 1919.

Little is known of the early life of Francine Clery (1877-1960), who married Robert Sterling Clark in Paris in 1919. A Frenchwoman with a particular interest in the stage and in music, she shared his enthusiasm for art collecting, if not for horses. They visited the dealers together and she freely gave her opinions. Mr. Clark called her his "touchstone in judging pictures." He once wrote to a friend that she was "an excellent judge, much better than I am at times, though I have known her to make mistakes on account of charming subjects." A very private person like her husband, Mrs. Clark kept close connections with her family in France which included a daughter by a previous marriage.

In the early 1920s the Clarks moved their principal residence from Paris to New York, with country houses first in Cooperstown, New York, and then in Upperville, Virginia. The Second World War, culminating in the dropping of the atomic bomb in 1945, caused Mr. Clark to become increasingly concerned with finding a safe home for their by then extensive collections. In 1949 he settled on Williamstown where both his father and grandfather had been trustees of Williams College.

Clark's life as a race horse owner and art collector was happily capped by a double triumph, the winning of the Epsom Derby in 1954 by his chestnut colt, Never Say Die, and the opening of the Institute in 1955.

The Collection

While the collection continues to grow by purchase and gift, it still bears the distinct stamp of the Clarks' taste. Mr. Clark's appetite as a collector was undoubtedly encouraged by the pictures that he and his three brothers inherited from their father, Alfred Corning Clark, in 1910. While living in Paris from 1911 until 1921, he laid the foundations of his own collection, buying many of the old master paintings and the first examples of some of his favorites--Sargent, Homer, Degas, and Renoir. After 1920 he concentrated on late nineteenth-century French pictures, which dominate the collection. At the same time he was building a choice collection of silver, of prints and drawings, and of illustrated books.

Mr. Clark's diaries and letters reveal a man who loved pictures and very much enjoyed the business of collecting, which in his case involved numerous conversations and occasional arguments with his favorite dealers, Knoedler and Durand-Ruel. He relied on no outside advisers, was associated with no museums and, indeed, took a somewhat jaundiced view of directors, critics, and art historians. During his lifetime the pictures were lent only occasionally to dealers and few people saw the collection, much of which was in storage. "Going public" in 1955 after a lifetime of privacy was both an excitement and a nuisance. He wrote to a friend, "Do not mention the opening of the Institute to anyone, as you will treat me to a cloud of newspapermen to the detriment of my health."

over

The Institute

The Institute is housed in a complex of buildings erected over a period of nearly thirty years. The red granite building in which you stand was designed by Pietro Belluschi and The Architects Collaborative in 1973. It includes offices, a 320-seat auditorium, and five galleries, three of which are for temporary exhibitions. Across the court is a major art historical research library which houses the Williams College Graduate Program in the History of Art, offered in collaboration with the Clark. Also in this building is the Bibliography of the History of Art, a part of the Getty Art History Information Program and the Centre National de la Recherche Scientifique. It publishes abstracts of current art historical literature in all western languages.

To the north of us is the original white marble building which opened in 1955. With its classical portico, large central gallery, and smaller rooms opening off long halls, it seems to have been designed very much to Mr. Clark's wishes. He dismissed two architects before engaging Daniel Perry of Port Jefferson, Long Island, in 1952. Early designs show an open central court which was subsequently enclosed to provide more hanging space. The domestic scale of the smaller galleries suited that of the pictures the Clarks had collected, while the court (popularly known as the Renoir Room) and adjoining "hall" served as grander spaces for the display of the larger Impressionist and American paintings. An apartment for the Clarks was constructed in three of the galleries. Their small octagonal sitting room with Alfred Stevens's paintings of the <u>Four Seasons</u> still survives.

The 1963 service building at the rear of the complex, with its 1986 addition, is the home of the Williamstown Regional Art Conservation Laboratory, which provides conservation services to museums and corporate and private collections throughout the Northeast.

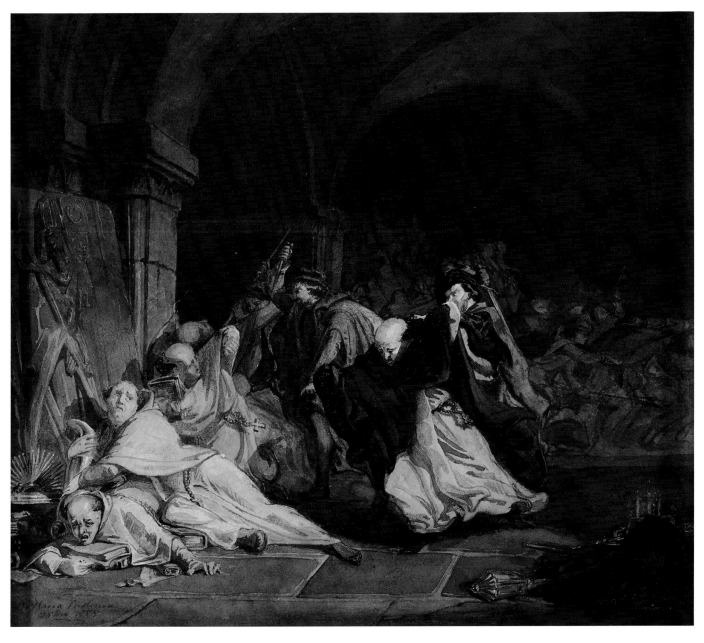

3.

THE MASSACRE OF THE MONKS OF TAMOND

1855
Pencil, watercolor, and gouache,
heightened with white
10 1/2 × 11 1/2 in. (26.2 × 29.1 cm)
Collection of Steven and
Peggy Barshop

Executed soon after Alma-Tadema's departure from the Academy of Fine Arts in Antwerp, this sketch was probably a study for an oil, *The Destruction of Terdoest Abbey in 1571*, 1857 (destroyed). The oil painting did not sell after a lukewarm reception in Brussels; and Alma-Tadema, extremely self-critical and ruthless with works he found wanting, gave the canvas to his mother's cook, who used it as a tablecloth.[1]

Between 1855 and 1865, Alma-Tadema painted a number of catastrophic subjects, few of which have survived. Reflecting the interests of his early mentor, Louis de Taeye (1822–1890), the subject of *The Massacre of the Monks of Tamond* is taken from Netherlandish history. The picture represents a specific incident of murder and destruction associated with an uprising that took place in Belgium during the Reformation.

Unlike the emotionally subdued pictures that comprise most of Alma-Tadema's oeuvre, *The Massacre of the Monks of Tamond* is an animated and evocative scene, graphic in its portrayal of violence. The crowded composition is organized to emphasize the agony of the monks. The chaos is reinforced by stylized angular forms and sharp contrasts of color. Such themes of death and destruction were abandoned by Alma-Tadema in the mid-1860s in favor of less dramatic Egyptian subjects.

JGL

1. Vern G. Swanson, *The Biography and Catalogue Raisonné of the Paintings of Sir Lawrence Alma-Tadema* (London: Garton and Co., 1990), pp. 25, 124.

44

4.

THE DEATH OF GALSWINTHA

1865
Opus XXXII
Oil on panel
12 3/4 × 9 3/4 in. (32.4 × 24.6 cm)
Collection of Carolyn Farb
Houston

In *The Death of Galswintha*, Alma-Tadema draws upon the *Historia Francorum*, written by Gregory of Tours in 590. It chronicles events in France during the reign of the Merovingian dynasty. Alma-Tadema was introduced to this narrative by his mentor Louis de Taeye (1822–1890), for whom he worked as studio assistant from 1855 to 1858. His painting style reflects de Taeye's emphasis on accuracy of archaeological detail. Alma-Tadema's interest in Merovingian history may have originated in his childhood, when coins and ornaments from the Merovingian period were discovered in Friesland, where he grew up.[1]

Alma-Tadema produced his first Merovingian scene, *Clotilde at the Tomb of Her Grandchildren* (location unknown), in 1858; and he continued to illustrate Merovingian subjects into the 1870s. In focusing on this relatively obscure period in Frankish history, Alma-Tadema was unique among the well-known artists of his day. His choice signified a commercial risk: the general public was unfamiliar with Merovingian history, and the violence of the period did not lend itself to works that would be visually appealing.

In *The Death of Galswintha*, Alma-Tadema illustrated the murder of King Chilperic's wife by his order. Galswintha is shown half-fallen from her bed after being strangled by one of the palace slaves. A decade later, Alma-Tadema produced a variant of this morbid scene in a set of watercolors entitled *The Tragedy of an Honest Wife* (cat. no. 16).

The frame for *The Death of Galswintha*, made by Thomas Maws according to Alma-Tadema's design, includes this inscription in French along the inner border:

AINSI PERIT GALSVINTHA FEMME DE HILPERIK ROI DU NEOSTERRIKE ET FILLE D ATHANAGILD ROI DES GOTHS D ESPA[G]N [Q UNE SOR]TE DE REVELATION INTERIEURE SEMBLAIT AVE[R]TIR D AVANCE DU SORT QUI LUI ETAIT RESERVE FIGURE MELANQOLIQUE ET DOUCE QUI TRAVERSA LA BARBARIE MEROVINGIENNE COMME UNE APARITION D UN AUTRE SIECLE L AN DE GRACE DLXVIII (So died Galswintha, wife of Chilperic, king of Neustria, and daughter of Athanagild, king of the Goths of Spain, whom a sort of interior revelation seemed to warn in advance of the fate that was reserved for her, a melancholy and gentle figure who crossed the barbaric Merovingian land like an apparition from another age. The year of our Lord, 568).[2]

The influence of Baron Leys (1815–1869), in whose studio Alma-Tadema worked from 1859 to 1862, is apparent in this painting. Leys reinforced de Taeye's emphasis on historical accuracy. He also influenced Alma-Tadema with his crisp, precise style; the deep, jewel-like tones of his palette; and his close attention to detail.

A significant transition occurred in 1865. Inspired no doubt by a trip to Pompeii two years earlier, Alma-Tadema completed the first classical painting to receive an opus number. From then on, genre scenes from ancient Greece and Rome dominated his work.

KLC

1. Georg Ebers, *Lorenz Alma Tadema: His Life and Works*, trans. Mary J. Safford (New York: William S. Gottsberger, 1886), p. 5.
2. I am grateful to Alice Wohl, an editor at the Bibliography of the History of Art, Williamstown, for her assistance in translating the inscription. Bracketed letters in the French text represent the translator's insertions where the text is not legible and where a letter is missing.

5.

PREPARATIONS FOR
THE FESTIVITIES

1866
Opus XXXIII
Oil on canvas
21 1/16 × 27 5/32 in. (53.5 × 69 cm)
Sterling and Francine
Clark Art Institute

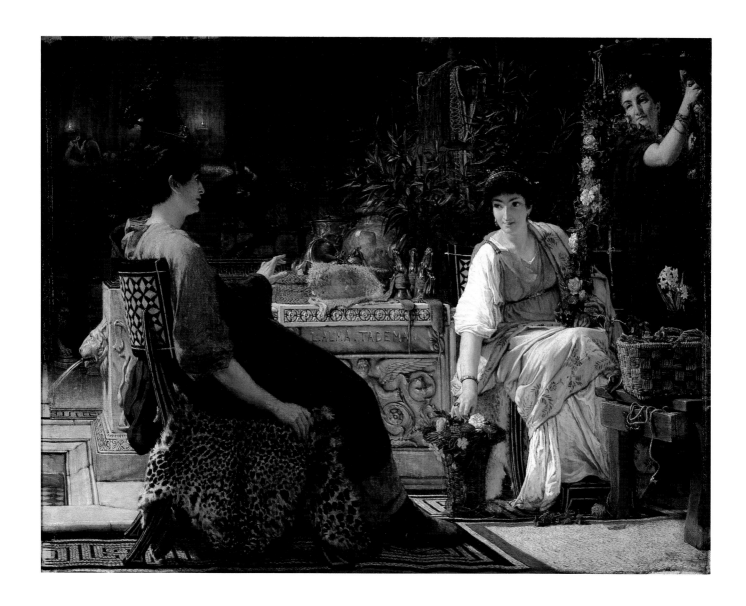

In 1866, Alma-Tadema was establishing himself as a talented and appreciated artist. When *Preparations for the Festivities* was shown in Brussels that year, it helped secure one of his earliest honors, knight of the Order of Leopold, bestowed by King Leopold himself. Alma-Tadema had been living in Brussels for a year and was already working for the important art dealer Ernest Gambart.

Having concentrated on Merovingian and Egyptian subjects prior to his move to Brussels, Alma-Tadema began in 1865 to depict ancient Greek and Roman themes. *Preparations for the Festivities* is among the first of these paintings, which he continued to create for the rest of his career.

Alma-Tadema's initial artistic training took place in Antwerp and Brussels, and the influence of Dutch and Flemish seventeenth-century genre painting is reflected in his paintings of ancient culture. Images such as *Preparations for the Festivities* show that Alma-Tadema was, like many of his seventeenth-century Netherlandish predecessors, primarily interested in scenes of everyday life rather than dramatic historical events. Alma-Tadema made the ancients accessible to his nineteenth-century audience by minimizing action and showing instead Greeks and Romans in daily routines to which his contemporaries could easily relate.

Preparations for the Festivities takes place in a domestic environment. A man talks to two women who seem to be listening intently while assembling a floral garland. A servant in the distance at the left ties a finished swag to lighted wall lamps. The room is being prepared for a festival of Bacchus in which a temporary symbol of the god is a central element. Because the picture is packed with accessories, the viewer must search for this symbol, which is located above and behind the seated woman.[1] A chiton, a tunic worn by men and women in ancient Greece, has been hung on a wooden mast and crossbeam to form the body of this portable statue. A mask above this represents Bacchus's head, and a wreath of ivy has been placed behind it.

During the festival, an altar was set up in front of the statue of Bacchus, and the items that Alma-Tadema has depicted there were undoubtedly intended for the sacred ritual. Three bronze rhyta (drinking cups) wrapped with *taeniae*, sacred ribbons used in prayer, rest on the table along with other metalwork vessels and a marble funerary urn.[2] Alma-Tadema surely gained inspiration for this composition from painted vases that treat precisely this bacchic theme. In fact, Alma-Tadema's interpretation is very close to the image on a Greek red-figured stamnos (vase) by the Dinos painter, c. 420 B.C. (Museo Archeologico Nazionale, Naples). Although it is not certain when Alma-Tadema learned of this vase, he had probably seen it when he was in Naples three years earlier, in 1863. No doubt he was aware of it by 1871, when he transformed the design into a wall painting in his work *Une Fête Intime* (location unknown).[3]

Even though Alma-Tadema was frequently criticized for the lifelessness of his figures—a charge that could well apply to the stiffly painted man in this composition—the two women look like thoughtful, living human beings. Furthermore, every one of the still-life details, both organic and inorganic, is exquisitely rendered. Alma-Tadema loved to paint flowers; and the blossoms and laurel plant bring vitality, as do the women, to the dark interior.

Neither the marble altar nor the fountain behind it have been identified, although the winged figure holding the rinceau in the bas-relief on the altar looks like a stucco wall decoration discovered in a Pompeian bath.[4] Alma-Tadema has carefully chosen this design: the winged figure echoes the motif of the women with the floral garland. A deliberate connection between figures and still-life details is frequent in his paintings (see *Unwelcome Confidence*, cat. no. 42).

The visible side of the lion's head fountain appears to be ornamented with a lion skin in relief, suggesting that the decoration deals with a Herculean theme. This fountain supports a bronze statue based on *The Galloping Horse* from Herculaneum, dated after the late fourth century B.C. (Museo Archeologico Nazionale, Naples). Alma-Tadema drastically increased the size of this statue—

the original is approximately eighteen inches long. It is shown much closer to its actual size in *A Sculpture Garden* (cat. no. 17).[5]

Alma-Tadema worked hard to depict accurately the details of ancient Roman life. The mosaics, clothing, chairs, stool, and even the metal shears on the table and the basket on the floor follow ancient precedents.[6] However, other objects, such as the wooden table with its modern-looking handle, are questionable. Even at this early stage in his career, Alma-Tadema was willing, it seems, to create certain objects from his imagination.

PRI

1. I would like to thank Elizabeth McGowan, assistant professor of art, Williams College, Williamstown, for pointing this out and for identifying and explaining the significance of the objects depicted.

2. The rhyta appear to be identical to those in *The Women of Amphissa* (cat. no. 37). They are copied after an example in the Museo Archeologico Nazionale in Naples. See Museo Archeologico Nazionale di Napoli, *Masterpieces of Art in the National Museum in Naples. First Part: The Bronze and Marble Sculptures, the Antiquities of Pompeii and Herculaneum*, Medici Art Series (Florence: G. Fattorusso, 1926), p. 29.

3. It shows a chiton and mask hung on a post embellished with a few strands of ivy. It also shows an altar with cups, one of which looks similar to a cup on its side in Alma-Tadema's composition. Elizabeth McGowan suggested vase painting as Alma-Tadema's source; I discovered the vase in the collection of the Museo Archeologico Nazionale and its inclusion in *Une Fête Intime*.

4. The stucco decoration is illustrated in Amedeo Maiuri, *Pompeii* (Zurich, Leipzig, and Vienna: Amalthea-Verlag, 1929), p. 48. Note that Alma-Tadema's name is inscribed on the altar as if it were carved in marble. This is one of only two known paintings that the artist signed in this manner. The other is *At the Shrine of Venus*, 1888 (New Orleans Museum of Art), in which the signature appears to be carved on a bed frame. The rest of his paintings are signed in script and are usually followed by their date or opus number.

5. For an illustration, see Metropolitan Museum of Art, *The Horses of San Marco*, trans. John and Valerie Wilton-Ely (Milan and New York: Olivetti, 1977 and 1979), p. 20. My thanks to Stefano De Caro, superintendent at the Museo Archeologico Nazionale, Naples, for providing me with the dimensions of this piece.

6. The shears, which appeared at first to be an anachronism, were published as surgical instruments in Domenico Monaco, *Specimens from the Naples Museum* (Naples: Naples Museum, 1895), pl. 131.

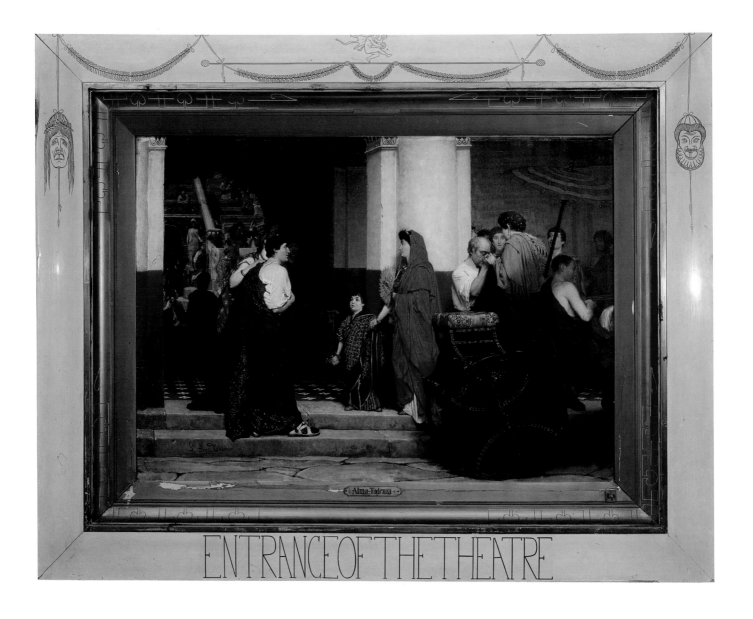

ENTRANCE OF THE THEATRE

6.

ENTRANCE TO A
ROMAN THEATER

1866

OPUS XXXV

Oil on canvas

27³/₄ × 38³/₄ in. (70.5 × 98.4 cm)

*Collection of Haussner Family
Limited Partnership, Baltimore*

In this work, which has been cited as a major example of the early Pompeian phase of Alma-Tadema's career, elegantly clad Romans of various ages greet one another outside a theater. A balding man on the right helps a woman descend from a carriage, a curious vehicle that appears to be a cross between an ancient chariot and a London hack. Affixed to the carriage is an *umbraculum*, or parasol.[1] On the wall behind these figures appears to be posted a forerunner of the modern playbill. Looking through the doorway at the left, one sees spectators taking their seats in the amphitheater. A statue of a woman with her hair massed in ringlets in the Flavian style (Musei Vaticani) is discernible in the background.[2] An engraving of 1758 showing the entrance to the Small Theater at Pompeii may have provided Alma-

Tadema with a source for his recreation of the theater.[3]

The picture frame carries out the Roman theater motif. The sides are incised with theatrical masks and the top with a dancing Silenus from the Villa di Cicerone, Pompeii.

WRJ

1. *Harper's Dictionary of Classical Literature and Antiquities* (New York: Harper and Brothers, 1898), s.v. "umbraculum."
2. Illustrated in Margarete Bieber, *Ancient Copies: Contributions to the History of Greek and Roman Art* (New York: New York University Press, 1977), fig. 766.
3. Illustrated in August Baumeister, *Denkmäler des Klassischen Altertums . . .* , vol. 3 (Munich and Leipzig: R. Oldenburg, 1885), p. 1737.

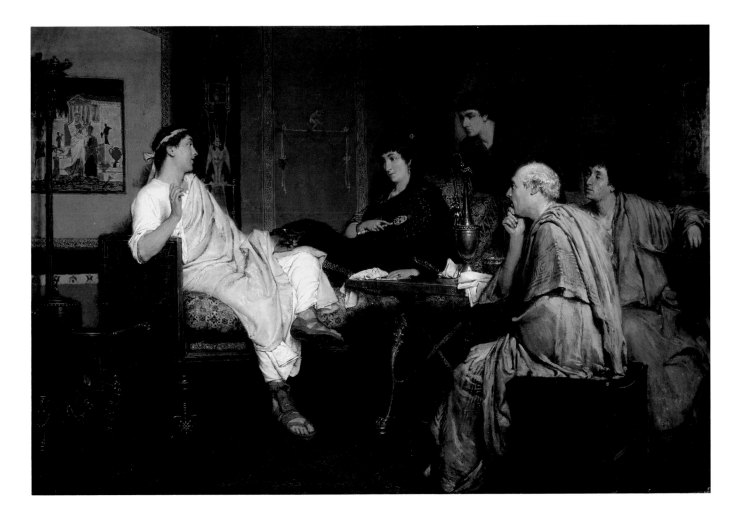

7.

TIBULLUS AT DELIA'S HOUSE

1866

OPUS XXXVIII

Oil on panel

17 1/8 × 25 3/8 in. (43.5 × 64.6 cm)

Museum of Fine Arts, Boston

Robert Dawson Evans Collection

17.3239

This painting of the Roman elegiac poet Albius Tibullus (c. 55–c. 19 B.C.) is one of eight portrayals of ancient authors executed by Alma-Tadema. The young Tibullus is shown reciting his poems to a group of attentive listeners in the well-appointed house of his mistress Delia. The audience presumably includes her and his patron, the wealthy statesman Marcus Valerius Messalla Corvinus. They are grouped around a small table on which stands a wine jug and discarded hand towels. At the extreme left are a bronze stove and a stand surmounted by a double oil lamp.

Very few facts about Tibullus's relatively short life are known today. Biographical information has been culled from his surviving writings and from references made by other ancient authors. He was reputedly of equestrian rank and had inherited an estate that was confiscated in 41 B.C. by Mark Antony for the use of his soldiers. Tibullus died quite young, soon after Virgil, and was memorialized by Ovid in his *Amores*.

Book I of the poems of Tibullus is devoted to his affair with Delia, his first great love. Delia is thought to be a pseudonym for a married woman named Plania who had a clandestine relationship with Tibullus. Delia was the inspiration for many poems, but the affair came to an abrupt end when Tibullus discovered that he was not the only lover whom Delia entertained in her husband's absence.

Alma-Tadema received his first major commission in 1864, when the influential art dealer Ernest Gambart ordered twenty-four paintings. Soon after, the artist moved his family from Antwerp to the more cosmopolitan city of Brussels, where Gambart's firm had offices. *Tibullus at Delia's House*, painted in the summer of 1866, was one of the works ordered by Gambart; and it was sold the following year to an American, W. Prescot Hunt of Boston. Alma-Tadema's art was never popular in the Netherlands; but this picture, full of recognizable antiquities from Pompeii, would have appealed to the American taste for classical subjects. It was also appreciated in London, where it was exhibited in 1867 at Gambart's French Gallery to very favorable reviews:

"Tibullus' Visit to Delia" has the merit of being a study and feast for

49

the antiquary, so careful and true are the restorations. The pigments are a little opaque, as if the artist had carried in his mind the ancient practice of tempera. Yet does the painter put forth the full power of his palette, and through contrasts and harmonies gain marvelous results.[1]

This picture is typical of Alma-Tadema's early Pompeian style. The composition, subject, treatment of the figures, earthy palette, precise detail, and archaeological accuracy are all associated with this phase of his career. The organization of the picture—figures grouped together within a shallow interior space—is simple when compared with later works. Tibullus, reclining on a couch, is the obvious focus of the composition. He is spotlighted by an unseen light source, and his robes and skin are much brighter than those of the others in the room. All the figures appear to be somewhat stiff and wooden. This is a criticism that was directed at Alma-Tadema throughout his career. Perhaps intentionally, he lavished equal attention on the furnishings and the human figures so that this composition has the appearance of a tableau vivant. The rigidity is effectively offset by the warmth and richness of the colors. The deep reds and earth tones found in Pompeian art dominated his palette at this time and were also used to decorate his studio in Brussels.

Alma-Tadema was extremely discriminating and accurate in his use of archaeological detail. The objects included here are appropriate to the scene and could have been found in such an interior during Tibullus's lifetime. The wall paintings are similar to those in houses in Pompeii, and several of the furnishings can be identified as extant objects from the ruins of Pompeii or Herculaneum, now in the Museo Archeologico Nazionale, Naples. *Tibullus at Delia's House* contains objects that Alma-Tadema encountered first at Pompeii in 1863 and later in the collections not only of the Museo Archeologico Nazionale but also of the British Museum in London. Photographs and engravings of these pieces were published in the first half of the nineteenth century in catalogues of collections and exhibitions. Alma-Tadema possessed a vast library of

books on archaeology and ancient history. He also collected photographs of antiquities and owned illustrations of the objects that appear frequently in his paintings.

The samovar-like bronze stove at the lower left is an unusual object that demonstrates Alma-Tadema's extensive knowledge of Roman archaeology. It is very similar to one dating from the first century A.D. that was found in a villa near Stabiae and published in 1842 by the Museo Reale Borbonico (now the Museo Archeologico Nazionale). The stove (see fig. 7) is composed of a cylindrical storage tank and a thin-walled semicircular section surrounding a firebox used to heat liquid, which is then released through a spout on the side. Because Alma-Tadema added a bronze skillet to the top of the stove, he may not have understood how it functioned.[2]

The stand that holds aloft a double oil lamp is of a type often seen in Pompeian wall paintings. The elegant bronze folding table of the first century A.D. from Pompeii (Museo Archeologico Nazionale) appears in several paintings by Alma-Tadema, including *Flowers* (cat. no. 12). Behind Tibullus is a wall painting, also from Pompeii, depicting the mythical Leda and the swan. Although the present location of this picture is not known, it was reproduced in several publications about Pompeian wall paintings during Alma-Tadema's lifetime.[3] The Pompeian bronze stool in the right foreground is similar to pieces existing today in museum collections in Naples, Berlin, and London.[4]

Alma-Tadema designed the frame for *Tibullus at Delia's House*, as he did for many of his paintings. Composed of an entablature, columns, and moldings found in classical architecture, it is representative of a type that he began to develop in the late 1860s. This post-and-lintel frame appears relatively simple when compared to other neoclassical frames and it complements the painting effectively. With its decoration restricted to recognizable architectural elements, the frame enhances the composition and does not compete with it.[5]

JGL

1. Quoted in Percy Cross Standing, *Sir Lawrence Alma-Tadema, O. M., R. A.* (London: Cassell and Company, 1905), p. 37.
2. For descriptions of bronze stoves, see Museum of Fine Arts, Boston, *Pompeii, A.D. 79*, exhib. cat., 1978, pp. 172–73. For their use, see Thomas H. Dyer, *The Ruins of Pompeii* (London: Bell and Daldy, 1867), pp. 91–92.
3. See Salomon Reinach, *Répertoire de peintures grecques et romaines* (Paris: Editions Ernest Leroux, 1922), p. 17, pl. 8.
4. See Gisela Richter, *The Furniture of the Greeks, Etruscans, and Romans* (London: Phaidon Press, 1966), fig. 564; and Museum of Fine Arts, Boston, *Pompeii, AD 79*, p. 170, fig. 142.
5. See Lynn Roberts, "Nineteenth Century English Picture Frames," *International Journal of Museum Management and Curatorship*, 1986, no. 5, p. 278.

8.

LESBIA WEEPING OVER A SPARROW

1866
Opus XL
Oil on panel
25 ³/₄ × 19 ⁷/₁₆ in. (65.4 × 50.5 cm)
Museum of Fine Arts
Brigham Young University
Provo, Utah

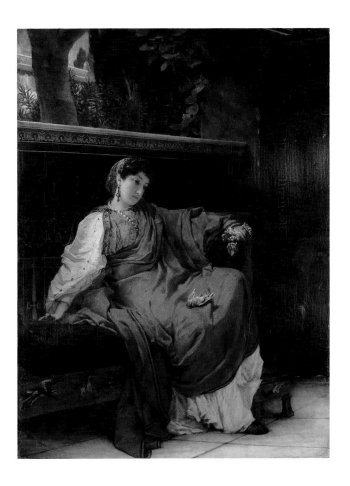

The Roman lyric poet Catullus (c. 84–54 B.C.) had a tumultuous affair with a married woman named Clodia who, in the literary guise of Lesbia, became his poetic muse. "Odi et Amo," a poem about the death of Lesbia's pet sparrow, inspired this painting by Alma-Tadema. His first wife, Pauline, was the model for Lesbia. The picture was painted a year after the couple lost their infant son and Pauline herself battled with smallpox and severe emotional problems that resulted in a nervous breakdown. These tragedies in Alma-Tadema's family life may be reflected in this sympathetic painting of a melancholy figure mourning the loss of her small pet.

Lesbia's reaction to the death of her sparrow was a popular subject for Victorian neoclassicists and was also painted by Edward Poynter (1836–1919) and John Godward (1861–1922). The theme was controversial and inspired heated debate over the nature of the ancient Romans' feelings toward animals. This painting was championed by Georg Ebers and Helen Zimmern, who felt that Alma-Tadema convincingly portrayed the compassion and humanity of the Romans; but it was also condemned by a German critic who felt pagans were not capable of loving animals.[1]

The second of three paintings devoted to the subject of Catullus and Lesbia,[2] this picture has been interpreted as a sexual allegory.[3] Traditionally, Lesbia has been identified with Venus and, in the context of her relationship with Catullus, female wantonness. Because the sparrow, a symbol of lust, lies lifeless in her lap, Lesbia mourns not only the death of her pet but also the loss of the sexual relationship with her lover.

Although Alma-Tadema did not explain the significance of his pictures, his Victorian audience would have appreciated the layers of symbolism attributed to *Lesbia Weeping over a Sparrow*.

JGL

1. Helen Zimmern, "The Life and Works of Alma Tadema," *Art Journal* (London), n.s., special no. (1886), p. 10; and Georg Ebers, *Lorenz Alma Tadema: His Life and Works*, trans. Mary J. Safford (New York: William S. Gottsberger, 1886), pp. 42–44. The anonymous German critic is referred to by both these authors.
2. The others are *Catullus at Lesbia's*, 1865, and *Catullus Reading His Poems at Lesbia's House*, 1870 (both, location unknown).
3. Joseph A. Kestner, *Mythology and Misogyny, The Social Discourse of Nineteenth-Century British Classical-Subject Painting* (Madison: University of Wisconsin Press, 1989), pp. 271–84.

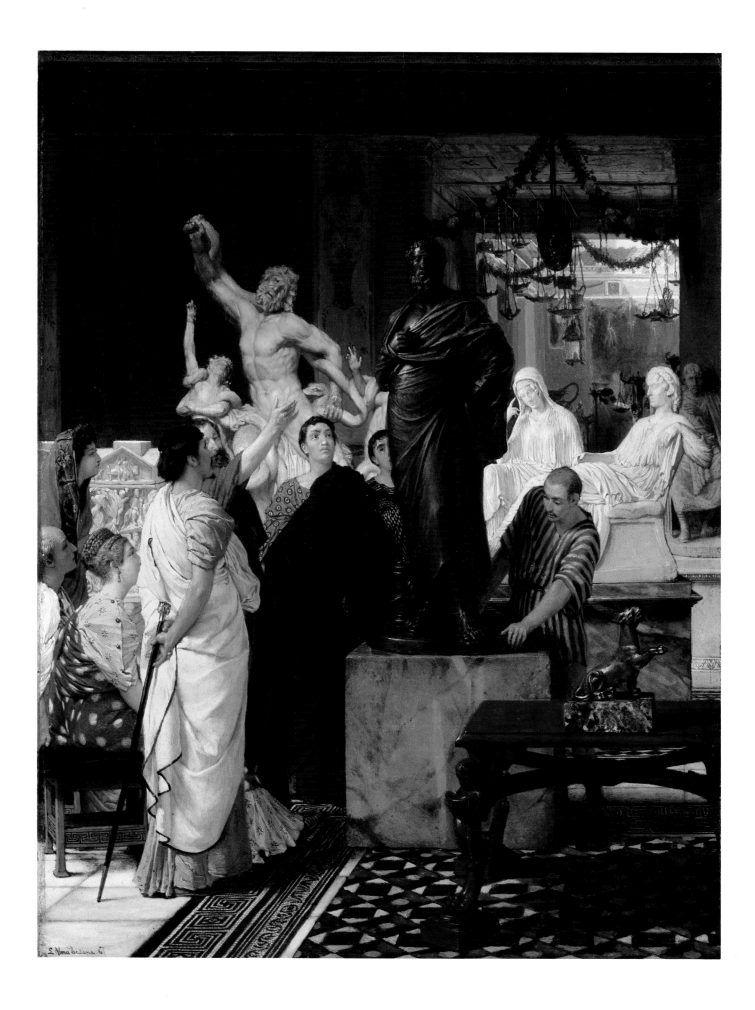

9.

A SCULPTURE GALLERY
IN ROME AT THE
TIME OF AUGUSTUS
also known as
A DEALER IN STATUES
1867
O PUS XLIX
Oil on panel
24 1/2 × 18 1/2 in. (62.2 × 47 cm)
Montreal Museum of Fine Arts
Purchase
Horsley and Annie Townsend Bequest

A Sculpture Gallery in Rome at the Time of Augustus marks the first attempt by Alma-Tadema to recreate the appearance of a dealer's gallery in ancient Rome. This picture was painted as a pendant to *The Collector of Pictures at the Time of Augustus* (private collection), also of 1867. Alma-Tadema went on to paint two additional pairs of sculpture and paintings galleries and at least four other pictures that depict Romans inspecting works of art.[1]

Alma-Tadema's treatment of the subject of art dealers and collectors was destined to become popular for an obvious reason: the paintings show connoisseurs scrutinizing art works just as the buyers of Alma-Tadema's pictures would have done. In addition to making nineteenth-century collectors feel connected to the world of the ancients, the subject glorified the very act of purchasing pictures.

A Sculpture Gallery in Rome at the Time of Augustus shows four men and two women studying a bronze statue of Sophocles, while the dealer points out its merits. Alma-Tadema portrayed himself as the red-haired dealer; the three standing listeners may have been modeled on friends.[2] It has been suggested that the dark-haired woman standing on the left is Alma-Tadema's first wife, Pauline.[3] These figures are probably portraits, because Alma-Tadema is known to have used his family and friends as

models throughout his career, for example, in *A Sculpture Garden* (cat. no. 17).

The composition is filled with sculpture familiar to Alma-Tadema from his many trips to Italy. The life-size bronze of Sophocles derives from a Roman marble (Musei Vaticani) after a Greek statue of the fourth century B.C. The friezelike group of white marble statues behind it includes, from left to right, a Roman sarcophagus of the third century A.D. (Musei Capitolini, Rome); the *Laocoön*, second century B.C., and a Roman copy of a fifth-century B.C. statue of Penelope (both, Musei Vaticani); and, finally, a statue from the third century A.D. (Musei Capitolini), thought in Alma-Tadema's day to represent Agrippina, the mother of Caligula. Behind her is a Roman copy (Musei Vaticani) of a third-century B.C. Greek statue of the poet Poseidippos. The small bronze panther mounted on a marble block in the foreground has not been identified. Alma-Tadema used this image frequently; it appears as an architectural element in *Between Venus and Bacchus* (cat. no. 29).

The scene cannot be dated on the basis of these works of art. Janet Brooke points out that the two objects from the second and third centuries could not have appeared in this interior, which is dated to the first century A.D. by the style of the Pompeian paintings that cover the walls and ceilings.[4] Although the anachronism may have been unintentional, Alma-Tadema could have chosen to integrate these items purely for aesthetic effect.

The artist often took the liberty of changing the scale and medium of works of art. In this instance, he seems to have changed the *Sophocles* to bronze for contrast against the light half of the painting, while the *Laocoön* is placed against a dark brown wall. Although the former is the central element, the latter demands almost equal attention. Helen Zimmern could have been referring to this picture in her 1902 biography of the artist when she wrote, "Alma Tadema's pictures may at times seem to proclaim too loudly the equality of all visible things, and this equal attention to each object sometimes prevents the concentration of our attention on the central point of interest."[5] Nevertheless, the strong diagonal inclination of the arms of both the *Laocoön* and the dealer draws attention to the bronze (the outstretched hand of the dealer also conveniently covers the

genitalia of the *Laocoön* for the Victorian viewer) and presents it as the pivotal area of interest.

This scene takes place in an inner chamber, while a view is afforded into the front room of the gallery and across to another store front.[6] This division of space is common in the early work of Alma-Tadema, as are the dark colors. The reds, browns, and golden yellows were inspired by paintings that he saw at Pompeii; and many of the painted walls may be copies after Roman originals.[7]

PRI

1. *A Sculpture Gallery*, 1874 (Hood Museum of Art, Hanover, N.H., bequest of Arthur M. Loew), and *A Picture Gallery in Rome*, 1874 (Towneley Hall Art Gallery and Museum, Burnley, Lancashire), constitute the second pair; the third is *A Sculpture Garden* (cat. no. 17) and *A Picture Gallery*, 1873 (cat. no. 15). The theme is also represented in *A Roman Lover of Art*, 1868 (Yale University, New Haven, Conn.); *A Roman Art Lover*, 1868 (Glasgow Art Gallery and Museum); *A Roman Art Lover*, 1870 (Milwaukee Art Center); and *Antistius Labeon, A. D. 75*, 1874 (location unknown). Figures studying art obviously fascinated Alma-Tadema because he also painted numerous portraits of family and friends examining pictures on easels.
2. Vern G. Swanson, *The Biography and Catalogue Raisonné of the Paintings of Sir Lawrence Alma-Tadema* (London: Garton and Co., 1990), p. 144.
3. Janet M. Brooke, "The Cool Twilight of Luxurious Chambers: Alma-Tadema's 'A Dealer in Statues,'" *Revue d'Art Canadienne*, nos. 1–2 (1982), p. 28. This article treats, among other interesting issues, Alma-Tadema's French sources for this composition.
4. Ibid., p. 32.
5. Helen Zimmern, *Sir Lawrence Alma Tadema, R. A.* (London: George Bell and Sons, 1902), p. 30.
6. The shop across the way looks much like an illustration of a Roman fish shop in August Mau, *Pompeii in Leben und Kunst* (Leipzig: Wilhelm Engelmann, 1908), p. 286. Perhaps this image was reproduced in a text prior to 1875 that was available to Alma-Tadema. Typically, Roman shops had two rooms: the front room was open to the street except for a counter on which merchandise was displayed, and the back room held more goods.
7. For instance, the painted rinceau that caps the doorway and stretches along the adjacent wall appears to be a copy of a painted frieze in the Museo Archeologico Nazionale in Naples. See Brooke, "The Cool Twilight," pp. 33–34, for a list of possible sources.

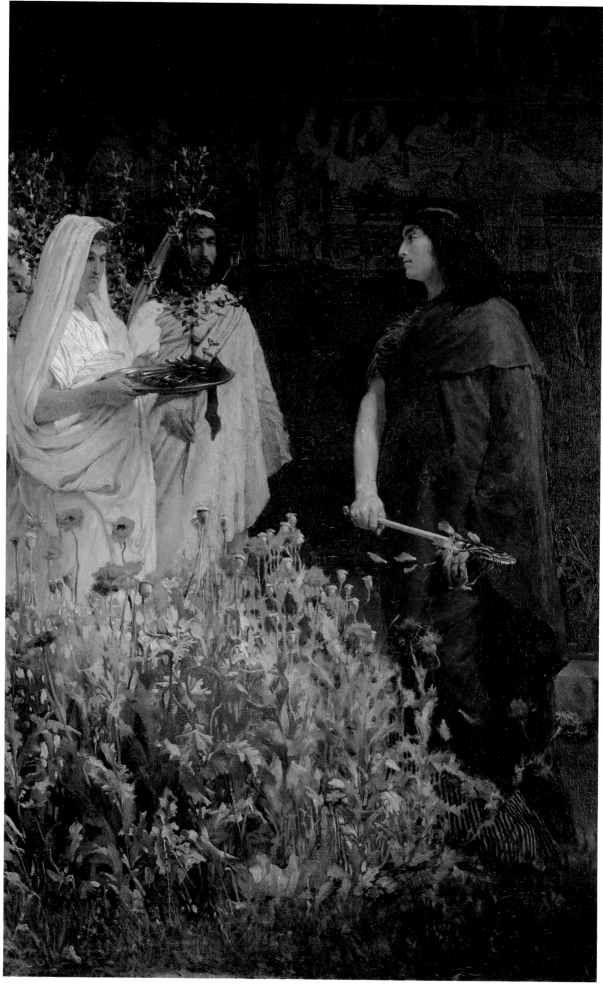

10.

TARQUINIUS SUPERBUS

1867

OPUS LI

Oil on panel

22 1/2 × 15 in. (57.1 × 38 cm)

Collection of

Martin and Marcia Werner

Tarquinius Superbus, the last of the Etruscan kings who ruled Rome before the Republic, reigned in the sixth century B.C. Little is known about his life. He reputedly murdered his predecessor, became an infamous despot, and died in exile. The story represented by Alma-Tadema is loosely based on an actual event, the siege of the city of Gabii by the Etruscans.

Tarquinius is shown in his garden with emissaries from Gabii, bearing the keys to their city and branches of myrtle, traditional symbols of peace. Refusing to speak, the king lops off the heads of poppies with his scepter. Eventually, the bewildered Gabiians abandon their mission and return home, where they report Tarquinius's strange behavior to his son Sextus, who has gained their confidence by pretending to be a traitor to Rome. Sextus quickly grasps the message in his father's actions and issues orders for the execution of the leading citizens of Gabii. This enables his army to take control easily and deliver the city to Tarquinius.

Not a well-known subject for artists or their audiences, the story of Tarquinius Superbus was encountered by Alma-Tadema in his readings of Livy.[1] Perhaps he found it an effective means to incorporate into a painting the elegant frescoes that had been discovered in Etruscan tombs. Adapted here to decorate the garden walls, they identify the story as Etruscan.

Although the subject is remote, Victorian audiences were expert at "reading" pictures; they would have easily understood the evil inherent in Tarquinius and the violence of the deeds to follow. The painting was extremely popular. Helen Zimmern, writing in 1886, called *Tarquinius Superbus* "a truly mag-

nificent piece of work. . . . This entire canvas is instinct with tragic power. . . . Such a work as this clearly proves that Tadema . . . can paint the soul when he chooses."[2] After he moved to England in 1870, Alma-Tadema rarely portrayed violent, macabre, or melancholy subjects. He preferred cheerful scenes; and, as his career advanced, they dominated his paintings.

Tarquinius Superbus was painted in Brussels in 1867. It was probably the last of the twenty-four paintings commissioned by Gambart.[3] The rich reds and browns belong to Alma-Tadema's Pompeian period and were widely acclaimed. The structure of the painting enhances the explosive mood; it seems evident that Alma-Tadema has manipulated his design to maximize tension. The intense figure of Tarquinius occupies a shallow space between the frescoed garden wall and the massive clump of leggy poppies in the foreground. The panel is divided diagonally, the dark figure of the king set against the white-robed Gabiians. The contrast of light and dark and the manipulation of the space into constricted areas effectively heighten tension.

The Etruscan wall paintings that Alma-Tadema has placed on the rear wall are quite accurate and can be identified as extant tomb paintings. However, he has combined frescoes from different locations.[4] The decorative details of these scenes are closer to engraved illustrations, published as the various sites were excavated, than to the actual paintings. Alma-Tadema generally strove for accuracy in his renderings of antiquity, but here he clearly manipulated history to suit his artistic needs. He did not visit the Etruscan sites until 1900 and was forced to depend upon engraved repro-

ductions and reconstructions, which he found in the literature devoted to the excavations in Etruria. Alma-Tadema was not overly concerned with the accuracy of the details but preferred to achieve a recognizable context for his composition. The wall paintings that he so carefully reproduced on the garden wall were actually discovered in underground tombs—they were funerary decorations that would never have been found in an outdoor setting. Alma-Tadema wanted to create an Etruscan ambience and did so effectively by employing images that would have appealed to his worldly patrons, many of whom had taken the Grand Tour.

JGL

1. Livy's *History of Rome from Its Foundation*, bk. 1, chaps. 53–54.
2. Helen Zimmern, "The Life and Works of Alma-Tadema," *Art Journal* (London), n.s., special no. (1886), p. 11.
3. Vern G. Swanson, *The Biography and Catalogue Raisonné of the Paintings of Sir Lawrence Alma-Tadema* (London: Garton and Co., 1990), p. 145.
4. The frieze of athletes and the left half of the banquet scene are after wall paintings of the fifth century B.C. in the *Tomb of the Monkey*, in Chiusi. The right half of the banquet scene closely resembles a fresco, also from the fifth century B.C., in the *Tomb of the Triclinium*, in Tarquinia. These paintings, with the damaged or missing sections supplied, were published as engravings. Alma-Tadema's depictions correspond closely to contemporary prints of the tomb paintings and suggest that he was very familiar with the ongoing excavations in Etruria.

11.

THE SIESTA

1868
OPUS LV
Oil on panel
5 1/4 × 13 1/2 in. (13 × 34.2 cm)
Collection of
J. Nicholson, Beverly Hills

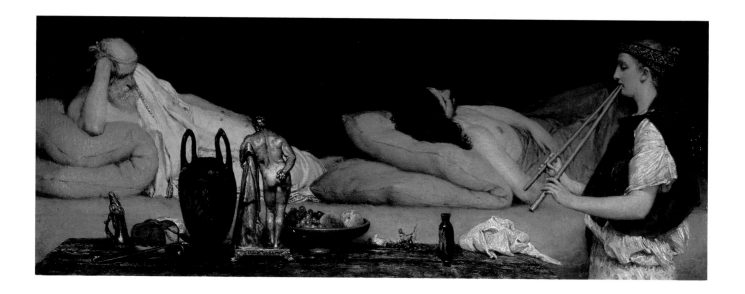

The Siesta dates from Alma-Tadema's Pompeian period (1865 to 1870) in which he used warm, saturated colors to paint Roman subjects in enclosed interiors. More than twenty of his works show a flute being played either for dancers or for an audience. In *The Siesta*, two men recline on cushions while a female slave plays a double flute, or *aulos*. Objects on the marble table in the foreground include a Greek deer's head rhyton; a large *lebes gamikos*, a Greek vase; and a small statue of the *Farnese Hercules* (colossal Roman copy of the Greek original, c. fourth century B.C., Museo Archeologico Nazionale, Naples)—evidence of Alma-Tadema's fascination with archaeological detail.[1]

This scene might depict guests at a *symposium*, or drinking party. Symposia, which were popular events in Athens, featured stimulating conversation, music, dancing, and a variety of games and amusements; however, wine-drinking remained the focus. Typically, two guests shared a couch, as in *The Siesta*. The Romans adopted the Greek tradition of symposia.[2]

Another, much larger painting by the same title (location unknown) was also done in 1868. It is a mirror image of this painting with minor variations in detail. The second version was commissioned by Ernest Gambart as part of a series— *The Siesta, The Service, The Dinner,* and *The Wine*—to decorate a dining room. Although smaller versions of the other scenes exist, only *The Siesta* was realized as a full-scale work. Perhaps Gambart's commission was inspired by the original painting. Although Alma-Tadema produced a third work entitled *The Siesta,* 1873 (location unknown), its composition differs markedly from the earlier ones.

KLC

1. I am grateful to Guy Hedreen, assistant professor of art, Williams College, Williamstown, for identifying the flute, the rhyton, and the statue.
2. *Harper's Dictionary of Classical Literature and Antiquities* (New York: Harper and Brothers, 1898), s.v. "symposium." This source was suggested by William Johnston, assistant director for curatorial affairs, Walters Art Gallery.

12.

FLOWERS
also known as
WOMAN AND FLOWERS
1868
OPUS LXI
Oil on panel
19⁵/₈ × 14⁵/₈ in. (49.8 × 37.1 cm)
Museum of Fine Arts, Boston
Gift of Edward Jackson Holmes
41.117

According to Vern Swanson, *Flowers* is the correct title for this genre picture dating from Alma-Tadema's last year in Brussels. The artist referred to this painting as "my little woman, red background"; and, for many years, it was confused with a lost picture known as *Woman and Flowers*, 1868, recently rediscovered in a private collection in England.[1]

In *Flowers*, a Roman woman leans toward several potted plants and inhales the fragrance of delicate carnations and roses. There are also forget-me-nots, a vibrant flame rhododendron, and a shrub thick with yellow flowers.[2] According to Edmund Gosse, the artist's brother-in-law, this painting was inspired by the actions of Anna Alma-Tadema, who was only a year old at the time and obviously not the model. Many sources claim that Artje Tadema posed for this picture; the frail dark-haired woman with the rather long nose and full upper lip, however, more closely resembles known portraits of the artist's first wife, Pauline (see cat. no. 8), who died the following year.[3]

The composition of the painting is simple: the furniture is perpendicular to the picture plane; the space is shallow and occupied by only a few objects.[4]

The figure of the woman is painted with careful attention to the delicacy of surface and texture. The flowers, however, appear to be the true subject of the painting, for they seem more lifelike than she does. In fact, this entire scene is composed as a still life: the flowers, furniture, tiger skin, and woman are given equal importance. Alma-Tadema has reveled in the various textures and surfaces found in this small space; his colors, applied over a white ground, are delicate, harmonious, and luminous.

When *Flowers* was exhibited at the Royal Academy in Amsterdam in 1868, it was extremely well received. As a result, Alma-Tadema was made a knight of the Order of the Dutch Lion. The painting may reflect the stylistic influence of Alfred Stevens (1823–1906), the successful Belgian painter known for his scenes of well-dressed, aristocratic young women in elegantly appointed rooms. Alma-Tadema first met Stevens in Paris in 1864 and through him made several important acquaintances in Parisian art circles.

In 1873 Alma-Tadema incorporated the woman from *Flowers* into one of a series of four panels designed for a cupboard in Townshend House. Removed from her domestic setting, the figure, in a panel entitled *Hospitality* (Stichting

Het Fries Museum, Leeuwarden), bows gracefully toward two figures on a facing panel.[5]

The spirit of *Flowers*—a Roman scene—seems inherently Dutch. Stylistically, the picture is strongly connected to the tradition of Dutch genre painting; this Roman woman could easily have been painted by Jan Vermeer (1632–1675) or Pieter de Hooch (1629–c. 1684). Alma-Tadema's Dutch roots, particularly evident in his continued delight in painting flowers, remained firm throughout his career.

JGL

1. Vern G. Swanson, *The Biography and Catalogue Raisonné of the Paintings of Sir Lawrence Alma-Tadema* (London: Garton and Co., 1990), p. 150.
2. Alma-Tadema always painted flowers from life. My thanks to Henry Art, professor of biology at Williams College, Williamstown, for confirming the identification of the flowers.
3. Swanson, *Biography and Catalogue Raisonné*, p. 150.
4. The Roman bronze table from Pompeii, now in the Museo Archeologico Nazionale, Naples, was used several times by Alma-Tadema; for another example, see cat. no. 7.
5. See Swanson, *Biography and Catalogue Raisonné*, p. 346, fig. 159.

13.

AN EXEDRA
1869
OPUS LXXV
Oil on panel
15 × 23 ³/₄ in. (38.1 × 60.3 cm)
Vassar College Art Gallery
Poughkeepsie, New York
Gift of Mrs. Avery Coonley
(Queene Ferry, '96)

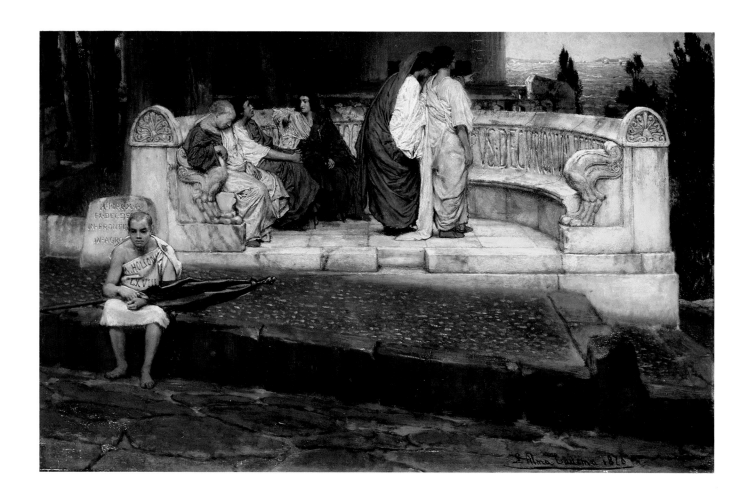

The exedra, a semicircular marble bench in an outdoor setting, offered an excellent stage upon which to arrange figures. It allowed Alma-Tadema to create powerful juxtapositions of the intimate space enclosed by the bench and the wide vista of land and sea beyond it. Started in Brussels and finished in London late in 1869, this picture represents the first of many that were composed around a marble exedra. Over twenty variations of this theme were produced between 1869 and 1910 (see cat. nos. 20, 26, and 34).

Included in Alma-Tadema's vast collection of photographs were four views of Roman exedrae in Pompeii. He may not have possessed all four photos at the time *An Exedra* was created, but he did have a specific site in mind: the tomb of Princess Mamia in Pompeii. This well-known site overlooking the Bay of Naples was popular in the nineteenth century. The poet Goethe called it "Ein herrlicher Platz, des schönen Gedankens wert" (A magnificent place, worthy of the splendid idea).[1] Alma-Tadema also described the spot in a letter to M. Knoedler:

This is a round seat outside the gate of Herculaneaum built over the ground upon which the tomb stood of Mammia [*sic*], a great Pompeiian lady. The decree by which the town of Pompeii granted her request to put up the seat stands in front of it, engraved in marble. The tomb is seen behind. The little street to the right leading to the sea is now filled up again, and over the sea one perceives the promontory of Sorrento and the Island of Capri. The slave of Holconius, who carries his sunshade, sits on the pavement. Those seats on the wayside was [*sic*] for the use of passersby to rest.[2]

The actual source for *An Exedra* is recognizable, but it is clear that Alma-Tadema embellished the setting to suit his composition. Photos of the site, on the Street of the Tombs in Pompeii, do not show the large columned Tomb of the Istacidii that he has reconstructed in the background, nor is it clear that he understood the inscription on the stele to the left of the seated slave.[3] The inscription refers to the adjacent tomb of Porcius, east of the tomb of Mamia. Alma-Tadema, in the letter quoted above, recalled a dedicatory inscription in front of the tomb stating that it had been erected by the town. It is unclear whether he referred to the text of the stele or the lettering incised into the back of the exedra itself. The latter is mostly hidden by figures and thus difficult to decipher.

Rarely are Alma-Tadema's figures as expressive as those in this painting, which depicts a wide array of emotional and physical states. The melancholy slave seated in the left foreground wears his master's name and an identification number on his garment, a chiton. Photographic in its immediacy, this work looks ahead to the ambitious pictures of the 1880s and 1890s, when Alma-Tadema captured the effects of stop-action photography in busy scenes of everyday life in the ancient world.

JGL

1. Johan Wolfgang Goethe, "Gedenkansgabe der Werke, Briefe und Gespräche," *Die Italienische Reise* vol. II (Zurich: Artemis-Verlag, 1980), p. 223.
2. Alma-Tadema to Knoedler, Feb. 8, 1892, Vassar College Art Gallery.
3. The fragmented stele is inscribed: M. PORCI M.F./ EX. DEC. DE CRETO/ IN. FRONTE M.P.X./ XV. IN. AGRUM. P ED. XXV. See Constant Cuypers, "*The Question* by Lourens Alma Tadema," *Nederlands Kunsthistorisch Jaarboek* 27 (1976), p. 86, fn. 15. For the entire text of the stele see August Mau, *Pompeii in Leben und Kunst* (Leipzig: Wilhelm Engelmann, 1908), p. 429. The inscription refers to an official decree which granted an area measuring twenty-five feet long by twenty-five feet deep to M. Porcius, for his tomb.

14.

A ROMAN EMPEROR—
CLAUDIUS
1871
Opus LXXXVIII
Oil on canvas
33 7/8 × 68 5/8 in. (86 × 174.3 cm)
Walters Art Gallery, Baltimore

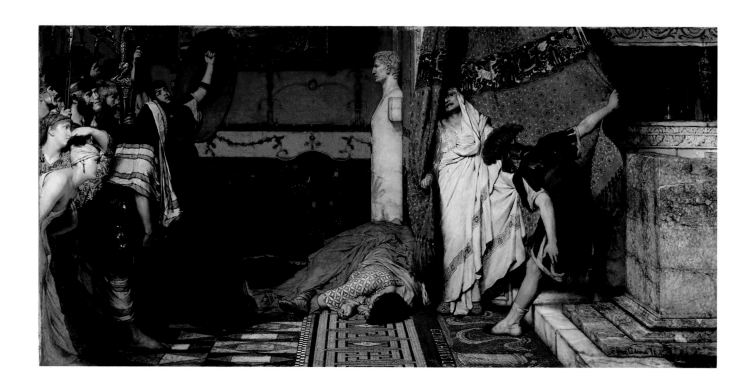

Though he was seldom drawn to violent subjects, especially during his later career, Alma-Tadema appears to have been intrigued by the assassination in A.D. 41 of the emperor Caligula and the proclamation of Claudius as his successor. These momentous events, which foreshadowed the decline of Rome, were portrayed three times by Alma-Tadema over a span of thirteen years. As stated by the ancient authors Dio, Suetonius, and Josephus, the debauched Caligula (A.D. 12–41) was set upon by a band of conspirators led by Cassius Chaerea and brutally murdered on January 24th.[1] The same day, the emperor's wife, Caesonia, and their daughter, Julia Drusilla, were also put to death. Meanwhile, the weak and retiring Claudius (10 B.C.–A.D. 54) had fled to an apartment known as the Hermaeum and, according to Suetonius, concealed himself behind a curtain on a balcony. A palace guard, Gratus, found him and identified him as the son of Drusus, the conqueror of the Germans. Claudius was then carried to the camp of the praetorian guard, where he was proclaimed emperor.

Characteristically, Alma-Tadema did not dwell on the gory assassination but instead depicted its aftermath. In his first treatment of the subject, *Proclaiming*

Claudius Emperor, 1867 (private collection), he showed Claudius groveling before Gratus.

In the present picture, some guards and a couple of women greet the cowering Claudius, as Gratus pulls aside the curtain to reveal him. Stretched across the floor in the center, at the base of a herm, are the bodies of Caligula and his family. Alma-Tadema has lavished his customary attention on archaeological detail. On the wall, which is decorated in the Pompeian Second Style, hangs a polyptych showing the battle of Actium in which Augustus defeated the naval forces of Antony and Cleopatra in 31 B.C. The boats were copied from a wall painting found in the Temple of Isis at Pompeii.[2] On the left, the floor is *pavimentum sectile*, a pavement of colorful marbles; on the right, before an altar, is a mosaic of a serpent.[3] GENIUS HUI(U)S LOC(I) (guardian spirit of the place), an inscription in the mosaic, confirms that the area served as a *lararium*, or household shrine. On the altar are an Aztec basalt rattlesnake, undoubtedly an intentional incongruity; some glass flasks; and a caryatid holding a lamp. The curtain, which appears to be of Chinese origin, is embroidered with a band of galloping horses.[4] The herm bears the head of Augustus (63 B.C.–A.D. 14), the founder of the Julio-Claudian line, to whom Claudius was a grandnephew. Bloody handprints at the base of the herm recall Jean-Léon Gérôme's masterpiece, *The Death of Caesar*, 1867 (Walters Art Gallery), shown that year at the Exposition Universelle in Paris, in which the body of the fallen emperor lies beside a statue of Pompey, the base of which is similarly stained. There the similarity ends, for Gérôme emphasized the drama of the event whereas Alma-Tadema reduced it to more human, if not banal, terms.

When exhibited at the Royal Academy in 1871, *A Roman Emperor—Claudius*, because of the intensity of its colors and the lightening of the palette, was thought to represent a departure from the dark tones of Alma-Tadema's Belgian period in the direction of English Pre-Raphaelitism.[5]

Apparently, Alma-Tadema was dissatisfied with both this and the previous version. He disliked the figure of Caligula in the earlier painting and thought that he had neglected the praetorian guards in this one. Therefore, he decided to paint a third version, *Ave, Caesar! Io, Saturnalia!* (cat. no. 23), in which he could rectify these shortcomings.[6]

WRJ

1. Suetonius, *Lives of the Caesars*, bk. 4, pars. 58–60; bk. 5, par. 10; Josephus, *Jewish Antiquities*, bk. 19, lines 106–14, 216–20; Dio, *Roman History*, bk. 59, lines 29–30; bk. 60, line 1.
2. Fausto and Felice Niccolini, *Le case ed monumenti di Pompei desegnati e descritti*, vol. 3 (Naples: 1854), p. 16, pl. 4.
3. Derived from a wall painting at Pompeii, illustrated in *Le Collezioni del Museo Nazionale di Napoli*, vol. 1 (Rome: De Luca, 1986), pp. 168–69, fig. 322.
4. For Alma-Tadema's collection of Oriental art, see the preface to Alfred Owre, *Illustrated Catalogue to the Noteworthy Collection of Cloisonné . . .* (New York: American Art Association, 1917).
5. Sir Edmund William Gosse, *Illustrated Biographies of Modern Artists*, vol. 1, pt. 4 (London and Paris: L. Baschet, 1883), p. 90.
6. "The Royal Gold Medallist and his Pictures," *Journal of the Royal Institute of British Architects*, 3rd ser., 13 (June 30, 1906), p. 444.

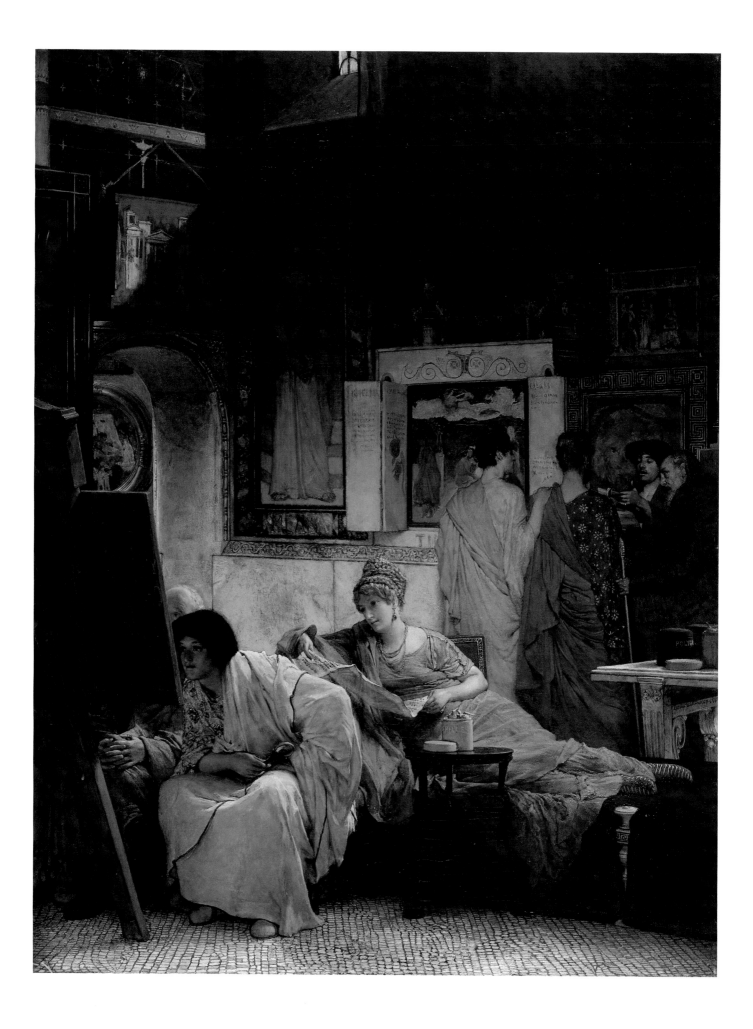

15.

A PICTURE GALLERY
1873
OPUS CXVII
Oil on panel
30 1/4 × 23 1/4 in. (76.8 × 59.1 cm)
Private collection

Ernest Gambart, Alma-Tadema's dealer, commissioned *A Picture Gallery* and *A Sculpture Garden* (cat. no. 17) for engraving purposes. A limited edition of engravings increased both Alma-Tadema's exposure and Gambart's profits.[1] The two paintings were eventually paired in the private art gallery of the American collector William H. Vanderbilt in New York.

A Picture Gallery not only dealt with one of Vanderbilt's passions, it also helped to perpetuate the two-hundred-year-old tradition of paintings that celebrate the collecting of art. This theme was prevalent in Antwerp from about 1640 to about 1700.[2] It grew steadily in popularity; and, in the nineteenth century, paintings of artists and their studios were in great demand.[3]

This painting is only one of many by Alma-Tadema that show ancient Roman artists, dealers, and collectors.[4] An article in the *Journal of the Royal Institute of British Architects* of June, 1906, claims that he painted the first version, *The Collector of Pictures at the Time of Augustus*, 1867 (private collection), in response to a challenge to depict such a scene.[5] According to Vern Swanson, Alma-Tadema read Pliny's *Natural History* (bks. 34 and 35) in order to learn about artists and dealers in ancient times.[6]

The composition of the 1867 painting was used again in *A Picture Gallery*. The latter shows a reclining blonde woman—Laura Alma-Tadema served as the model—looking up from a parchment scroll toward a painting on an easel in the left foreground. An inscription on the back of the easel identifies the painting as a monochrome by Apelles, a Greek painter of the fourth century B.C. The round box on the Delphic table in front of the woman is labeled with Apelles's name. Apparently, the scroll was removed from this container. Three seated figures study the monochrome (only one leg of the viewer at the far left is visible). Three men in the background stand before the painting of a lion, while

a fourth man reads from another scroll.

The space occupied by the figures is shallow, but an arched doorway of white marble indicates a recession into an adjacent gallery. Alma-Tadema has employed chiaroscuro in the same way as in *A Sculpture Gallery in Rome at the Time of Augustus* (cat. no. 9), and the interior alternates between areas of bright light and deep shadow. *A Picture Gallery* is regarded as transitional—midway between his dark, saturated Pompeian palette and later, much lighter tones.

All of the paintings in the gallery are based on works of art in the Museo Archeologico Nazionale in Naples, which Alma-Tadema visited on several occasions. The central panel of the triptych above the arch is a copy of a Third Style wall painting, *Medea and the Pleiades* (House of the Group of Glass Vases, Pompeii). Alma-Tadema has assigned this painting to the first-century B.C. artist Marcus Ludius. The round painting seen through the arch is based on a Pompeian mosaic, *Strength Captivated by Love*. The picture above the easel may be *The Battle of Issus*, a painted copy of the famous mosaic.[7] The narrow, vertical painting directly below the window is a nearly life-size image of Medea from Herculaneum, believed to be a copy of a painting by the first-century B.C. artist Timomachus. Next to it hangs *The Sacrifice of Iphigenia* (House of the Tragic Poet, Pompeii), inscribed on the bottom of its frame with the name Timanthes, the fifth-century B.C. artist who Pliny (bk. 35, chap. 73) believed painted it. The painting at the right, above the lion, shows a theatrical rehearsal and is based on a Pompeian mosaic, *The Tragic Poet* (House of the Tragic Poet).

The lion was copied after a mosaic from the House of the Centaur, Pompeii.[8] Contemporary scholars were probably aware that certain mosaics, such as *The Battle of Issus*, were copies of Greek paintings no longer extant.[9] Alma-Tadema may, therefore, have felt that this mosaic was copied after a paint-

ing by Pausias.[10] Pliny (ibid., chap. 126) commended Pausias for his accurate depictions of foreshortened animals.

PRI

1. Engravings after paintings, made available to the public in limited editions, were an essential component of a Victorian artist's success. Rodney K. Engen explains, "A painter's reputation was often decided by the popularity of the engraving rather than the success of the painting, and the copyright of a 'salable' painting was often a better investment than the painting itself." Gambart commissioned paintings in order to sell both the pictures and engravings, which were signed by the artist and the engraver (*Victorian Engravings* [London: Academy Editions, 1975], p. 10).
2. Zirka Zaremba Filipczak, *Picturing Art in Antwerp, 1550–1700* (Princeton: Princeton University Press, 1987), p. 5.
3. Madeleine Fidell Beaufort, Herbert L. Kleinfield, and Jeanne K. Welcher, *The Diaries 1871–1882 of Samuel P. Avery, Art Dealer* (New York: Arno Press, 1979), pp. li, lx.
4. This exhibition includes *A Sculpture Gallery in Rome at the Time of Augustus* (cat. no. 9), *A Sculpture Garden* (cat. no. 17), *Sculptors in Ancient Rome* (cat. no. 18), and *Architecture in Ancient Rome* (cat. no. 19).
5. "The Royal Gold Medallist and his Pictures," *Journal of the Royal Institute of British Architects*, 3rd ser., 13 (June 30, 1906), p. 444.
6. Vern G. Swanson, *The Biography and Catalogue Raisonné of the Paintings of Sir Lawrence Alma-Tadema* (London: Garton and Co., 1990), p. 145.
7. The front portion of a horse and the tip of a spear are visible in this version. *The Battle of Issus* hangs in an identical position in *The Collector of Pictures at the Time of Augustus*, 1867 (private collection) and *A Picture Gallery in Rome*, 1874 (Towneley Hall Art Gallery and Museum, Burnley, Lancashire).
8. Alma-Tadema compiled an enormous library of reference books pertaining to antiquity, and it is quite likely that he possessed a publication such as M. Robiou, *Chefs-d'oeuvre de l'art antique*, 1st ser., vol. 2 (Paris: A. Levy, 1867), which reproduced the mosaics (pls. 97–99, 102–104) that the artist used as sources in this painting.
9. In 1887, A. Baumeister informed his readers that *The Battle of Issus* mosaic was almost certainly a copy after the famous Greek painting of this subject. A. Baumeister, *Denkmäler des Klassischen Altertums...*, vol. 2 (Munich and Leipzig: R. Oldenbourg, 1887), p. 873.
10. There is no inscription visible in this version; but, in the 1874 version, the last four letters of the artist's name, -SIAS, appear under the same image.

16.

THE TRAGEDY OF AN
HONEST WIFE

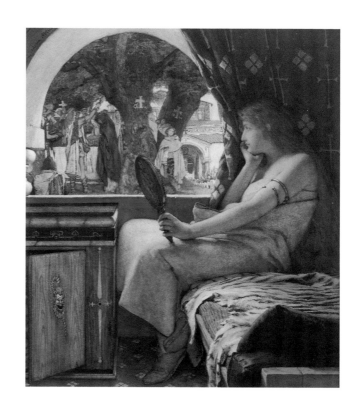

a. Fredegunde,
Seated before a Window,
Watches Galswintha's Arrival
1875
Opus CXLVII
Watercolor on paper
Mount: 25 3/4 × 18 3/4 in.
(65.3 × 47.7 cm)
Fogg Art Museum
Harvard University
Cambridge, Massachusetts
Gift of Samuel D. Warren

b. Galswintha on Her
Deathbed
Opus CXLVII
Watercolor on paper
Mount: 25 13/16 × 18 3/4 in.
(65.5 × 47.7 cm)
Fogg Art Museum
Gift of Samuel D. Warren

Alma-Tadema returned to Merovingian history for this series of three watercolors. In the previous decade, after *The Death of Galswintha* (cat. no. 4), he had focused on subjects drawn from classical Roman history. Clearly, the Merovingians intrigued him, if not his public, and he valued these works. *The Tragedy of an Honest Wife* was among six paintings that he contributed to the English art section of the 1876 Centennial Exposition in Philadelphia.

The Tragedy of an Honest Wife, or the "tragedy of an estimable woman" as Alma-Tadema referred to it,[1] depicts three scenes in the life of Galswintha as told by Gregory of Tours in the *Historia Francorum*, written in 590. In the first scene, Fredegunde, the abandoned wife of King Chilperic I, jealously watches the marriage ceremony in 566 of the king and Galswintha, symbolized by the ritual of the groom breaking a willow branch over the bride's head. After their marriage, Galswintha, upset by Chilperic's continued interest in Fredegunde, begs to return to her native Spain. Chilperic, wanting to go back to Fredegunde, yet not wishing to lose Galswintha's dowry, orders her death.

The second scene depicts Galswintha a year later, lying dead after being strangled by a slave. This image lacks the shocking effect of *The Death of Galswintha*, which emphasizes the violence of her murder. In the final scene, King Chilperic kneels in mourning before Galswintha's tomb. The broken cord at the top of the composition and the lamp on the floor allude to a miracle described by Gregory of Tours:

After her death God showed forth a great miracle. A lamp was suspended by a cord above her tomb, and without being touched of any, this lamp fell to the paved floor. But the hardness departed from the pavement before it. It was as if the lamp sank into some soft substance; it was buried up to the middle without being broken at all. Which thing appeared a great miracle to all who saw it.[2]

A few days after Galswintha died, King Chilperic again took Fredegunde as his wife.

Alma-Tadema inscribed on the mat of the second scene an excerpt from a French translation of Gregory's Latin narrative. These three watercolors were possibly studies for a mural, never executed, that was intended for Townshend House, the artist's London residence. The central area of the design, where the text is now inscribed on the mat, would have accommodated a doorway. A folding screen (location unknown) depicting the same subject also was not completed.[3]

In 1878 Alma-Tadema returned to the theme in an oil painting, *Fredegunde and Galswintha: A. D. 566* (Kunsthistorisches Museum, Vienna), which is clearly modeled on the first scene in this series. The oil painting marks Alma-Tadema's final use of Merovingian history in his paintings.

KLC

1. Georg Ebers, *Lorenz Alma Tadema: His Life and Works*, trans. Mary J. Safford (New York: William S. Gottsberger, 1886), p. 71.
2. Gregory of Tours, *The History of the Franks*, trans. O. M. Dalton, vol. 2 (Oxford: Clarendon Press, 1927), p. 138.
3. I am grateful to Vern Swanson, director, Springville Museum of Art, Springville, Utah, for providing this information.

c. KING CHILPERIC BEFORE
GALSWINTHA'S TOMB
OPUS CXLVII
*Watercolor over black chalk
on paper
Mount: 25 3/4 × 12 13/16 in.
(65.3 × 32.5 cm)
Fogg Art Museum
Gift of Samuel D. Warren*

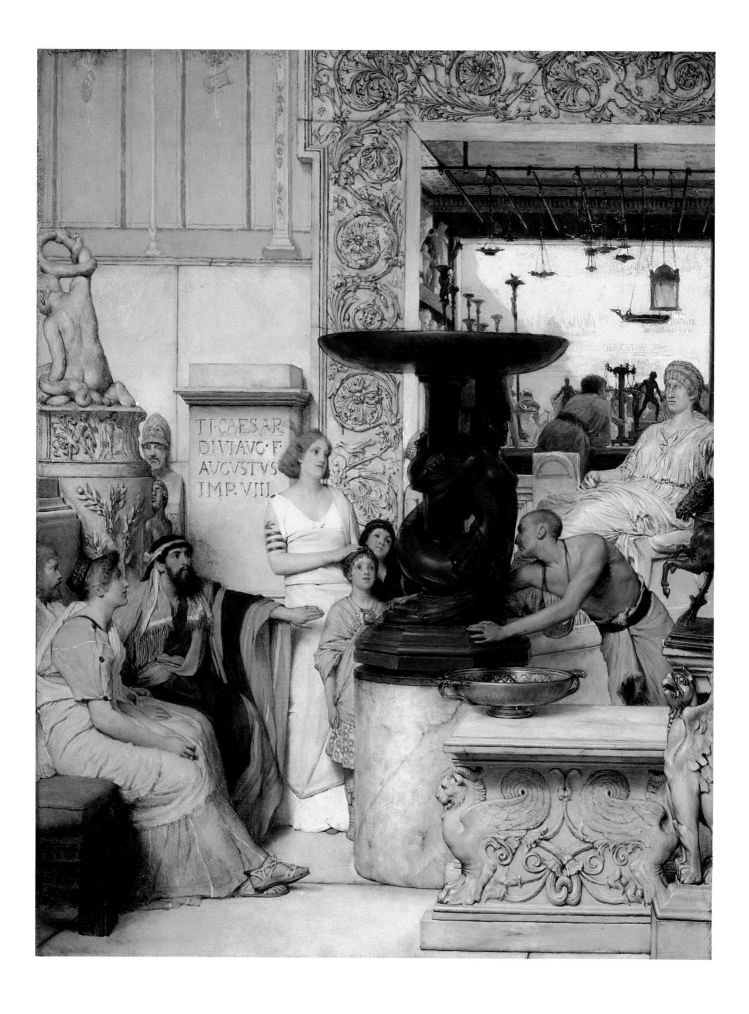

17.

A SCULPTURE GARDEN
also known as
THE SCULPTURE
GALLERY
1875
OPUS CLVII
Oil on panel
30¹/₄ × 23¹/₄ in. (76.8 × 59.1 cm)
Memorial Art Gallery of the
University of Rochester, New York
Marion Stratton Gould Fund

A Sculpture Garden was painted two years after *A Picture Gallery* (cat. no. 15); by the 1880s, the two were paired in the collection of William H. Vanderbilt in New York. Except in size, these two paintings are nearly identical to the 1874 pair (*A Picture Gallery in Rome*, Towneley Hall Art Gallery and Museum, Burnley, Lancashire; *A Sculpture Gallery*, Hood Museum of Art, Hanover, N.H., bequest of Arthur M. Loew) painted for the French villa of Ernest Gambart, Alma-Tadema's dealer. The enormous pictures painted for Gambart dwarf the 1873 and 1875 versions, which were painted for engraving purposes.

A Sculpture Garden is interesting in many respects. The composition is similar to that of *A Sculpture Gallery in Rome at the Time of Augustus* (cat. no. 9). In both pictures, the artist creates a shallow foreground space that opens on the right into another salesroom. Again, many of the figures are portraits. Alma-Tadema is the drastically cropped, bearded figure who sits farthest to the left. Also seated are his sister-in-law Ellen Gosse and her husband, Edmund. The standing figures are portraits of Alma-Tadema's wife, Laura, and his two daughters, Anna and Laurense.

The room is again filled with identifiable works of art. Just as in *A Sculpture Gallery in Rome at the Time of Augustus*, a slave, identified by the tablet hanging from his neck, turns a centrally located piece of sculpture—this time a porphyry *Mermaid Tazza* from Pompeii now in the Museo Archeologico Nazionale in Naples (fig. 8). On the left is a marble version of the bronze *Infant Hercules Strangling Serpents* (Palazzo Reale di Capodimonte, Naples; see fig. 9). It stands on the drum of a column, fourth century B.C. (British Museum, London), from the Greek temple of Artemis at Ephesus.[1] Furthermore, the rinceau carved around the doorway on the right is a copy of a door frame in the House of Eumachia in Pompeii. Alma-Tadema was obviously fond of this architectural detail; he used it in many paintings and as the frame for the doorway of his own home at 17 Grove End Road, London (fig. 4).

The statue of the seated woman on the right was in Alma-Tadema's day believed to be Agrippina, the mother of Caligula. A marble of the third century A.D., it is now in the Musei Capitolini, Rome. The white marble table in front of the *Mermaid Tazza* is from the Casa Rufi in Pompeii. On it rests a silver dish of the first century B.C. (Antikenmuseum, Berlin). The gargoylelike table at the right thus far defies identification, but *The Galloping Horse* on top of it is a bronze thought to be of the fourth century B.C. from the Museo Archeologico Nazionale in Naples. Finally, next to an inscribed half-pilaster, there is a Roman copy of a bust of Pericles from the middle of the fifth century B.C. (Musei Vaticani).[2]

Alma-Tadema deliberately altered the appearance of certain ancient works of art. As early as 1867 in *A Sculpture Gallery in Rome at the Time of Augustus*, he transformed a marble statue into bronze. At least three important objects have been modified in *A Sculpture Garden*: the door frame has been reworked into a T-shape, one of the carved figures on the drum of the column has been replaced by the branch of a tree, and the *Infant Hercules Strangling Serpents* has been changed from bronze to marble.[3]

Although Alma-Tadema certainly had the opportunity while in Naples to view both the *Infant Hercules Strangling Serpents* and the *Mermaid Tazza*, it seems likely that he copied them from a book. While painting, he must often have consulted his enormous library and duplicated images from literary sources.

Great emphasis is placed on the basin by the contrast of its dark form against the overall brightness of the rest of the painting. Compositionally, this is the opposite of its pendant, *A Picture Gallery*, in which a bright center is surrounded by darkness. *A Picture Gallery* is a transitional work, whereas *A Sculpture Garden* is typical of Alma-Tadema's work in the mid-1870s and thereafter.

PRI

1. My thanks to Elizabeth McGowan, assistant professor of art, Williams College, Williamstown, for helping me find an illustration of the column drum.
2. Vern G. Swanson, *The Biography and Catalogue Raisonné of the Paintings of Sir Lawrence Alma-Tadema* (London: Garton and Co., 1990), p. 185, explains that the carving on the pilaster announces that the Augustan age has just begun.
3. Alma-Tadema depicted the *Infant Hercules Strangling Serpents* as a bronze in *The Juggler*, 1870 (location unknown).

18.

SCULPTORS
IN ANCIENT ROME

1877
OPUS CLXXX
Oil on copper
12 1/4 × 12 1/2 in. (31.1 × 31.8 cm)
Private collection

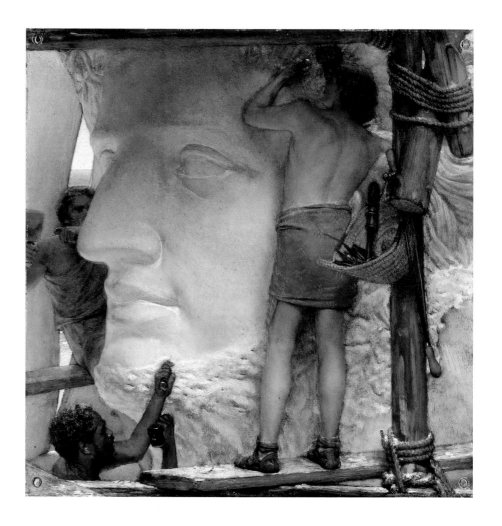

19.

ARCHITECTURE
IN ANCIENT ROME

1877
OPUS CLXXXI
Oil on copper
12 1/4 × 12 1/2 in. (31.1 × 31.8 cm)
Private collection

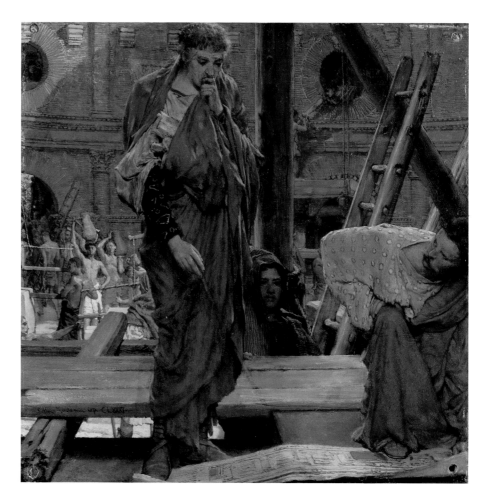

These two small paintings on copper belong to a group of three on the theme of ancient artists at work.[1] Copper was an unusual medium for Alma-Tadema; it is likely that he obtained the plates from his engraver, Leopold Lowenstam (1842–1898).[2] The monuments depicted are imaginary; the colossal marble head and the elaborate brick building with circular windows have no counterparts in the real world. With these compositions, Alma-Tadema may have exercised his notorious sense of humor, or perhaps he paid homage to what he considered the potential for greatness in the Roman world. The latter, tempered with the former, offers a likely explanation for the creation of these two unusual paintings.

Much scholarly conjecture has been devoted to the identity of the colossal head being carved into marble in *Sculptors in Ancient Rome*. It was recently labeled the head of Apollo, which would indicate that the sculpture was Greek.[3] This seems unlikely because of its stylistic similarity to Roman imperial portraiture. Helen Zimmern claimed the head represented the emperor Augustus (63 B.C.–A.D. 14),[4] an opinion shared by a critic for the *Art Journal*, who wrote in 1878 that it was "the head of a figure of such colossal proportions as to suggest a comparison with the head of an Egyptian sphinx."[5]

There are several colossal heads in existence that Alma-Tadema would have known. The most famous and perhaps the most impressive is the huge head of Constantine the Great from the fourth century A.D. in the Palazzo dei Conservatori in Rome. It stands over eight feet tall and is the only extant portrait on a scale close to the one Alma-Tadema has created. The features and style of his sculpture predate the colossal Constantine and are much closer to portraits of the Julio-Claudian emperors. The first of them, Augustus, is usually depicted, however, with more refined and delicate features than those in Alma-Tadema's monument; and Augustus is not shown with a beard, as this statue seems to be. Alma-Tadema's head looks to this author more like Hadrian (A.D. 76–138), an emperor represented by Alma-Tadema in *Hadrian in England*, 1884 (destroyed).[6] The scaffolding around the sculpture suggests that it is only a fragment of a monumental work.

In *Architecture in Ancient Rome*, the central figure is an architect, standing close to the picture plane and studying construction plans. A kneeling assistant at the right awaits instructions. Behind them, the work goes busily forward. The wall under construction in the background reveals several decorative and structural elements used by the Romans, as well as some possibly unknown to them. Alma-Tadema, who studied Roman building techniques, was well acquainted with their use of brickwork. That this building never existed is unimportant. This tiny picture of a monumental subject and its companion, *Sculptors in Ancient Rome*, deliver a strong message of the creative and technical genius that existed in antiquity.

JGL

1. The third is *Painters*, 1877 (location unknown).
2. Vern G. Swanson, *The Biography and Catalogue Raisonné of the Paintings of Sir Lawrence Alma-Tadema* (London: Garton and Co., 1990), p. 197.
3. Ibid.
4. Helen Zimmern, "The Life and Works of Alma Tadema," *Art Journal* (London), n.s., special no. (1886), p. 21.
5. "Sculpture in Ancient Rome," *Art Journal* (London), n.s., 17 (1878), p. 124.
6. The painting was cut apart by Alma-Tadema in 1886 and repainted as three separate works. The original composition is known through engravings.

SPRING IN THE GARDENS OF THE VILLA BORGHESE

1877

OPUS CLXXXIII

Oil on canvas, mounted on a panel

8 1/4 × 13 3/4 in. (21 × 34.9 cm)

Madison Art Center, Wisconsin

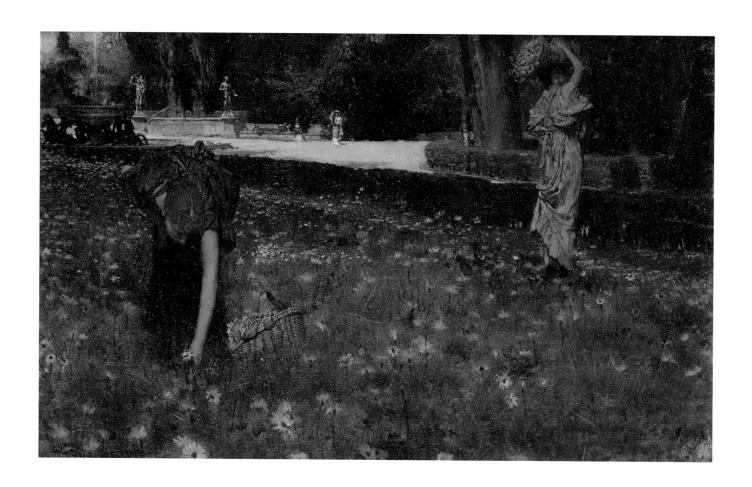

While visiting Rome during the winter of 1876–77, Alma-Tadema began a series of four oil paintings, each depicting a season of the year. The original *Spring*, 1877, was destroyed in World War II. *Spring in the Gardens of the Villa Borghese* is the second version. The third— *Spring*, 1877 (Mesdag Museum, The Hague)—is a painted door panel. A watercolor, the fourth version, is entitled *Flora: Spring in the Gardens of the Villa Borghese*, 1877 (private collection). It was not unusual for Alma-Tadema to execute different versions of the same subject. He frequently made minor vari-

ations, altered the size of the work, or used different media, as the variants of *Spring* illustrate.

The young woman bending to pick a flower in the foreground of the oil painting *Spring in the Gardens of the Villa Borghese* appears in three of the four versions. The background is repeated in the watercolor *Flora*, and it comprises the entire composition of the painted door panel. The couple on the bench, who are incidental figures in this series, become the focus of three works that are similar in composition and theme: *Pleading*, 1876 (Guildhall Art Gallery,

London); *The Question*, 1877 (location unknown); and *Xanthe and Phaon* (cat. no. 32).

The setting of *Spring in the Gardens of the Villa Borghese* has been variously identified as the gardens of the Villa Pamphilj and an imaginary Roman park in addition to the gardens in the title. While in Rome in 1875, Alma-Tadema wrote of picking flowers at the Villa Borghese. In 1878 his friend and biographer, Carel Vosmaer, writing in his journal after a visit to the Villa Borghese, wondered whether it was "here [that] the conception was born for Tadema's painting *The Girls Picking Anemones*. Or was it Pamfili?" A few days later, Vosmaer went to the Villa Pamphilj with Alma-Tadema and his wife. The artist "pointed out to his wife the purple anemones, and we stopped to pick them. His painting *Anemones*," Vosmaer wrote, "with that girl leaning over to pick flowers, was conceived here."[1]

Constant Cuypers, writing about the door panel, suggested that the setting was imaginary. He found the fountain to be only "reminiscent" of the eighteenth-century *Fountain of the Seahorses* designed by Unterbergher and Pacetti in the Villa Borghese,[2] when in fact it is identical. The statues *Hermes and the Infant Dionysus* and *Hercules* that appear at the right of the fountain in the painting are in the Borghese Gardens, as well, but not in this location.[3]

Spring in the Gardens of the Villa Borghese inspired Vosmaer's 1880 novel *Amazone*. In that story, Aisma, a painter meant to recall Alma-Tadema, visits the gardens of the Villa Borghese with Marciana, a widow whom he has met on his visit to Italy, and she gathers anemones.[4] Furthermore, Vosmaer drew inspiration for a later scene from the young couple seated on the bench in the background of this painting. Vosmaer could have seen the painted door panel at the Mesdag Museum; moreover, the watercolor *Flora* may well have been the work exhibited at The Hague in 1878 with the title *Anemones*.[5] While the subject fascinated Alma-Tadema, as the number of compositional variants attest, *Spring in the Gardens of the Villa Borghese* fascinated his public as well, as Vosmaer's thematic borrowings for *Amazone* attest.

KLC

1. Quoted in Constant Cuypers, "*The Question* by Lourens Alma Tadema," *Nederlands Kunsthistorisch Jaarboek* 27 (1976), p. 83.
2. Ibid., pp. 83 and 89.
3. Vern G. Swanson, *The Biography and Catalogue Raisonné of the Paintings of Sir Lawrence Alma-Tadema* (London: Garton and Co., 1990), p. 198.
4. Both Cuypers, "*The Question*," p. 81, and Swanson, *Biography and Catalogue Raisonné*, p. 198, refer to this episode in the novel in relation to Alma-Tadema's images of women picking anemones; but their interpretations differ.
5. Swanson, *Biography and Catalogue Raisonné*, p. 198, suggests that Vosmaer saw the door panel. Cuypers, "*The Question*," pp. 83 and 89, proposes that *Flora* and *Anemones* are identical.

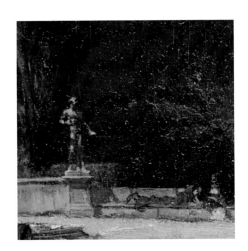

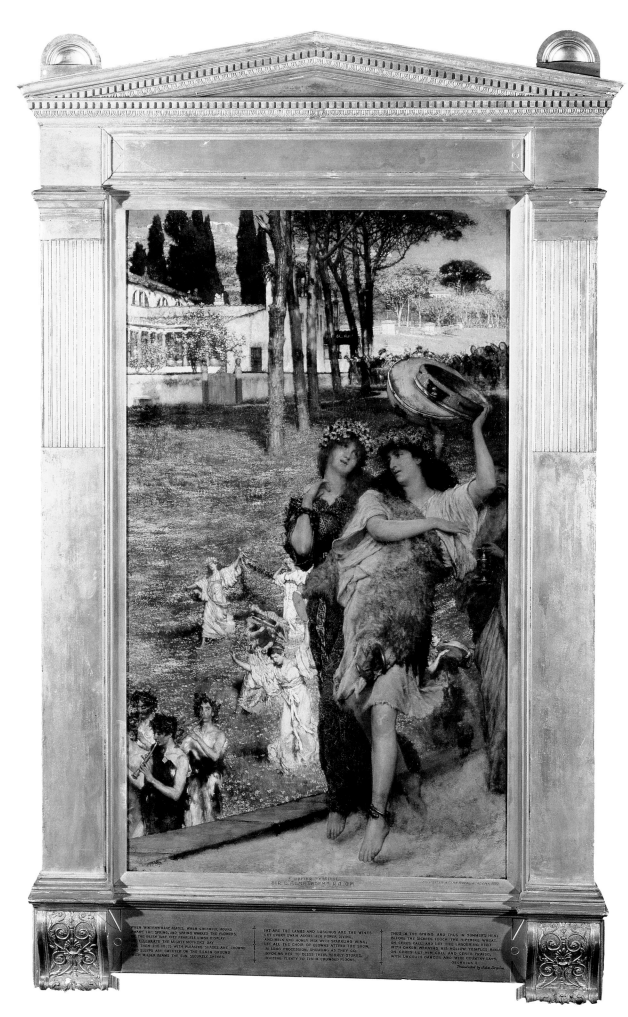

A SPRING FESTIVAL
SIR L. ALMA TADEMA R.A. OM

EXHIBITED AT THE ROYAL ACADEMY 1880

21.

ON THE ROAD TO THE
TEMPLE OF CERES:
A SPRING FESTIVAL

1879
OPUS CCVIII
Oil on canvas
35 × 20 3/4 in. (88.9 × 52.7 cm)
Forbes Magazine Collection, New York

This visual ode to Ceres, the goddess of crops and fertility, was inspired by Virgil's *Georgics I*. Twenty lines from book one, translated by the English poet John Dryden, are inscribed on the picture frame.[1]

During the winter of 1876–77, Alma-Tadema took his family to Rome after a gas explosion severely damaged their London home. He devoted a great deal of time to portraying the gardens of the Villa Borghese and studying the works of Renaissance painters, whose influence is evident in his subsequent pictures. This Italianate landscape, completed after his return to London, has the lightened palette and sunny atmosphere that Alma-Tadema had adopted nine years earlier upon his move to England.

The painting is noteworthy because it combines three important subjects: landscape, dancing bacchantes, and processions. The friezelike format of the procession allowed the exploration of figures in an endless variety of poses. A type of picture particularly popular with Victorian audiences, it was repeated several times by Alma-Tadema throughout his career.[2]

The bacchante in the foreground of this painting is similar to a figure in an important early work, *The Vintage Festi-val*, 1870 (Hamburger Kunsthalle, Hamburg), and identical to the dancer in *A Harvest Festival* (cat. no. 24). Alma-Tadema's processional pictures usually display little movement. Instead, they reveal a moment just before or after an action has taken place. Consequently, the lively figures in *On the Road to the Temple of Ceres: A Spring Festival* are unusual in their energetic display of motion.

Alma-Tadema would certainly have known of a marble relief from Herculaneum, now in the Museo Archeologico Nazionale, Naples, depicting a bacchic procession.[3] In the scene, which may have provided a source for *On the Road to the Temple of Ceres* and other processionals, a male flute player follows closely behind a dancing maenad holding aloft a drum or tambourine.

Alma-Tadema's bacchic pictures were condemned by the critic John Ruskin, who felt that they emulated all that was insipid and immoral about the Roman Empire: "It is the last corruption of the Roman State, and its Bacchanalian phrenzy, which M. Alma-Tadema seems to hold it his heavenly mission to pourtray [*sic*]."[4]

JGL

1. John Dryden, *The Works of John Dryden*, vol. 14 (London: W. Miller by J. Ballantyne and Co., 1808), pp. 41–42.
2. For example, *The Vintage Festival*, 1870 (Hamburger Kunsthalle, Hamburg); *Une Fête Intime*, 1871 (location unknown); *A Dedication to Bacchus*, 1889 (Elton Hall Collection, Northamptonshire); *Spring*, 1894 (J. Paul Getty Museum, Malibu).
3. Margarete Bieber, *The Sculpture of the Hellenistic Age* (New York: Columbia University Press, 1967), fig. 802.
4. John Ruskin, *The Works of John Ruskin*, ed. E. T. Cooke and A. Wedderburn, vol. 33 (London: George Allen, 1908), p. 322.

22.

MY SISTER IS NOT IN

1879
Opus ccx
Oil on panel
16 × 12³/₈ in. (40.6 × 31.4 cm)
Walters Art Gallery, Baltimore

This small picture illustrates Alma-Tadema's skill in interpreting Roman subjects in terms that could be readily understood and appreciated by his wealthy clients.

A gracefully posed maiden draws a curtain in an unconvincing attempt to conceal her sister from a suitor who peers through a gap in the curtain. The setting is an upper-bourgeois interior, as indicated by the marble wall veneers and reliefs and the decoration of the couch—an elaborate silver-inlaid bronze fulcrum, surmounted by the infant Hercules strangling two serpents. A similar couch, encrusted with silver, was discovered at Pompeii and is illustrated in the early catalogues of the Museo Archeologico Nazionale in Naples.[1] Set in the marble floor is the greeting SALVE (Welcome), which was also found over the door of Alma-Tadema's first London home, Townshend House.

This work is derived from a noted painting, *Idylle, ma sœur n'y est pas*, 1853 (location unknown), by the French artist Jean-Louis Hamon (1821–1874).[2] In the early 1850s, several painters residing together on the rue de Fleurus—Hamon and Jean-Léon Gérôme (1824–1904) among them—became known as the *néo-Grecs* because their charming, often piquant views of ancient life looked back to *le style grec* of the eighteenth-century master Jean-Marie Vien. Hamon's picture expressed the same sentiment as did Alma-Tadema's, although the protagonists in the former picture were children rather than adults. It was acquired by the empress Eugénie for her apartments at Saint-Cloud after its success at the 1853 Salon and hence could have been known to Alma-Tadema only through an engraving.

WRJ

1. *Raccolta de' più interessanti dipinti, mosaici ed altre monumenti rivenuti negli Scavi di Ercolano, di Pompei, e di Stabia che ammiransi nel Museo Nazionale* (Naples: Tarallo e Paderni, 1871), pl. 142.
2. Thought to have been lost in the destruction of the Tuileries in 1871, Hamon's painting or a version of it was cited in the Rainbeaux sale, Paris, 1936, no. 32.

23.

AVE, CAESAR!
IO, SATURNALIA!

1880
Opus CCXVII
Oil on panel
8³/₄ × 17³/₄ in. (22.2 × 45.1 cm)
Akron Art Museum
Gift of Mr. Ralph Cortell

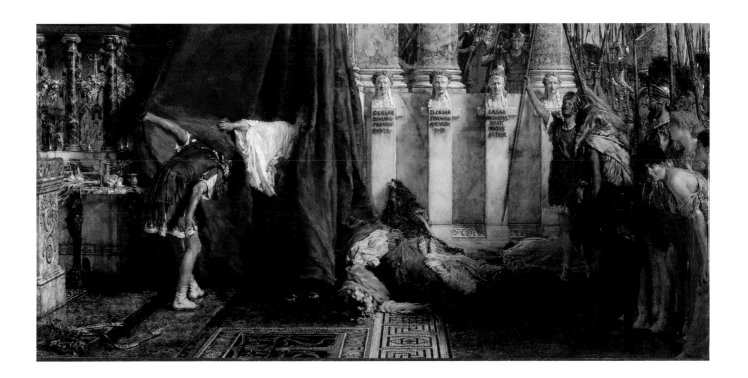

The last of three paintings concerning the assassination of Caligula (A.D. 12–41) and the subsequent proclamation of Claudius (10 B.C.–A.D. 54) as emperor of Rome, this small picture is by far the most dramatic. Alma-Tadema was dissatisfied with his earlier versions of this subject—*Proclaiming Claudius Emperor*, painted in 1867 (private collection, Baltimore), and *A Roman Emperor—Claudius*, painted in 1871 (cat. no. 14). Although he seldom painted historical subjects after settling in London in 1870, he returned to this theme in 1880.

As is also true of catalogue number 14, the painting represents the moment when the terrified Claudius is discovered cowering behind a curtain. Instead of killing him as he expects, the praetorian guard proclaim, "Ave, Caesar! Io, Saturnalia!" (Hail, Caesar! Hurrah for Saturnalia!).[1]

The evolution of this picture was outlined in 1906 in the *Journal of the Institute of British Architects*: "In the first picture the Praetorians were good, but the poor Emperor looked like a bundle of clothes rolling out of the cupboard, and it did not please [Alma-Tadema] at all. Then he painted the second one. . . . That was much better, but he had lost the importance of the Praetorians. Therefore he painted a third version with the Praetorians of the first and the scene of the event rendered more imposing, only the tragic impression was not so great as in no. 2."[2]

This painting reverses the composition of the second version. Here, Claudius hides behind a curtain on the left side of the picture, and the crowd of guards and giddy revelers approaches from the right. The scene is elongated, the composition more horizontal, and

the design carefully structured to emphasize drama and tension. Alma-Tadema uses perspective and repeated forms to manipulate the viewer through the action. Strong vertical elements— massive columns, a geometric floor pattern, and four ancestor herms— reinforce and stabilize the scene. These are counteracted by the frenzy and chaos of the crowd on the right and the dark mass of the curtain that engulfs the cowering figure on the left. As Gratus, one of the praetorians, bows before the new emperor, the arc of the guard's arm echoes the position of Claudius's arm in a reassuring way that may foreshadow their future political alliance.

The snakes at the foot of the altar add to the excitement of the painting. In *A Roman Emperor—Claudius*, they are incorporated into the pattern of the mosaic in the floor and serve to identify the room as a *lararium* (household shrine). In this later version, the serpents are alive and slither menacingly toward Gratus's feet.

In the midst of this emotionally charged scene, there is something endearing about Claudius. All that can be seen of him, hidden like a child in the living-room drapes, is his outstretched right arm and his toes peeking from beneath the curtain. He is hardly heroic, and his vulnerability adds a touch of pathos (a quality rarely encountered in Alma-Tadema's work) to an otherwise savage subject.

Helen Zimmern found in the painting a "subtle, delicate, indescribable touch of humour" that she considered to be critical to its success: "The introduction of this humorous element . . . adds to the tragedy of the whole, . . . this blending of humour and horror heightens the effect of the whole work. . . . The accessories have all the perfection we are accustomed to in works by this artist, but here the interest in the human beings is so strong we hardly notice them."[3]

It is interesting that this episode in Roman history captured Alma-Tadema's attention. Claudius may have been a character that Alma-Tadema found sympathetic. Sickly in his youth (as was Alma-Tadema) and physically awkward, he was considered an embarrassment by the imperial family. Consequently left to his own devices, Claudius developed into an avid scholar and historian. Although none of his works survive, he is credited with a multivolume history of the Romans and Etruscans, as well as an autobiography. One of his many military accomplishments was the conquest of Britain. That Claudius was responsible for connecting Britain to the Roman Empire may have had special appeal to the Anglophile Alma-Tadema.

JGL

1. Saturnalia, the festival of the god Saturn, took place in the winter and was characterized by debauchery and abandon. The traditional cry of the revelers was "Io, Saturnalia!"
2. "The Royal Gold Medallist and his Pictures," *Journal of the Institute of British Architects*, 3rd ser., 13 (June 3, 1906), p. 444.
3. Helen Zimmern, "The Life and Works of Alma Tadema," *Art Journal* (London), n.s., special no. (1886), p. 11.

24.

A HARVEST FESTIVAL
also known as
A DANCING BACCHANTE
AT HARVEST TIME

1880
Opus CCXX
Oil on panel
31 × 34 in. (78.7 × 86.4 cm)
Forbes Magazine Collection, New York

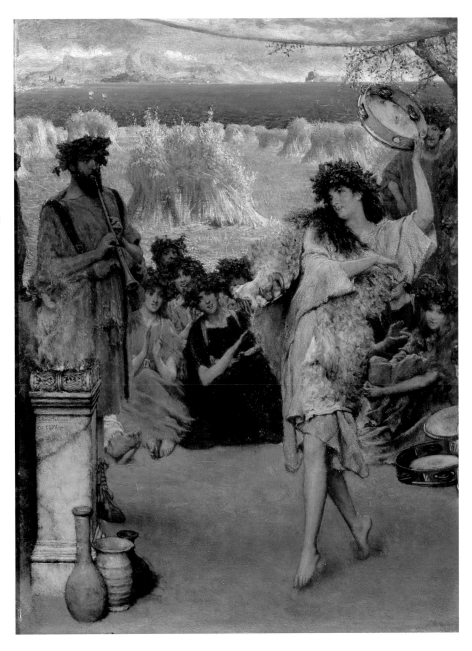

When Alma-Tadema moved to London in 1870, he began a series of pictures of bacchantes. These paintings, in which the female followers of Bacchus embody various levels of consciousness from sleep to delirium, are among his most sensuous works (see cat. nos. 21 and 37).

A Harvest Festival is one of only a handful of paintings in which Alma-Tadema depicts a lively figure in motion. This is, in fact, a celebration of the Dance, personified by the graceful bacchante. The other figures in the composition, particularly the hermlike flute player—most likely a self-portrait of Alma-Tadema—are stiff in comparison to the fluid, swirling dancer. The strik-

ing contrast between the stillness of the audience and the movement of the bacchante reinforces the notion that the dance itself is the focus of the painting.

The dancing bacchante is identical to the central figure in *On the Road to the Temple of Ceres: A Spring Festival* (cat. no. 21) from 1879. This pose reflects two well-known ancient sculptures: a marble figure of a dancer, fourth century B.C. (Museo Nazionale Romano, Rome), attributed to the Hellenistic sculptor Lysippos,[1] and a marble figure known as the Berlin Dancer, which was acquired by the Staatliche Museum in Berlin in 1874.[2] These pieces were probably familiar to Alma-Tadema, and it is almost

certain that he owned photographs of them in addition to books of engraved illustrations. Alma-Tadema carefully researched the positions assumed by his dancers and attempted accurately to reflect the attitudes of ancient revelers.

JGL

1. Illustrated in Margarete Bieber, *The Sculpture of the Hellenistic Age* (New York: Columbia University Press, 1967), fig. 91.
2. Discussed in K. D. Shapiro, "The Berlin Dancer Completed, A Bronze Auletris in Santa-Barbara," *American Journal of Archaeology* 92 (1988), pp. 509–28.

25.

Drawing of
"A DANCING BACCHANTE AT HARVEST TIME"
for Engraving
c. 1880
Pencil on paper
16 1/4 × 12 1/4 in. (41.3 × 31.1 cm)
Forbes Magazine Collection, New York

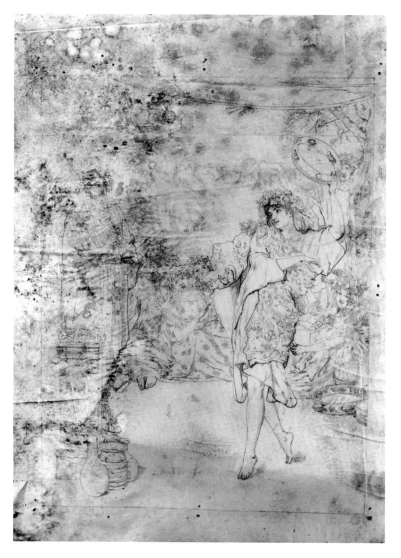

This drawing was done after the painting of the same title (cat. no. 24) in preparation for an engraving. Alma-Tadema frequently revised compositions when he repeated them for engraving purposes, and here one can note some changes. Harmonious color and energetic motion are stressed in the painting; outline, contour, and surface pattern are emphasized in the drawing. There is little modeling with light and shadow and no chiaroscuro. The overall effect is two-dimensional. The fact that Alma-Tadema's finished drawings are consistently precise and highly detailed indicates that this example was done just to assist in the printmaking. His approach to the repeated commissions from the dealer Gambart for duplicates of extant paintings was described in the *Journal of the Royal Institute of British Architects* of 1906:

It had never been his wish to play the parrot and to say the same thing over and over again. As the picture-dealer wanted to publish the pictures, several things which, according to the painter's notion, were not adapted to black and white, he changed, and so made quite different pictures of the same subject. In that manner it was interesting to repeat oneself.[1]

Alma-Tadema was a shrewd business-man who appreciated the commercial value of engravings, and he closely supervised the production of the prints that were made after his paintings.[2]

JGL

1. "The Royal Gold Medallist and his Pictures," *Journal of the Royal Institute of British Architects*, 3rd ser., 13 (June 30, 1906), p. 444.
2. For a discussion of Alma-Tadema's working relationship with his engraver, Leopold Lowenstam, see Vern G. Swanson, *Alma-Tadema: The Painter of the Victorian Vision of the Ancient World* (New York: Charles Scribner's Sons, 1977), pp. 33–34.

SAPPHO AND ALCAEUS

1881
Opus CCXXIII
Oil on canvas
26 × 48 in. (66 × 121.9 cm)
Walters Art Gallery, Baltimore

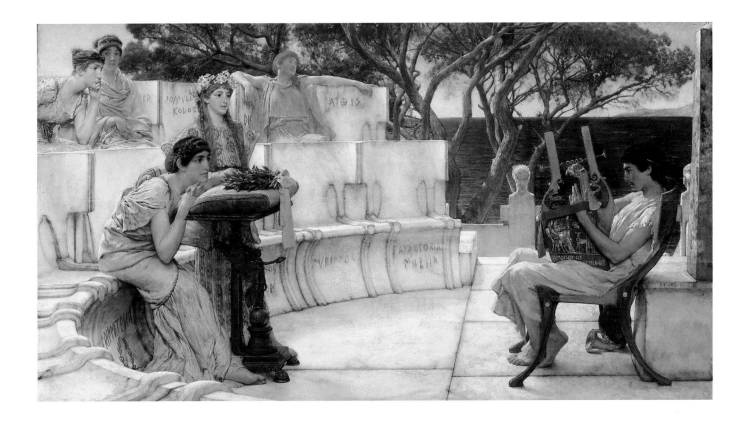

"As for the Lesbian Alcaeus, thou knowest in how many revels he engaged, when he smote his lyre with yearning love for Sappho. And the bard who loved that nightingale caused sorrow, by the eloquence of his hymns to the Teian poet." This is a fragment of verse by Hermesianax, the elegiac poet of Colophon in the early fourth century B.C.[1] It was thought by Georg Ebers to be the literary basis for the painting *Sappho and Alcaeus*.[2] The setting is a marble exedra overlooking the sea on the island of Lesbos (Mytilene) in the late seventh century B.C. The poetess Sappho, her daughter Kleis, and several companions listen intently as the poet Alcaeus plays his kithara. Against the background of sky and sea are silhouetted several gnarled olive trees.

Alma-Tadema's intention to enter this picture in exhibitions at both the Royal Academy in London and the Royal Academy in Berlin probably accounts for the inordinate care that he took to achieve an illusion of archaeological exactitude. The motifs are derived from divergent sources. The marble seating, for example, replicates the seats of honor in the Theater of Dionysus, Athens, though the names of officials inscribed on the backs and bases of the seats have been replaced with the names of members of Sappho's sorority, inscribed in deliberately archaic Greek. Discernible across the upper tier are [Mnasi]dika, Gongyla of Colophon, . . . Athis, and below, Errina of Telos, . . . Gyriano, and Anactoria of Miletos.

The features of the poetess, who wears her hair bound in a distinctive net (*sakkos*), appear to have been derived from a marble statue from the fifth century B.C. in the Villa Albani known

as *Sappho* or *Kore Albani*.³ A single source for the figure of Alcaeus, seated on a klismos (chair with characteristic splayed legs), has not been identified. Most likely, it was taken from Greek pottery. Because the kithara is associated with Apollo, the artist has appropriately inlaid Alcaeus's instrument in mother-of-pearl with a scene of Apollo and Artemis, copied from a bell krater of the early fifth century B.C. from Nola, preserved in the British Museum, London.⁴ Artemis is masked by the poet's arm; but her attribute, a deer, is clearly identifiable. Among other accessories is a silver rhyton near the poet's foot. Although he could not locate an ancient prototype for Sappho's lectern, Alma-Tadema ingeniously combined two elements: a famous lampstand from Pompeii that he had represented in an earlier picture, *Catullus Reading His Poems at Lesbia's House*, 1870 (location unknown), and a common sculptured form, Victory on a globe.⁵

Despite these efforts, *Sappho and Alcaeus* was later criticized in the *Nation* for archaeological inaccuracies.⁶ The anonymous, caviling critic observed that the lectern was an anachronism and that the artist had erred in the use of the archaic Attic, rather than the Lesbic, form of the Greek alphabet in the inscriptions.

Despite the criticisms, the removal of this popular painting from England was widely deplored. Its sale to the American collector W. T. Walters occasioned this comment from the critic for the *Art Journal*: "The light of that summer-blue sea, the gold of the poet's lyre, and the white of the sun-warmed marble are now only memories in England, for the picture has found a far-away home."⁷

In *A Reading from Homer* (cat. no. 34), which has frequently been cited as a sequel to the *Sappho and Alcaeus*, Alma-Tadema avoided the complaints of scholars by presenting less archaeological detail.⁸

WRJ

1. Preserved in *Deipnosophistae*, bk. 13, line 598, by Athenaeus, an Egyptian writer who flourished about A.D. 200.

2. Georg Ebers, *Lorenz Alma Tadema: His Life and Works*, trans. Mary J. Safford (New York: William S. Gottsberger, 1886), p. 88.

3. Margarete Bieber, *Ancient Copies: Contributions to the History of Greek and Roman Art* (New York: New York University Press, 1977), p. 121.

4. *Lexicon Iconographicum Mythologiae Classicae* (Zurich and Munich: Artemis, 1984), vol. 2: pt. 1, p. 275; pt. 2, p. 246, fig. 745a.

5. The lampstand was discovered at Pompeii in 1812 and is illustrated in an engraving in *A Guide in the National Museum of Naples and its Principal Monuments Illustrated* (Naples: printed at S. Pietro a Maiella 31, n.d.), p. 84. The Victory, also found at Pompeii (1823), is illustrated as pl. 50.

6. *Nation* 43 (Sept. 16, 1886), pp. 235–40.

7. "The Works of Laurence Alma-Tadema, R. A.," *Art Journal* (London), n.s. (March 1883), p. 68.

8. Infrared photography of *Sappho and Alcaeus* reveals that the artist initially intended to place Alcaeus on a raised, curved dais similar to the one on which the speaker sits in *A Reading from Homer*.

29.

BETWEEN VENUS AND BACCHUS

1882
OPUS CCXLII
Watercolor
22 3/4 × 11 1/2 in. (57.8 × 29.2 cm)
Walters Art Gallery, Baltimore

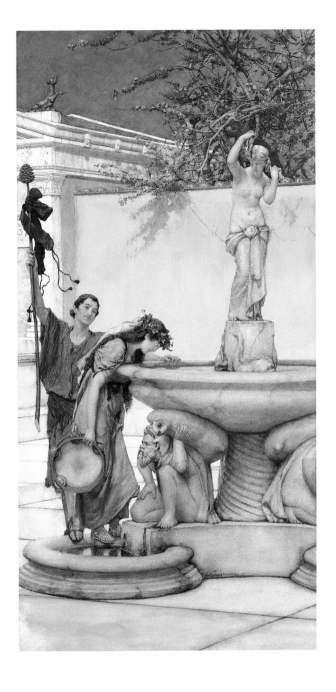

A maenad holding a tambourine, an instrument associated with the cult of Bacchus, gazes at her reflection in a fountain. Beside her, another votary of the god of wine holds aloft a sacred staff, the thyrsus. The setting is a sun-drenched courtyard paved in marble. Barely discernible on the upper right portion of the wall is the faded painting of a figure dancing on a garlanded thyrsus, much like a wall painting in *Tibullus at Delia's House* (cat. no. 7).[1] Growing beyond the wall is a luxuriant pink flowering tree. An acroteriun affixed to the roof of the temple at the left, in the shape of a panther, is sharply silhouetted against the intense blue of the sky. It is the same form, though much enlarged, that appears as a bronze statuette in *A Sculpture Gallery in Rome at the Time of Augustus* (cat. no. 9) and probably derives from a Roman bronze once in the celebrated collection of the count James Alexandre Pourtalès-Gorgier, Paris.[2]

In his conception of the fountain, Alma-Tadema drew from many sources. The supports for the basin—grotesque crouching males with wineskins on their shoulders—resemble the figure of Silenus of the middle of the second century A.D. in the bema of Phaidros in the Theater of Dionysus, Athens, but are more likely derived from the fountain in the Pio-Clementine collection of the Musei Vaticani.[3] The Aphrodite in the center of the fountain is a copy of a Greek statue of the middle of the third century B.C. (Musei Vaticani).[4]

WRJ

1. A similar wall decoration is illustrated in *Le Collezioni del Museo Nazionale di Napoli*, vol. 1 (Rome: De Luca, 1986), p. 140, fig. 123.
2. Salomon Reinach, "Panthère de bronze, collection de M. le Baron de Rothschild," *Monuments et Memoirs* (Paris: Fondation Piot L'Académie des Inscriptions et Belles-Lettres, 1897), pp. 105–14, discusses related works.
3. The Silenus figures are illustrated in John Travlos, *Pictorial Dictionary of Ancient Athens* (New York and Washington: Praeger, 1974), fig. 689. The fountain in the Pio-Clementine collection is illustrated in Salomon Reinach, *Répertoire de la statuaire grecque et romaine*, vol. 1 (Paris: E. Leroux, 1930), p. 414.
4. *Lexicon Iconographicum Mythologiae Classicae* (Zurich and Munich: Artemis, 1984), vol. 2: pt. 1, p. 76; pt. 2, p. 66, no. 667.

27.

THE ARCHER

c. 1882
Etching, artist's proof
Sheet: 12 5/16 × 8 11/16 in. (31.3 × 22 cm)
Sterling and Francine
Clark Art Institute

28.

THE LOVERS

c. 1882
Etching on chine collé
Sheet: 8 11/16 × 11 7/32 in. (22 × 28.5 cm)
Sterling and Francine
Clark Art Institute

In the late 1870s and early 1880s, Alma-Tadema produced several etchings for book illustrations. Like his drawings, they are detailed and precise with bold contours and distinct textures. Although not prolific as a printmaker, he was well versed in the techniques of printmaking and possessed the technical expertise that allowed him to explore diverse atmospheric effects.

These two etchings were made for Helen Zimmern's 1883 edition of *The Epic of Kings, Stories Retold from Firdusi*.[1] They are the only illustrations for the text, which also includes a prefatory poem by the poet and literary historian Edmund Gosse, Alma-Tadema's brother-in-law.

The Persian poet Firdusi (c. 935– c. 1020) is remembered for his epic poem, the *Shah-nameh*, which recounts the history of the kings of Persia from mythical times through the seventh century. Consisting of nearly 60,000 couplets, the saga is longer than Homer's *Iliad* and *Odyssey* combined. Helen Zimmern's publication is a paraphrase of the original text based on a French translation made by Jules Mohl in the 1870s.

Alma-Tadema's illustrations represent scenes from the love story of Zal and Rudabeh. Zal, a heroic white-haired youth who had been raised by a mythical bird and later became a powerful king, encountered the servants of the beautiful Rudabeh, a young woman whom he wished to court. According to a quotation inscribed on *The Archer*, "And seeing a waterbird fly upward he took his bow and shot it through the heart and it fell amongst the rose gatherers."[2] This was considered an omen, and Rudabeh's servants arranged for the two young people to meet. The first encounter of this future husband and wife is portrayed in *The Lovers*: "And they gazed upon each other and knew that they excelled in beauty; and the hours slipped by in sweet talk while love was fanned in their hearts."[3]

The two etchings differ dramatically in emotive and atmospheric intensity. *The Lovers* is an intimate interior scene composed of sharply contrasting areas of dark and light. Rudabeh and Zal— who resembles an old man with his white beard—sit on couches in the corner of a room bathed in strong light from the upper right. Deep shadows and rich textures are skillfully constructed with crosshatching and lines of varying thickness. *The Lovers* is printed on chine collé, a delicate Chinese paper applied to a heavier sheet of white paper. This process creates a translucent surface that gives the print a subtle luminosity.

The Archer is stylistically similar to many of Alma-Tadema's drawings in which contour is emphasized. The quality of light is very different from that of *The Lovers*. Whereas light was used to unify the composition in *The Lovers*, it is used here to divide the space into separate components.

The figure of Zal dominates the foreground. His boldly outlined figure is sparsely detailed and contrasts with the forms of the servants in the middle ground. They compose one rhythmic mass, animating the otherwise still image. The architecture in the background is crisply drawn; a crenelated roof— forming a graceful, fluid design—serves as a backdrop. The composition reinforces the narrative aspect of this print. Beneath the harsh Middle Eastern sun, the story unwinds: the arrow is released, the bird falls to the ground, and the servants react.

JGL

1. Helen Zimmern, *The Epic of Kings, Stories Retold from Firdusi* (London: T. Fisher Unwin, 1883), illustrated as frontispiece and p. 48.
2. Ibid., p. 45.
3. Ibid., p. 49.

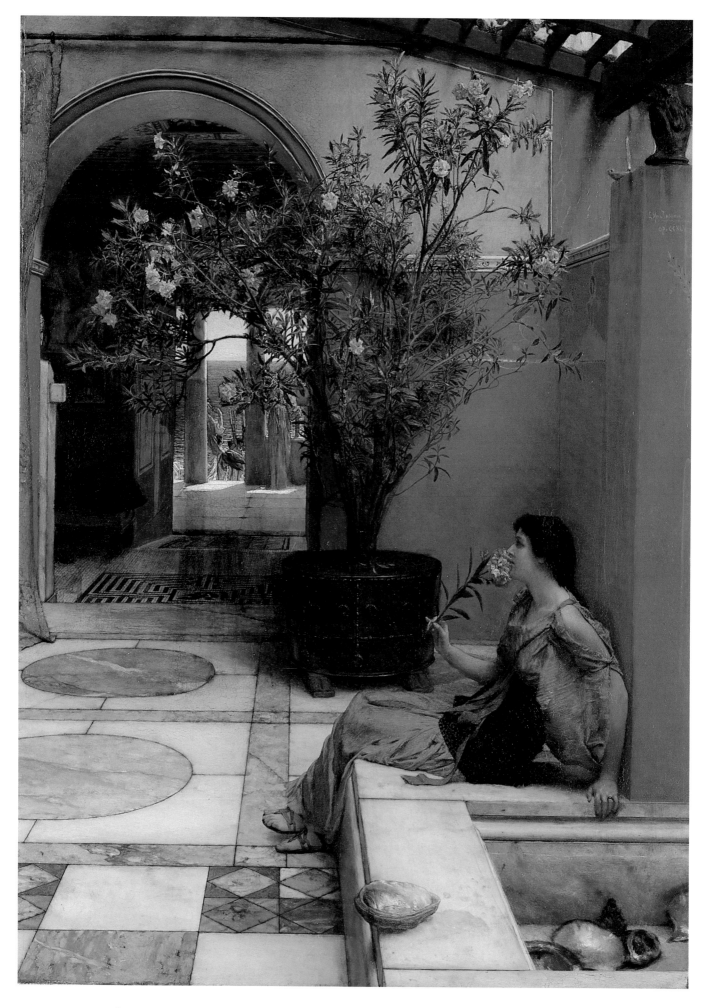

30.

THE OLEANDER

1882
OPUS CCXLV
Oil on panel
36 1/2 × 25 1/2 in. (92.8 × 64.7 cm)
Private collection

When *The Oleander* was exhibited at the Royal Academy in 1883, it was widely acclaimed. Singled out in most literature devoted to Alma-Tadema, the picture has been universally praised not only for its sensuous color, clarity, and high degree of detail but also for its effective juxtapositions of space, color, and light. The picture owes its existence to an impressive oleander tree, brought from Brussels to London a decade earlier, that suddenly burst into bloom in 1881. The artist told his friend Georg Ebers that he worked feverishly to complete the painting while the tree still held its blossoms.[1]

Flowers were critically important in Alma-Tadema's oeuvre, and they were always painted from life. Cosmo Monkhouse, writing for *Scribner's* in 1895, reported:

> No other artist has ever made so much use of flowers to beautify his pictures as Alma-Tadema. They frequently aid him in his difficulties of color and composition. A picture which will not come right is often settled by a mass of splendid bloom from his garden or conservatory. In this respect he has allowed himself some liberty of anachronism . . . introducing the latest variety of purple clematis or rose azalea into the gardens and palaces of ancient Rome.[2]

A great deal has been written about the contrast between the lush foliage and vibrant blossoms of the oleander and the dull, lifeless figure of the woman who sits in the foreground beside a shallow marble pool. Helen Zimmern wrote in 1886, "Is not 'The Oleander' almost more human than the girl sitting beside it?"[3] She concluded that the artist intentionally stressed the vitality of the tree to emphasize that it was the subject of his picture. This fact is underscored by the light that falls on the oleander and leaves the woman in relative shadow. She is no more significant to the overall composition than the abalone shells scattered on the bottom of the reflecting pool or the patterns of the marble floor. There is a dramatic contrast between these accessories and the focal, tonal, and spatial centrality of the oleander tree.

With *The Oleander*, Alma-Tadema succeeded in creating a visual feast. The rich warm colors of the highly detailed foreground contrast sharply with the cool luminous blues of the distant sea. The setting is a quiet interior; there is no narrative—just the vibrant saturated colors; and the effective cropping and manipulation of space and subject make the picture dynamic, sensual, and magical.

JGL

1. Percy Cross Standing, *Sir Lawrence Alma-Tadema, O. M., R. A.* (London: Cassell and Company, 1905), p. 74.
2. Cosmo Monkhouse, "Laurens Alma-Tadema, R.A.," *Scribner's Magazine* 18 (Dec., 1895), p. 672.
3. Helen Zimmern, "The Life and Works of Alma Tadema," *Art Journal* (London), n.s., special no. (1886), p. 15.

31.

SHY
1883
OPUS CCXLIX
Oil on panel
18 × 11 ¹/₂ in. (45.7 × 29.2 cm)
Private collection

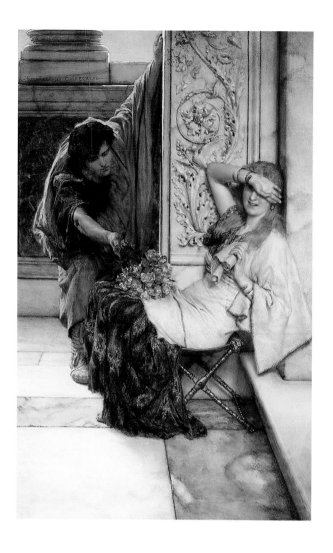

In 1886 this painting was described as "a pleasant, happy subject, which tells its own story simply and directly."[1] Typical of Alma-Tadema's later work, *Shy* is one of several pictures devoted to the unspoken dialogue between lovers (see also cat. nos. 41 and 47).[2] Extremely popular with Victorian audiences, these often ambiguous subjects invited interpretation. Although the compositions—usually limited to two figures in an intimate setting—are extremely sentimental, they successfully capture complicated emotions and awkward moments. Alma-Tadema's perceptive and empathetic presentation of vulnerable young lovers makes their appeal universal and timeless.

This closely cropped composition is photographic in effect. It possesses a sense of spontaneity, of quick actions frozen as in a snapshot. The subject of *Shy* is as simple as its title—a young woman, reading on a stool by a doorway,[3] is startled when an admirer tosses a large bouquet onto her lap. The vibrant reds of the roses are the only vivid colors in the picture. The bouquet forms the focal point of the composition and unifies the scene technically, aesthetically, and symbolically.

The sentimental quality of *Shy* is subtly tempered with humor. Alma-Tadema signals the young man's embarrassment through his awkward pose. He does not enter the room and appears poised to run in the opposite direction. Both figures blush. She, having recoiled from the sudden interruption, smiles coyly. He, serious and self-conscious, looks down at the flowers. By giving them, he has committed himself to proclaiming his affection.

JGL

1. Helen Zimmern, "The Life and Works of Alma Tadema," *Art Journal* (London), n.s., special no. (1886), p. 23.
2. Others include *A Question*, 1877; *Amo Te, Ama Me*, 1881; *Vain Courtship*, 1900; and *Ask me no more . . . for at a touch I yield*, 1906. The whereabouts of these four paintings are unknown.
3. This doorway, from the House of Eumachia in Pompeii, appears in several paintings (cat. nos. 17 and 22) and was used in Alma-Tadema's home at 17 Grove End Road.

32.

XANTHE AND PHAON
1883
OPUS CCLIX
Watercolor
17³/₄ × 12³/₄ in. (45.1 × 32.4 cm)
Walters Art Gallery, Baltimore

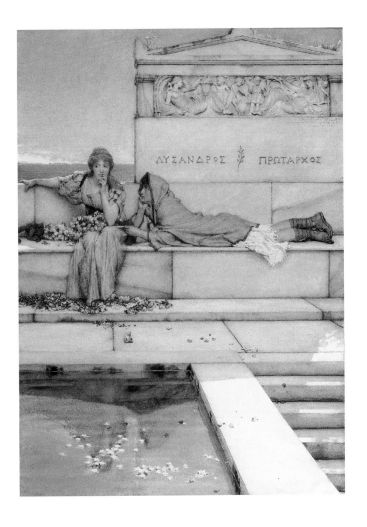

The novella *A Question, the Idyl of a Pic- ture by His Friend Alma Tadema, Related by Georg Ebers* tells of two cousins in ancient Syracuse, Xanthe and Phaon, whose love for each other was ob- structed by the machinations of a family retainer, Semestre.¹ Although the au- thor, an Egyptologist-turned-novelist, chose Alma-Tadema's *Pleading*, 1876 (Guildhall, London), as the frontispiece for the early editions of his book, he used a variant—*A Question* or *A Solicita- tion*, 1877 (location unknown)—as the inspiration for his text.²

The Baltimore collector William T. Walters was familiar with the once widely read novel and, during a visit to London in March 1883, commissioned this watercolor illustrating it. As Alma- Tadema subsequently noted, "I painted a picture, Ebers wrote a novel on my picture, and I have painted a picture upon his novel."³

The scene comes from chapter six of the novel. The lovers are posed on a marble bench on a dike between their fathers' properties. Alma-Tadema com- mented that he had made Phaon, stretched out at the right, as "noble- looking" as possible, whereas Xanthe,

disturbed by the rumors circulated by Semestre, appears "more sad than any- thing else." Her weaving of a wreath of roses has been interrupted and some petals have fallen into the pool. A stele behind the couple is inscribed with the names of their fathers, the brothers Ly- sander and Protarch, and carved in bas- relief with personifications of Plenty, an allusion to the family wealth. These were derived from figures representing Spring and Winter on the lid of a Ro- man sarcophagus of the second century A.D. in the Musei Vaticani.⁴ Phaon has not yet posed the question with which the novella culminates: "O Xanthe, dear, dear, Xanthe, will you have me or my cousin Leonax for your husband?"

Young lovers seated on marble benches beneath vibrant skies served as a recurrent subject for Alma-Tadema. Ebers apparently was particularly pleased with this version, because he made it the frontispiece in the fourth edition of his novel and included it among the twenty works illustrating his romances in *The Ebers Gallery*.⁵

WRJ

1. The novella was initially published in five in- stallments as "Eine Frage. Ein Idyll. Die Schaff- nerin und der Verwalter," in *Ueber Land und Meer; Allgemeine illustrierte Zeitung* 45, nos. 1–5 (Oct.-Nov., 1880) and as a book, *Eine Frage, Idyll zu einem Gemalde seines Freundes Alma Tadema* (Stuttgart-Leipzig: 1881). The English edition, *A Question, the Idyl of a Picture by His Friend Alma Tadema, Related by Georg Ebers*, translated by Mary J. Safford, appeared in New York in 1881.
2. Conflicting explanations of this discrepancy are offered in Constant Cuypers, "*The Question* by Lourens Alma Tadema," *Nederlands Kunst- historisch Jaarboek* 27 (1976), pp. 73–90, and Vern G. Swanson, *The Biography and Catalogue Raisonné of the Paintings of Sir Lawrence Alma- Tadema* (London: Garton and Co. 1990), p. 191.
3. Alma-Tadema to Walters, Dec. 22, 1884, de- stroyed in fire of 1904, reproduced in *The Wal- ters Collection, 65 Mt. Vernon Place, Baltimore* (Baltimore: privately printed, 1903), pp. 125–26.
4. Pierre Gusman, *L'Art décoratif de Rome de la fin de la république au IVᵉ siècle*, vol. 3 (Paris: Li- brairie centrale d'art et d'architecture, 1908), pl. 178.
5. *The Ebers Gallery* (Stuttgart and Leipzig: 1886, and Boston: Aldine Book Publishing Com- pany, n.d.).

33.

MISS ALICE LEWIS

1884
OPUS CCLXII
Oil on canvas
33 × 21 1/2 in. (84 × 54.6 cm)
Zanesville Art Center, Ohio

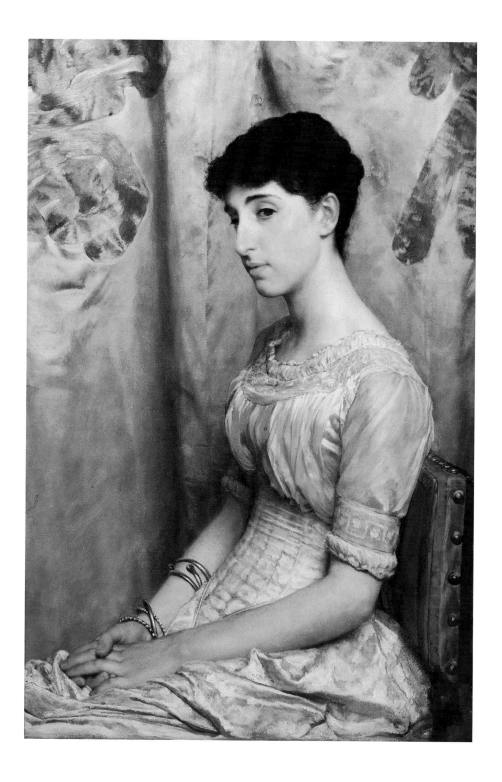

Like many other painters of the Victorian era in England, Alma-Tadema was not primarily interested in portraiture. He concentrated on his personal images of antiquity and painted portraits only for family members, friends, and occasional commissions. In fact, of the nearly one hundred portraits that Alma-Tadema executed in oil, over three-quarters were of family and friends. They were not painted for profit; many were given to the sitters or their relatives.

Alice Lewis's father, Sir George Henry Lewis, was a famous solicitor.[1]

He was both legal counsel to Alma-Tadema and a close personal friend. This portrait of Alice Lewis may have been painted in exchange for legal advice.[2]

Sir George Lewis had married Victorine Kann in 1863. She gave birth to Alice in March of 1865, and, unfortunately, died two months later due to complications resulting from childbirth.[3] Lewis married Elizabeth Eberstadt in 1867 and had three more children. The Lewises entertained frequently and had a great many friends in theatrical, musical, and artistic circles. Their children, even at a very early age,

were present at these social gatherings and were encouraged to interact with the guests.[4] Interestingly, although Alma-Tadema must have known Alice Lewis, his portrait of her is far from intimate.

Unlike other, more relaxed sitters such as Lily Millet (cat. no. 36), Alice Lewis sits stiffly with her head leaning awkwardly forward. She is shown in a three-quarter-length view, her chair set into the picture plane on a sharp angle. Curiously, Alice's face is neither in profile nor three-quarter view. Her head turns slightly towards the viewer, and she looks cautiously out of the corner of her eye. She appears almost reluctant to have her portrait painted, and for this reason the picture is particularly intriguing. Unlike her half-brother and half-sisters, Alice was timorous and withdrawn; and these traits caused serious concern to her father throughout his life.[5]

Alma-Tadema's studio is easily identified as the background of many portraits—for instance, *Mrs. Ralph Sneyd* (cat. no. 39), which shows the Mexican onyx windows of the artist's home at 17 Grove End Road. It is likely that this portrait also was painted in Alma-Tadema's home. The chair and Chinese silk curtain appear to be those in his Gold Room, illustrated in the 1882 issue of the *Magazine of Art*.[6] Alma-Tadema felt strongly that portraits should not be painted against a blank background but rather should include some semblance of the sitter's environment:

> When you or I meet a friend, we see not only him but his surroundings, whether it is in a room, a garden, or the street. I consider, therefore, that you should paint not only men and women, but some part of their accessories or environments, and it is upon this principle that most of my portraits have been executed.[7]

Although the setting of Alice Lewis's portrait is hardly elaborate, Alma-Tadema has adhered to this principle. He ignored it, however, in such works as the portrait of John Alfred Parsons Millet (cat. no. 40).

Unlike the clothing that appears in other portraits of women by Alma-Tadema—for instance, *Mrs. Frank D. Millet* and *Mrs. Ralph Sneyd*—Alice Lewis's attire is similar to the outfits of the women in his pictures of antiquity. The fretwork on the cuff of her sleeve and the spiral and twisted bracelets, for example, are based on Greek designs. A vogue for Greek dress, directly inspired by Alma-Tadema and other contemporary artists and authors, arose in the 1880s; and for a time, "Tadema togas" were all the rage. Alice Lewis's gown is not "à la Tadema," however, but rather in the aesthetic style, which featured loose, open-necked bodices and elbow-length, puffed sleeves often worn with Egyptian-style bracelets.[8] Developed by artists and dress reformers who saw the need to liberate women from the strict confines of the painfully tight dresses of the day, this style was very popular in artistic circles.

The tight draftsmanship of this basically monochromatic portrait gives the picture an almost photographic appearance. The sitter's white skin, so strongly contrasted against her jet black hair, brings full attention to her face. Moving down the graceful, curvilinear outline of her body, the eye comes to rest on the hands, carefully posed on her lap and beautifully painted. Even though Alma-Tadema was often criticized for the awkward, lifeless depictions of men and women in his scenes of antiquity, this portrait proves his ability to render human beings with an accurate sense of character, in this case, a reticent young woman.

PRI

1. He was known in his day for handling an extraordinary number of scandalous cases, including litigation resulting from the love affairs of King Edward VII.
2. Vern G. Swanson, *The Biography and Catalogue Raisonné of the Paintings of Sir Lawrence Alma-Tadema* (London: Garton and Co., 1990), p. 225. Swanson also points out that Alma-Tadema painted portraits in exchange for works of art by other artists; for example, his portrait of Giovanni Battista Amendola, 1883 (location unknown), was done in exchange for a statue by Amendola of Alma-Tadema's second wife, Laura (p. 222). Alma-Tadema may also have painted portraits in return for services rendered, and Lewis may have accepted works of art as payment. John Singer Sargent was one of Lewis's clients; and, according to Charles Merrill Mount, *John Singer Sargent: A Biography* (New York: W. W. Norton and Company, 1955), p. 199, Sargent's portrait of Lewis's wife, 1892 (location unknown), may have been done in gratitude for some legal assistance. However, Elaine Kilmurray, research director for portraiture for the John Singer Sargent catalogue raisonné, states in an entry in that forthcoming publication that the portrait *Mrs. George Lewis* was probably commissioned.
3. John Juxon, *Lewis and Lewis: The Life and Times of a Victorian Solicitor* (New York: Ticknor and Fields, 1984), pp. 50–51. My thanks to Elaine Kilmurray for pointing out this source.
4. Ibid., p. 195.
5. Ibid., pp. 88, 195.
6. "Artists' Homes. Mr. Alma-Tadema's at North Gate, Regent's Park," *Magazine of Art* 5 (1882), p. 188.
7. Quoted in Frederick Dolman, "Sir Lawrence Alma-Tadema, R. A.," *Strand Magazine* 18 (Jan., 1900), pp. 613–14.
8. My thanks to Caroline Goldtholpe of the Costume Institute at the Metropolitan Museum of Art for her generous assistance and opinions regarding the style of this dress. For a discussion of the aesthetic style, see Stella Mary Newton, *Health, Art & Reason: Dress Reformers of the 19th Century* (London: John Murray, 1974), and Madeleine Ginsburg et al., *Four Hundred Years of Fashion* (London: Victoria and Albert Museum in association with William Collins, 1984), pp. 43, 139.

34.

A READING FROM HOMER

1885

Opus CCLXVII

Oil on canvas

36 × 72 3/8 in. (91.4 × 183.8 cm)

Philadelphia Museum of Fine Arts

George W. Elkins Collection

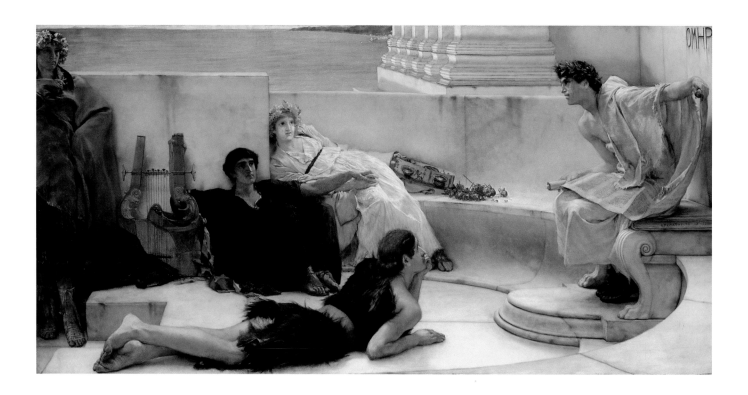

Alma-Tadema's most famous and successful painting has graced the pages of schoolbooks for generations and has been reproduced all over the world. *A Reading from Homer* was completed in only six weeks, just in time for the summer exhibition of the Royal Academy in 1885. It evolved from another work, *Plato Addressing His Disciples*, started in 1884 and abandoned eight months later when the difficult relationship between the figures and landscape could not be resolved. The roots of the composition may extend even farther back, to 1882, when Alma-Tadema mentioned to his dealer Charles Deschamps that he was working on a picture called *Singer of Homer*.[1] A photograph, owned by Alma-Tadema, of visitors viewing sculpture at Rome's Capitoline Museum may have provided the inspiration for the composition.

A Reading from Homer was purchased through Deschamps by Henry G. Marquand, a wealthy American banker, businessman, and connoisseur. Marquand commissioned Alma-Tadema to design a music room (fig. 5) for his New York mansion and authorized him to hire other artists to design neoclassical decorations and furnishings. *A Reading from Homer* along with another work by Alma-Tadema, *Amo Te, Ama Me*, 1881 (location unknown), was installed in this room, which was dedicated to the arts.

The theme of artist and audience appeared often in Alma-Tadema's work.

Here it is expressed in one of his favorite formats: a few figures seated on a marble bench with a distant view of bright blue sea or sky. This particular picture, however, appears distinct from any formula. The composition is austere, uncluttered with the kind of accessories that typically abound in his pictures. The two accessories that do appear are familiar: the tambourine, associated with bacchic celebrations, and the kithara.

The composition is extremely still, yet the figures are arranged in such a way as to manipulate the viewer through the space with dizzying speed. The subject is simple: In a special seat dedicated to the reading of poetry (Homer's name is inscribed in Greek above it), a man recites from a scroll. Four listeners are absorbed in his narration. A man in shepherd's costume appears quite comfortable lying on the hard marble floor. Two lovers—a man holding a kithara and a woman with daffodils in her hair—clasp hands. A bouquet of vivid roses has been dropped on the bench next to the woman's tambourine.[2] The enigmatic figure on the left wears flowers in his hair, perhaps in honor of a festival. Within the cool tonality of the picture, the flowers are startling in their brightness; they serve visually to lead us to the middle of the scene. The cropping of the man on the left is unusual and may reflect the artist's interest in photographic effects and Japanese prints.

Alma-Tadema has created a disconnected group of individuals—even the lovers seem lost in their own imaginings. Perhaps the artist desired to express the universality of poetry, which can affect all types of people and transform reality into ideality. The eye moves constantly back and forth between the speaker, leaning toward his audience, and the cropped figure at the extreme left. Tension and dynamism are achieved by juxtaposing and balancing elements, both architectural and human, and by subtle touches of vivid color.

A Reading from Homer was one of the first paintings to be completed in Alma-Tadema's studio at 17 Grove End Road. Its domed ceiling was covered with aluminum, which created a cool, silvery atmosphere that was reflected in the pictures composed there. Alma-Tadema's palette changed noticeably at this time: the colors became brighter, lighter, and more luminous. *A Reading from Homer* was universally praised for its color, luminosity, and lifelike figures. Helen Zimmern, writing for the *Art Journal* in 1886, proclaimed: "The flesh painting in this picture is of the very best Alma-Tadema has done, and he has certainly never modeled anything more perfect than the figures of woman and lover. As to the luminosity of the work in its harmonious coloring it may rank with his very highest efforts."[3] The painting was extremely successful financially as well. It sold for a record 30,000 dollars in New York in 1903.

JGL

1. Alma-Tadema to Deschamps, March 2, 1882, Marquand Papers, Archives of the Metropolitan Museum of Art, New York.
2. This variety of rose was not developed until the nineteenth century.
3. Helen Zimmern, "The Life and Works of Alma Tadema," *Art Journal* (London), n.s., special no. (1886), pp. 24–25.

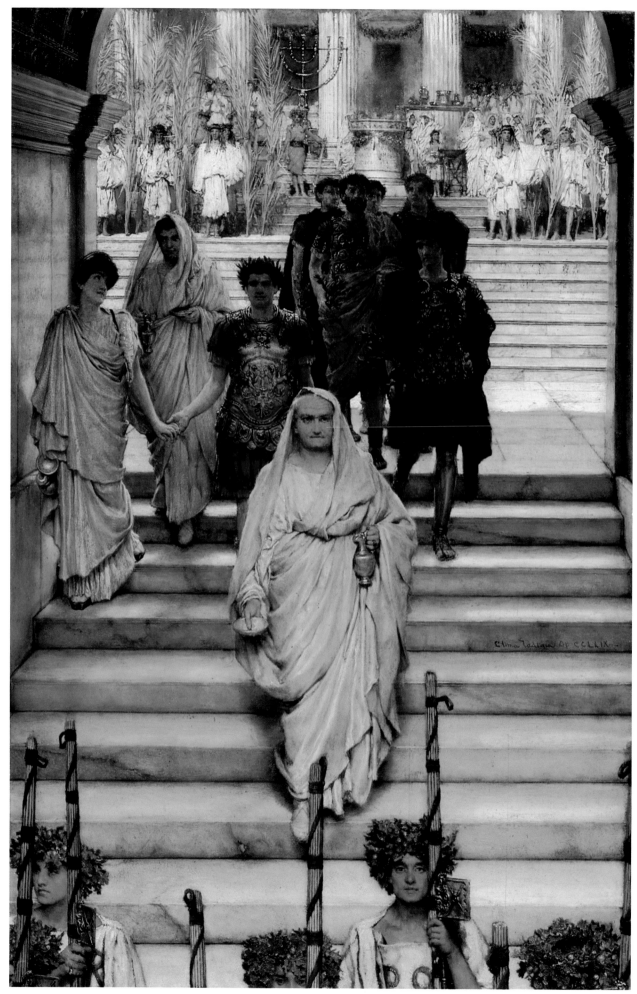

35.

THE TRIUMPH OF TITUS: THE FLAVIANS

1885

OPUS CCLXIX

Oil on panel

17 1/2 × 11 1/2 in. (44.5 × 29.2 cm)

Walters Art Gallery, Baltimore

Alma-Tadema has departed from his customary domestic genre scenes to portray a historical event, the *triumphus* shared by Titus with his father, the emperor Vespasian, following the capture of Jerusalem in A.D. 70. Rather than showing the triumphant chariot procession to the Capitoline Hill, recorded in a celebrated relief on the Arch of Titus (A.D. 81, Rome), the artist has taken a more intimate approach, depicting the imperial family leaving the temple after the victory ceremonies. In a letter explaining the subject to his client William T. Walters of Baltimore, Alma-Tadema located the setting as the steps of the Temple of Jupiter Victor on the Palatine Hill (actually the Capitoline) and identified the figures.[1] The aging Vespasian, clad in a white toga, leads the procession. He is followed by Titus, wearing a gold cuirass and holding the hand of his daughter Julia. She turns her head to address her father's younger brother and successor, Domitian, of whom she is "inordinately fond." (Eventually, she becomes pregnant by him and dies from an abortion.) The family members carry gold *oenochoae* (wine jugs) and *paterae* (dishes for sacrificial wine) used in the ceremonies. Five Roman officers bring up the rear. Several lictors, officials bearing fasces, are dramatically cropped in the foreground. At the temple facade in the background are priests holding palm fronds, musicians playing double flutes,

the high altar, and various spoils from Jerusalem, notably the seven-branched candlestick from the temple.

For a contemporary account of the procession, Alma-Tadema might have consulted the first-century Jewish author Josephus (*The Jewish War*, 7, 123–62). The faces of Vespasian, Titus, and Julia appear to derive from three portrait busts displayed together in the Musei Capitolini in Rome;[2] and Titus's cuirass, with a gorgon's head above griffins flanking a candelabrum, adheres to a standard type seen, for example, on a statue in the Villa Albani in Rome.[3]

A possible antecedent of *The Triumph of Titus: The Flavians* was *Reading*, 1866 (location unknown), which showed Vespasian listening to the report of the taking of Jerusalem.

WRJ

1. Alma-Tadema to Walters, lost in 1904 fire, reproduced in part in *Collection of W. T. Walters, 65 Mount Vernon Place, Baltimore* (Baltimore: privately printed, 1887) and subsequent Walters Gallery catalogues.
2. The busts of Vespasian, Titus, and a Flavian woman once thought to be Julia are illustrated in Henry Stuart Jones, *A Catalogue of the Ancient Sculptures Preserved in the Municipal Collections of Rome* (Oxford: Clarendon Press, 1912), vol. 1, p. 193, nos. 21–23; vol. 2, pl. 49.
3. Klaus Stemmer, *Untersuchungen zur Typologie, Chronologie und Ikonographie der Panzerstatuen* (Berlin: Mann, 1978), pl. 1, type 1, 2.

MRS. FRANK D. MILLET
1886
OPUS CCLXXVI
Oil on canvas
25 ¹/₂ × 20 in. (64.7 × 50.8 cm)
Private collection

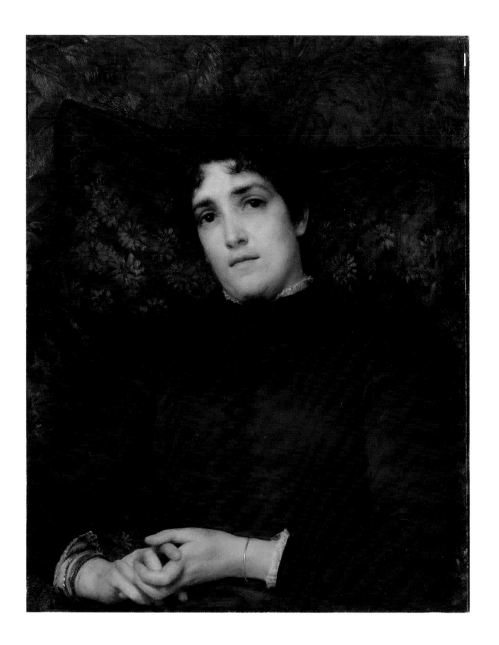

Like many American artists in the late nineteenth century, Frank D. Millet (1846–1912) went abroad to pursue his artistic training. He studied in Antwerp under Nicaise de Keyser (1813–1887), one of Alma-Tadema's former teachers, before going to England where he and his wife, Lily (1855–1933), met Alma-Tadema.

In the 1880s, a sizable group of American expatriate painters, including John Singer Sargent (1856–1925) and Edwin Austin Abbey (1852–1911), were drawn to Broadway, England, where Frank and Lily Millet lived. The Millets opened their home, Russell House, to these artists and their relatives and friends and provided a place for them to work, play, and entertain.

Alma-Tadema was one of the many artists who enjoyed visits to the Millets'

home and became one of their closest friends. Frank Millet and Alma-Tadema certainly respected and admired one another's work, and some of Millet's compositions bear a striking resemblance to those of Alma-Tadema. In one such painting, *Thesmorphia*, 1897 (destroyed),[1] Millet used Laura Alma-Tadema as a model along with his own wife and his son, John (for his portrait, see cat. no. 40). All of the artists at Russell House found ready models among their housemates. John Singer Sargent painted a portrait of Lily Millet and depicted her daughter Kate in a preliminary sketch of the children in the original version for his celebrated *Carnation, Lily, Lily, Rose*, 1885–86 (Tate Gallery, London).

There were many happy times in Broadway. Social gatherings were never

dull. Stanley Olson, in his book *Sargent at Broadway: The Impressionist Years*, relates the following story:

> Sargent suggested a game of throwing silhouettes behind a sheet and guessing the subject. Abbey opened the curtains on his costume store, and a few guests dressed up. And then the real high spirits were let loose. Dancing. A Virginia reel; Alma-Tadema swept the floor in a hooped-underskirt. Millet tested the trombone. When Abbey finished cutting out James's silhouette (to add to the frieze of habitués around the walls), he tortured one of the harpsichords. Alma-Tadema's daughter played the guitar. Sargent went to the piano to partner Lily Millet in a four-hand arrangement of *The Mikado*, singing all the parts, or, less entertaining, returned yet again to the drone of Wagner.[2]

Birthdays were especially important occasions, celebrated with extravagant parties. According to John Alfred Parsons Millet's unpublished manuscript, this portrait of Lily was painted as a birthday gift for Frank Millet.[3] Alma-Tadema also gave Lily a ring for one of her birthdays. It was described as a miniature portrait of her, surrounded by red stones.[4]

"Mrs. Frank," as Alma Tadema calls Lily in the inscription on her son's portrait, was more than simply Frank Millet's wife. A warm and generous personality made her "the crowned and acknowledged queen of this widening circle of friends, and worthily so if one can judge the paintings of her done by Sargent and Alma Tadema at that time."[5]

Mrs. Frank D. Millet is an intimate, personal representation of someone very significant to Alma-Tadema. The life-size, half-length portrait of Lily Millet seems much more relaxed than the more formal portraits of Alice Lewis (cat. no. 33) and Mrs. Ralph Sneyd (cat. no. 39). Alma Tadema depicts Lily in a tightly laced maroon dress. She sinks into a large blackish blue pillow decorated with a daisy pattern. As in the portraits of Alice Lewis and Mrs. Ralph Sneyd, Alma-Tadema has given serious attention to the sitter's hands. Lily's fingers are intertwined, giving the portrait a traditional second area of focus.

The Alma-Tademas and the Millets remained friends for the rest of their lives. The two artists died in 1912, Frank Millet on the Titanic on April 15 and Alma-Tadema just three and a half months later.

PRI

1. Illustrated in Pauline King, *American Mural Painting: A Study of the Important Decorations by Distinguished Artists in the United States* (Boston: Noyes, Platt and Company, 1901), p. 254.
2. Stanley Olson, *Sargent at Broadway: The Impressionist Years* (New York: Universe/Coe Kerr Galleries, 1986), pp. 21–22.
3. John A. P. Millet, "Diary Excerpts" (unpublished manuscript), Archives of American Art, roll 1101. If a birthday gift, the gift was late because Frank Millet's birthday was November 3; in his diary for December 14, 1886, he notes, "In London all week watching Tadema paint a portrait of Mrs. Millet."
4. John A. P. Millet, "In Search of an Ancestor" (unpublished manuscript), Archives of American Art, roll 1100.
5. John A. P. Millet, ibid.

THE WOMEN OF AMPHISSA

1887
Opus CCLXXVIII
Oil on canvas
48 × 72 in. (121.9 × 182.9 cm)
Sterling and Francine
Clark Art Institute

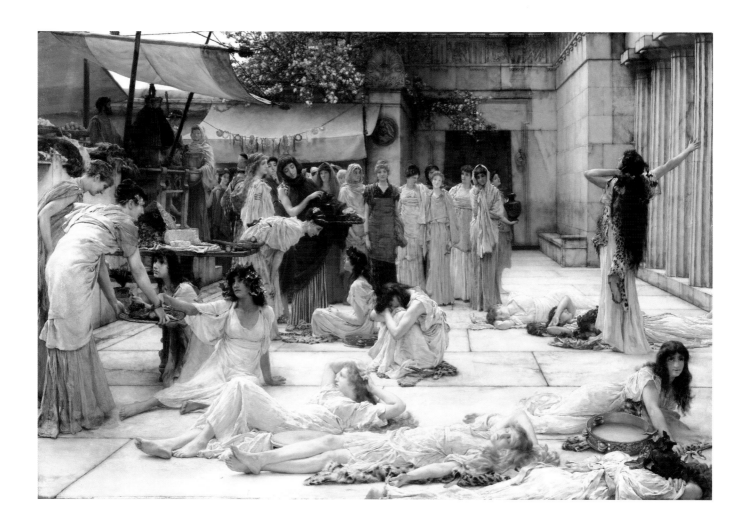

According to Alma-Tadema, George Eliot's novel *Daniel Deronda*, published in 1875, and the story of the Women of Phocis in Plutarch's *Moralia* (249F) provided the inspiration for this painting.[1] Eliot wrote:

> Then there occurred to [Daniel Deronda] the beautiful story Plutarch somewhere tells of the Delphic women: how when the Maenads, outworn with their torch-lit wanderings, lay down to sleep in the marketplace, the matrons came and stood silently round them to keep guard over their slumbers; then, when they waked, ministered to them tenderly and saw them safely to their own borders.[2]

Even though educated members of nineteenth-century British society were versed in ancient writings, Helen Zimmern warned the readers of the *Art Journal* in 1886 that the text on which Alma-Tadema based this painting "will certainly be unfamiliar to the greater mass of the public."[3]

The painting shows maenads (female

devotees of Bacchus) after a night of celebration as they awake in Amphissa, a city at war with their home district of Phocis. Fearing that soldiers might harm these bacchantes, the women of Amphissa guarded them while asleep and now offer food and wine before escorting them safely out of town.

The bacchantes are identified by their cloaks of leopard skin, the ivy wreaths in their hair, and several tambourines, all attributes of Bacchus. They are sprawled across the marketplace in varying degrees of consciousness, while the women of Amphissa form a protective wall.

The critic for the *Illustrated London News* of May 7, 1887, praised *The Women of Amphissa* for its emotional appeal: "Archaeology for once, at least, is made subordinate to art, and in the waking wanderers, as well as in their ministering protectors, we have a series of elaborate studies, not of costume and pose, but of sentiment and emotion."[4] A writer in the *Magazine of Art* of 1891 disagreed: "It must be owned that the dramatic element of the subject ... has been greatly missed; for in truth, it is altogether beyond the scope and power of conception of the artist. There is nevertheless much to admire both in conception and execution of the picture, if we accept Mr. Tadema's calm, unemotional standpoint."[5]

While the poses and facial expressions of the figures do not convey great emotion, the notion of individuals helping others is made apparent by the grateful look in the eyes of the two bacchantes at the left as they are given food and drink and by two women near the center, one bending solicitously to speak to a bacchante and the other preparing to serve food from a heavily laden tray. The brilliantly painted architecture and still-life details also demand considerable attention, however, so that the picture—without appearing overly sentimental or melodramatic—satisfies the Victorian desire for virtuous narrative subject matter.

The artist frequently used family and friends as models, and certainly in a picture of this scale he must have called upon them. Although the composition includes over thirty women, he calls attention to one—his wife Laura—by placing her in the center and contrasting her dark outfit with surrounding light garments.[6]

Alma-Tadema's paintings of antiquity were often criticized as images of Victorians in togas. He seems to have felt that his English contemporaries were in fact modern versions of the Greeks and Romans and that the similarities in his portrayals were therefore justified. The president of the Royal Academy, Frederick Leighton (1830–1896), obviously agreed with Alma-Tadema. Addressing the Liverpool Art Congress in 1888, Leighton stated, "In the art of the Periclean age ... we find a new ideal of balanced form, wholly Aryan and of which the only parallel I know is sometimes found in the women of another Aryan race—your own."[7]

Atypically, two preliminary pencil sketches (Birmingham University Library, England) exist for *The Women of Amphissa*. The large size of the canvas and the number of figures to be included persuaded Alma-Tadema to develop the composition in the more manageable scale of a drawing. Apparently, he was not satisfied with either solution because the finished painting does not resemble the sketches. He must therefore have gone back to his usual method of working directly on the canvas with only a general outline. This technique is remarkable in a painting as large and intricately detailed as *The Women of Amphissa*.[8]

The architectural setting is elaborate, though imaginary. The relief sculptures above the doorway are metopes of the fifth century B.C. (Museo Civico, Palermo) from the Temple of Hera in Selinus. Three come from the east side of the temple and one from the west.[9] It is not surprising that Alma-Tadema has grouped these metopes together; throughout most of his career, he seemed willing to modify antique objects to suit his compositional purposes. The pier that juts out on the left of the doorway is topped by a funeral stele, which would not have been found in the center of a marketplace. The shieldlike wall decoration on the pier is also archaeologically incorrect. It is actually a fish plate of the fourth century B.C. (British Museum, London).[10] Alma-Tadema has once again subordinated historical accuracy to aesthetic design.

Market stalls are set up on the left side of the painting. Fish and shells are strung between the two bronze-topped posts that support an awning.[11] Another awning, on the left, is held on either side by a thyrsus, a rod capped with a pine cone. The thyrsus is an attribute of Bacchus and, in many of Alma-Tadema's pictures, is carried by a bacchante. In *The Women of Amphissa*, however, he has chosen to make it a more subtle detail of the composition. Appropriately, this awning protects an area of the market that is devoted to wine. There is a wooden table, decorated with painted grapevines and large eyes like those painted on kylikes, or wine-drinking cups. It holds two examples of an ancient drinking vessel known as a rhyton.[12] Next to the table stands a single fluted column capped with a lekythos (oil flask) and draped with wineskins from which wine is being let into a huge silver krater.[13] The capital of the column is painted rather than carved, not unlike painted capitals excavated on the Acropolis in Athens and published in archaeological periodicals in the second half of the 1880s.[14] The inclusion of this object demonstrates Alma-Tadema's knowledge of recent archaeological finds. These freestanding columns were found with korai (statues of maidens) and were believed to be nonarchitectural and used instead as bases for statues.

The Women of Amphissa brought the artist recognition as a masterful painter and won a prestigious award—the Gold Medal of Honor at the Exposition Universelle in Paris in 1889.

PRI

1. Vern G. Swanson, *The Biography and Catalogue Raisonné of the Paintings of Sir Lawrence Alma-Tadema* (London: Garton and Co., 1990), p. 69.
2. George Eliot, *The Works of George Eliot: Daniel Deronda*, vol. 1 (Edinburgh and London: William Blackwood and Sons, n.d.), p. 291.
3. Helen Zimmern, "The Life and Works of Alma Tadema, " *Art Journal* (London), n.s., special no. (1886), p. 26.
4. "Royal Academy, Gallery No. III," *Illustrated London News* 90 (May 7, 1887), p. 517.
5. Claude Phillips, "The Modern Schools of Painting and Sculpture, as illustrated by the 'Grand Prix' at the Paris Exhibition. Great Britain and the United States of America," *Magazine of Art* (1891), p. 207.
6. Other figures also appear to be portraits, for instance, the young woman holding a leaf (who is the second figure to the right of Laura) and the woman wearing a peach-colored blossom in her dark hair, peering out from the opposite end of the line.
7. Philip Hook, "The Classical Revival in English Painting," *Connoisseur* 192 (June, 1976), p. 127.

8. An infrared photograph of this painting taken at the Williamstown Regional Art Conservation Laboratory shows only minor revisions by the artist and almost none that cannot be seen with the naked eye.

9. Although Alma-Tadema is not known to have traveled to Sicily, he could have seen illustrations of these metopes as early as 1873 in Otto Benndorf, *Die Metopen von Selinut* (Berlin: I Guttentag [D. Collin], 1873), pls. 7–10.

10. Copied after a south Italian fish plate (vase F 262). I would like to thank Ian Jenkins of the British Museum for identifying this object as the one in *The Women of Amphissa*. I also thank Brian F. Cook, the keeper of the Department of Greek and Roman Antiquities, for confirming that the ram's head rhyton (held out by the kneeling bacchante in the left foreground) is based on a red-figured vase (E 795) from Capua, c. 480 B.C., in the British Museum.

11. A Roman painting, no longer extant, reproduced in August Mau, *Pompeji in Leben und Kunst* (Leipzig: Wilhelm Engelmann, 1908), p. 286, shows a Roman fish shop with fish hanging from a garland strung across the shop front. Alma-Tadema was aware of this illustration, which he used in the background of *A Sculpture Gallery in Rome at the Time of Augustus* (cat. no. 9) and *The Flower Market*, 1868 (Manchester City Art Galleries, England).

12. They appear to be the same bronze rhyta that are shown in *Preparations for the Festivities* (cat. no. 5), copied after an example in the Museo Archeologico Nazionale in Naples. See Museo Archeologico Nazionale di Napoli, *Masterpieces of Art in the National Museum in Naples. First Part: The Bronze and Marble Sculptures, the Antiquities of Pompeii and Herculaneum*, Medici Art Series (Florence: G. Fattorusso, 1926), p. 29.

13. Ian Jenkins, "Frederick Lord Leighton and Greek Vases," *Burlington Magazine* 125 (Oct., 1983), p. 605, suggests that this is a copy of a first-century Roman silver krater (Staatliche Museum, Berlin) found with the Hildesheim treasure in 1868. Alma-Tadema owned a copy of this krater, and it appears in numerous paintings; see, for example, *Unwelcome Confidence* (cat. no. 42).

14. My thanks to Elizabeth McGowan, assistant professor of art, Williams College, Williamstown, for providing me with this information.

38.

HE LOVES ME,
HE LOVES ME NOT

c. 1889
Engraving, artist's proof with
ink and pencil on paper
24 × 32 1/2 in. (61 × 82.6 cm)
including frame
Collection of Scott and Luisa Haskins
Santa Barbara

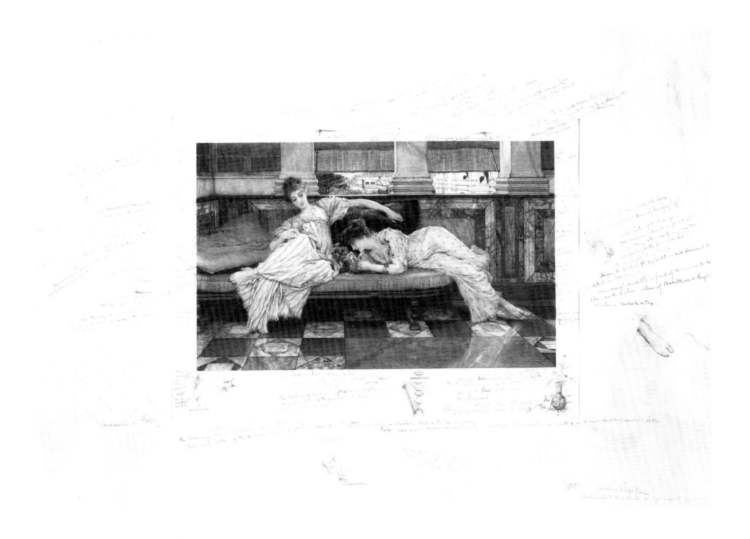

Engravings, etchings, and lithographs of popular paintings were mass-produced during the nineteenth century and were widely collected by the burgeoning middle class throughout the British Empire and the United States. Printed reproductions enabled artists to capitalize on the success of popular oil paintings by making them accessible to a public eager to decorate their homes with fashionable art.[1]

The predilection for story-telling and moralizing which was the dominating feature of much Victorian painting forged the link between the hitherto exclusive world of art and the general public. It was on this factor that the print industry flourished, and the link was effected through the production and distribution of reproductive engravings. For the first time art (in this sense) became available to every class of society, and as much a feature of home life as television is today.[2]

Like other Victorian painters, Alma-Tadema often sold the copyrights to his paintings separately from the pictures themselves. The copyright to *He Loves Me, He Loves Me Not*, painted in 1887 (destroyed in a fire in 1910), was purchased by Stephen T. Gooden. The print, engraved by Leopold Lowenstam (1842–1898), was issued in 1893 in a limited edition of 375 by the British Art Publishers Union in New York, an association that distributed engravings of popular pictures all over the world.[3]

Two elegant young women are the focus of this tightly cropped composition. They recline on a couch and lazily pull the petals off daisies in the adolescent pastime referred to in the title. The roofs of a Roman town are visible beneath partially drawn shades. The strong horizontal format of the picture is reinforced by compositional elements—the woman who stretches languidly across the picture plane, the geometric pattern of the marble floor, and the row of columns at the back wall.

This print, an artist's proof, is heavily annotated with Alma-Tadema's corrections. The margins of the printed sheet, as well as the mat, are covered with instructions and sketches of necessary revisions. Translating such a complex painting—packed with details, spatial juxtapositions, diverse textures, and patterns—into an engraving must have been a substantial challenge for Lowenstam.

Alma-Tadema worked closely with him from 1873 until the engraver's death in 1898. Their social relationship was familial; Lowenstam married Alice Search, the governess of Anna and Laurense Alma-Tadema, who became close friends of the Lowenstams' daughter. The working relationship between the two men, unfortunately, was not as cordial. Alma-Tadema was "too much of a perfectionist and always demanded extra work," according to Lowenstam's daughter Millie. "He was hot-tempered and could become excessively angry if details didn't go smoothly."[4]

JGL

1. For the production of Victorian prints, see Rodney K. Engen, *Victorian Engravings* (London: Academy Editions, 1975), and Hilary Guise, *Great Victorian Engravings, A Collector's Guide* (London: Astragal Books, 1980).
2. Hilary Beck, *Victorian Engravings* (London: Victoria and Albert Museum, 1973), p. 9.
3. Members of the Royal Academy usually restricted or limited publication of prints after their work because they felt it cheapened the original paintings.
4. Vern G. Swanson, *The Biography and Catalogue Raisonné of the Paintings of Sir Lawrence Alma-Tadema* (London: Garton and Co. 1990), p. 99.

39.

MRS. RALPH SNEYD

1889
Opus CCXCV
Oil on board
12 × 9 3/8 in. (30.5 × 23.8 cm)
Collection of
Michael D. and Sophie D. Coe

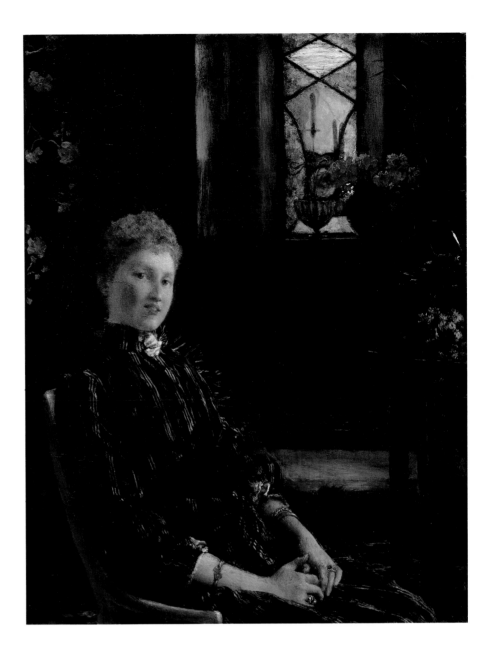

No evidence exists that suggests the Sneyds and the Alma-Tademas were friends. The portrait of Mrs. Sneyd, therefore, may be one of Alma-Tadema's relatively few commissioned portraits. He noted that these portraits were lucrative because they did not take much time but commanded high prices.[1] It is curious, however, that a commissioned portrait would be painted on such a small scale.[2]

This portrait of Mary Sneyd (d. 1923) was painted four years after her marriage to her cousin Ralph.[3] In 1888 Ralph Sneyd had inherited Keele Hall, the family estate in Staffordshire; but he and his wife chose to remain in London rather than return to the estate, which had been occupied by the Sneyds since the sixteenth century. It was sold in 1947 and became the University College of North Staffordshire, now known as the University of Keele.[4]

This small painting makes an interesting comparison to other portraits in the exhibition. The much larger portraits of Alice Lewis (cat. no. 33) and Mrs. Frank D. Millet (cat. no. 36) have wallpaper and a gold curtain, respectively, as backdrops. In contrast, Mary Sneyd is placed in a detailed setting that is recognizable as a room in the artist's home.[5] Alma-Tadema's obvious love of detail, evidenced by the extensive number of props that fill his images of antiquity, is not lacking in this portrait. Mary Sneyd's chair rests on a handsomely colored Oriental rug. Opposite her is a small Moorish table of a type popular in England in the 1880s. It holds several objects, including a small bouquet of flowers. A candelabra and more flowers

are on a second table in the background. Sunlight filters through a window of Mexican onyx; and Alma-Tadema beautifully captures its effect as it passes through a green glass bowl and translucent red petals.

The dark palette and careful attention to detail are reminiscent of Alma-Tadema's early work and its connection to Netherlandish genre paintings of the seventeenth century. Rather than recreate the Mediterranean environment of his images of antiquity, Alma-Tadema frequently used the richly colored interior of his home as the setting for portraits of women and placed the sitters amid the plethora of treasures to be found there.[6]

Helen Zimmern, in her 1902 biography of the artist, says of Alma-Tadema's portraits:

Despite their merits, it is hard to think of these portraits as Alma Tadema's; with his name, whether we will or no, we are forced to associate blue skies, placid seas, spring flowers, youths and maidens in the heyday of life, and a sense of old-world happiness and distance from our less beautiful modern existence and surroundings.[7]

Indeed, Alma-Tadema was known not for his portraits but for images such as *A Reading from Homer* (cat. no. 34) and *Sappho and Alcaeus* (cat. no. 26), which, as Zimmern points out, removed Victorian viewers from the reality of their industrialized society.

PRI

1. Vern G. Swanson, *Alma-Tadema: The Painter of the Victorian Vision of the Ancient World* (New York: Charles Scribner's Sons, 1977), p. 34.
2. The majority of portraits of women painted by Alma-Tadema between 1889 and 1899 were small like this portrait, but they were painted in exchange for works by other artists.
3. J. M. Kolbert, *The Sneyds: Squires of Keele* (Keele, England: University of Keele, 1976), unpaged. I would like to thank Martin Phillips, Special Collections and Archives, Keele University Library, for looking through the family documents and providing me with three booklets written by Kolbert about the Sneyd family.
4. J. M. Kolbert, *Keele Hall: A Victorian Country House* (Keele, England: University of Keele, 1986), postscript.
5. The Mexican onyx windows can be seen in photographs of his home, and the table beside Mrs. Sneyd is shown in Alma-Tadema's drawing room as it appears in "Artists' Homes. Mr. Alma-Tadema's at North Gate, Regent's Park," *Magazine of Art* 5 (1882), p. 184.
6. The portraits of men done between 1889 and 1899 are much less complicated. Most have a blank, or nearly blank, background and are at least twice the size of the portrait of Mary Sneyd.
7. Helen Zimmern, *Sir Lawrence Alma Tadema, R. A.* (London: George Bell and Sons, 1902), pp. 36–37.

40.

MASTER JOHN ALFRED PARSONS MILLET

1889
OPUS CCXCVII
Oil on canvas
9¹/₂ × 7¹/₂ in. (24.1 × 19 cm)
Private collection

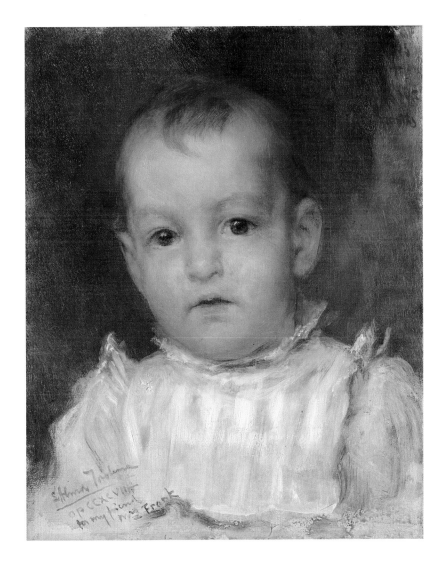

Just as the portrait of Lily Millet (cat. no. 36) was painted for her husband, this portrait of the Millets' son was painted for Lily. Alma-Tadema's inscription reads, "For my friend Mrs. Frank." A second inscription, in the upper right corner, "JOHN ALFRED PARSONS MILLET AETATIS SUE XIV MONTHS," informs the viewer that the child was fourteen months old when the picture was made.[1]

That he was named after the artists John Singer Sargent (1856–1925) and Alfred Parsons (1847–1920) is an example of the Millets' close relationship with the many artists who gathered at their home in Broadway in England. The author Henry James, a friend of both the Alma-Tademas and the Millets, spent a considerable amount of time there and became particularly fond of young John Millet. James established a correspondence with "dear little Jack" when the boy was only five years old.[2]

The bust-length portrait *Master John Alfred Parsons Millet* is like a snapshot. It appears to have been painted quickly. The flat, rust-colored background and the subject's bluish gray dress are thinly painted, save some areas of white impasto. In the lower left corner, Alma-Tadema has not carried the dress to the edge of the canvas, even though this area, which bears the inscription, was certainly meant to be seen. Although the head has been given full attention, a portion of the preliminary outline is visible around Jack's left ear.

PRI

1. This inscription is painted in red pigment and is very likely by another hand, as it looks nothing like Alma-Tadema's signature and inscription at the lower left.
2. Henry James, *Henry James Letters*, ed. Leon Edel, vol. 3: 1883–95 (Cambridge, Mass.: Belknap Press of Harvard University Press, 1980), pp. 501–2.

41.

PROMISE OF SPRING

1890
Opus CCCIII
Oil on panel
14¾ × 8¾ in. (38 × 22.5 cm)
Museum of Fine Arts, Boston
Bequest of Frances M. Baker. 39.94

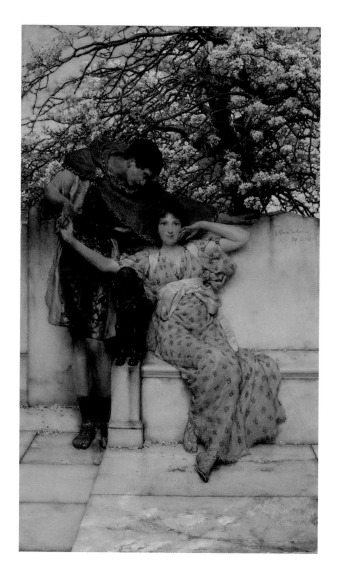

The substantial number of young lovers painted by Alma-Tadema demonstrates the special appeal that this theme held for him. Often both lovers are depicted—for instance, here and in *A World of Their Own* (cat. no. 47)—but, in other cases, Alma-Tadema portrays the woman alone, searching or waiting for her suitor—for example, in *Hopeful* (cat. no. 48). These scenes of love, generally small and painted late in his career, are not filled with archaeological details and are identifiable as images of antiquity only by the marble settings and ancient dress.

Besides being formulaic in subject, these images are usually sentimental. Paintings such as *Promise of Spring* must be admired for their carefully executed compositions and intense color and sunlight. In this example, the crescent shape created by the lovers' arms encapsulates the face of the Roman woman, whose steady stare catches the viewer's eye. At the same time, the blue and creamy white marble surroundings have a stunning complement in the Mediterranean sea and sky and the tree bursting into blossom.

PRI

42.

UNWELCOME CONFIDENCE
1895
OPUS CCCXXXII
Oil on panel
15 × 8⁷/₈ in. (38.1 × 22.5 cm)
Collection of Fred and Sherry Ross

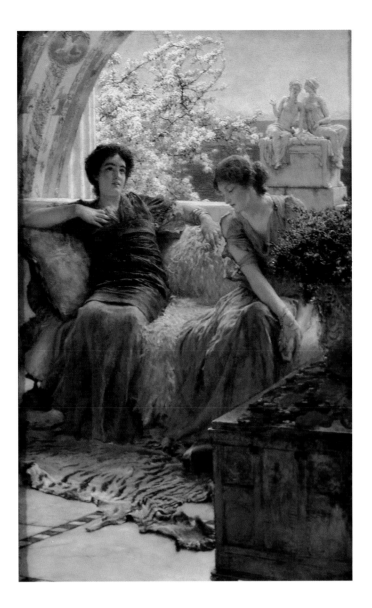

The objects that appear in Alma-Tadema's paintings often reinforce the actions of the figures, and this picture is no exception. Two women in the foreground—one talking, the other listening—are echoed by the figures in a marble sculpture in the background.[1] Unlike her sculpted counterpart who looks and leans eagerly toward her companion, however, the auburn-haired woman dressed in green stares at the floor and pulls her body away from the speaker—hence the title, *Unwelcome Confidence*.

Alma-Tadema uses both the title and the composition as tools of intrigue; one wonders what the woman in the grayish purple dress is divulging to her reluctant listener. This is just the sort of perplexity that delighted Victorian audiences. Alma-Tadema's contemporaries preferred narrative pictures that were not explicit but instead prompted the viewer to speculate about the painting's meaning.

Alma-Tadema's extraordinary sense of color is at work in *Unwelcome Confidence*. The green of one dress is repeated in the Roman painting on the arch, while the purple of the other is related to the brighter hue of the enormous bouquet of lilacs.[2] Warm colors—in the tiger-skin rug, the wooden chest, and the textile on top of it—form a perfect balance with cool colors in the sea and sky, the white marble statue, and the tree blossoms.

PRI

1. Although not a copy, the marble statue is reminiscent of, and perhaps inspired by, *Two Women Gossiping*, a terracotta statuette from Myrina, possibly second century B.C. (British Museum, London). It is illustrated in Gisela A. Richter, *A Handbook of Greek Art*, 3rd ed., rev. (London: Phaidon Press, 1963), p. 230.
2. The container for the lilacs is a copy of a silver krater, late first century B.C. (Staatliche Museum, Berlin). Alma-Tadema owned a copy of this krater, and it appears frequently in his paintings; see *The Women of Amphissa* (cat. no. 37).

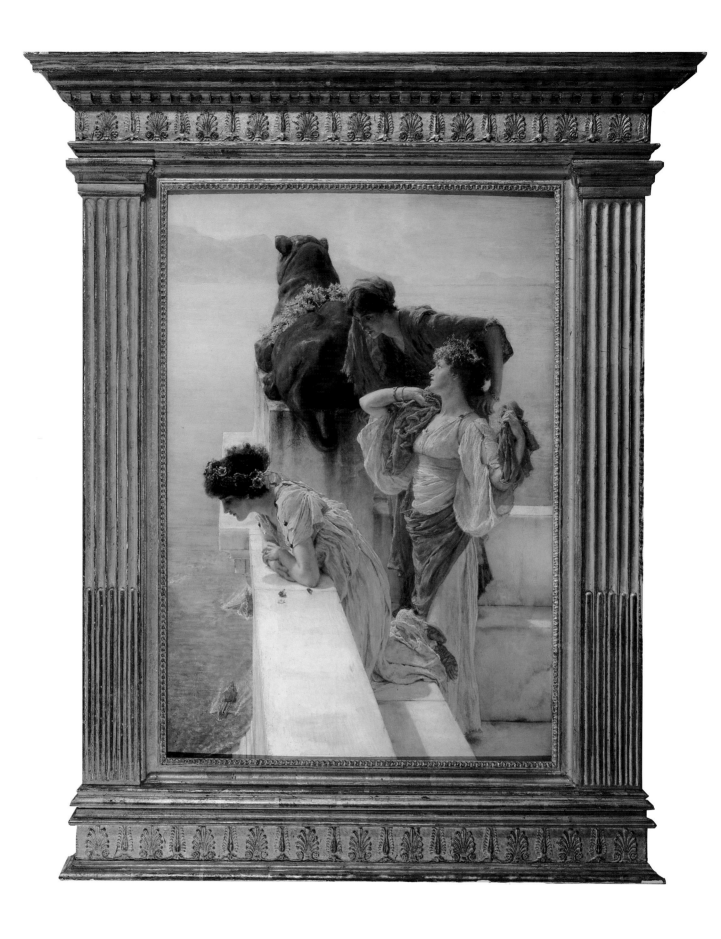

A COIGN OF VANTAGE[1]

1895
OPUS CCCXXXIII
Oil on panel
25 3/16 × 17 1/2 in. (64 × 44.5 cm)
Private collection

Despite its small size, this work has a dizzying monumentality. Three young women, perched high above the sea, watch the Roman fleet return to port. The dramatic composition demonstrates Alma-Tadema's skill and originality. A tightly controlled structure orchestrates the harmonious color, intense light, and vast space.

The vertiginous perspective and cropped format reflect Alma-Tadema's emulation of photography and Japanese prints. These influences are also evident in the naturalistic landscape and the panoramic background. The latter may have, in turn, influenced cinematographers; for instance, Cecil B. deMille is reputed to have admired Alma-Tadema's spectacular views of antiquity.

A Coign of Vantage is one of several pictures that descend from an oil sketch, *A Lake in Bavaria* (location unknown), painted in May of 1890 at the summer home of Georg Ebers in Tutzing, a town on the Starnberger See, southwest of Munich. In Alma-Tadema's work, this is a rare example of pure landscape—a view across the lake toward the distant Alps with two bronze lions on stone piers in the shallow water in the fore-ground. The cool saturated colors of the Bavarian countryside have been replaced in *A Coign of Vantage* by warm colors and the scintillating radiance of the intense Mediterranean sun. A bronze lioness crouches on a marble cornerstone. Though partially obscured, her garlanded form is majestic; the rich patina of the bronze reflects the delicate blues of the sea and sky.

Considered today to be among Alma-Tadema's greatest works, *A Coign of Vantage* was not well known during his lifetime. Upon its completion in 1895, it was sent to the New York dealer M. Knoedler, who quickly found an American buyer. The painting was not seen by the public until 1973 when it was included in the exhibition "Victorians in Togas" at the Metropolitan Museum of Art in New York.

Alma-Tadema employed dramatic vertical perspectives in other late works. *The Kiss* (private collection), completed in December, 1891, successfully combines an intimate scene between a Roman mother and child and a panoramic background that clearly depends on the oil sketch *A Lake in Bavaria*, which had been painted the previous spring. Other late examples of the use of vertical perspective include *God Speed!*, 1893 (location unknown), and *At Aphrodite's Cradle*, 1908 (private collection).

Within the radical structure of *A Coign of Vantage*, Alma-Tadema maintained a focus on the sensuality of the three elegant young women. He excelled in capturing the effect of penetrating sun on creamy flesh, translucent flower petals, and luminous marble. The rich, warm colors and the sharp definition of the delicate garments contrast effectively with the hazy coolness of the water and the distant hills. Thus, the precise detail and tonal harmony of the foreground increase the sense of height and distance and add to the considerable impact of the painting.

JGL

1. From Shakespeare's *Macbeth*, act 1, sc. 6, line 7, this expression means "an advantageous position."

44.

WHISPERING NOON

1896
OPUS CCCXXXV
Oil on canvas
22 × 15 ½ in. (55.9 × 39.4 cm)
Private collection

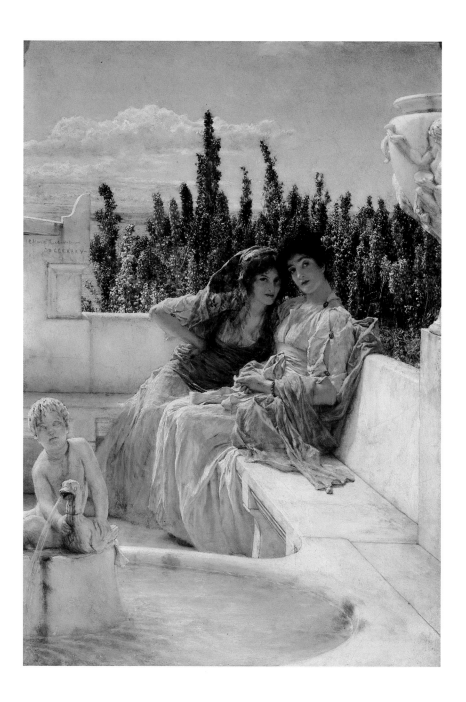

Whispering Noon is one of Alma-Tadema's most successful attempts at describing surfaces and textures struck by intense sunlight. The composition includes all of his favorite motifs: marble, flowers, sky, water, fabric, jewelry, and sensuous women. Extremely popular, the painting was exhibited at the Royal Academy's summer exhibition in 1896 and won the Great Gold Medal at the Exposition Internationale des Beaux-Arts in Brussels the following year.

Alma-Tadema has arranged the composition under a strong sun and portrayed with apparent delight the effect of this harsh light on diverse surfaces and textures. Although his juxtapositions of complementary colors and warm and cool tones were often obvious, they are subtly manipulated in *Whispering Noon*. The pale sky, together with the vivid blues and purples of the delphiniums, forms a dramatic backdrop for the two women huddled together on the creamy marble bench.

Like other late pictures, *Whispering Noon* is structured in a way that enhances the immediacy and spontaneity of the composition. The large urn on the right and the marble fountain on the left are cropped as if the picture were a photograph. The gossiping women stare intently out of the picture. Their eyes, meeting ours, create the uneasy impression that we may be the topic of their private conversation.

JGL

45.

A FLAG OF TRUCE

1900
OPUS CCCLVIII
Oil on panel
17¹/₂ × 8³/₄ in. (44.5 × 22.2 cm)
Private collection

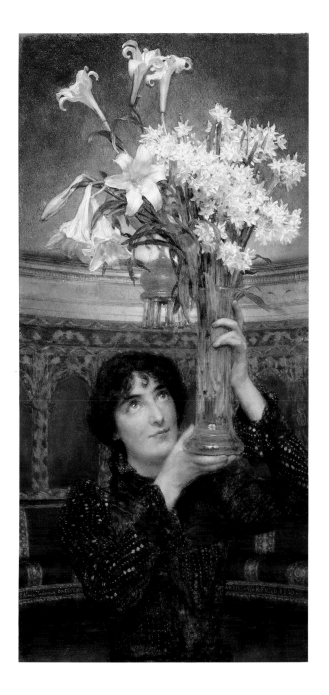

A rare political statement in Alma-Tadema's oeuvre, *A Flag of Truce* was painted to assist the Artists' War Fund, which supported soldiers wounded in the Boer War and the dependents and widows of soldiers. The Alma-Tademas were instrumental in organizing a benefit exhibition at Christie's in February of 1900. The artist's wife Laura contributed pictures to the show, as did his daughter Anna. His other daughter, Laurense, catalogued the 330 works donated by prominent British artists.

A Flag of Truce was painted in Alma-Tadema's studio at 17 Grove End Road. Its curved wall and built-in sofa are visible in the background as is the aluminum-covered domed ceiling. Although not a strong antiwar statement, the picture contains symbols that are meaningful in light of Alma-Tadema's stance as a pacifist. The well-dressed woman, who wears an elegant silk shirt-waist, holds aloft a vase of lilies and narcissi. The flowers are not carefully arranged but are bunched as if they had just been brought in from the garden. The choice of these particular flowers was not arbitrary: the lily is a traditional symbol of purity, and the narcissus symbolizes youthful death.

JGL

IMPATIENT
or
EXPECTATIONS
1901
Opus CCCLXVII
Watercolor on paper
7³/₄ × 5³/₄ in. (19.5 × 14.5 cm)
Private collection

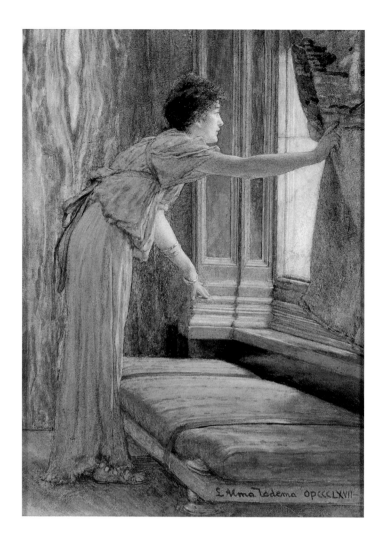

Most of the fifty-one watercolors to which Alma-Tadema assigned opus numbers were done as preliminary sketches for complex oil paintings, as copies of popular works, or as quick studies to resolve difficult compositional problems. His finished watercolors resemble his oils, and it is often difficult at first glance to distinguish them.

Impatient, or *Expectations*, was completed late in the artist's career. It has the precise draftsmanship, rich yet translucent color, and lack of narrative or subject that characterize the oil paintings from the same period. The ambiguous use of two titles suggests that there is no specific subject and that the simple composition was an opportunity to play with light and manipulate complementary colors into vibrant harmonies.

This small picture was given by the artist to Queen Alexandra, a family friend, probably at the time of King Edward VII's accession to the throne.

JGL

47.

A WORLD OF THEIR OWN
1905
Opus CCCLXXVIII
Oil on panel
5⅛ × 19¹¹⁄₁₆ in. (13 × 50 cm)
Taft Museum, Cincinnati
Bequest of
Charles Phelps and Anna Sinton Taft

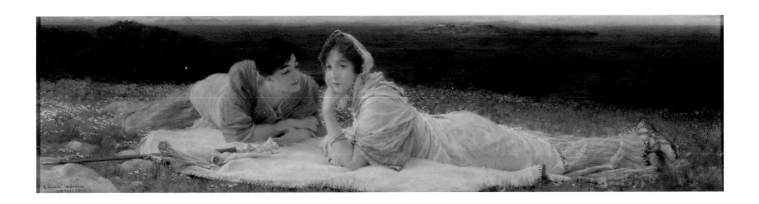

Alma-Tadema's only painting from 1905, *A World of Their Own* depicts the timeless theme of young love. The choice of a flower-covered hillside above the sea as a setting may have been influenced by the artist's visit to Folkestone on the English coast in March, 1905. The couple's classical costume and the accessories, such as the staff and brooch lying on the blanket, are allusions to antiquity. Alma-Tadema's shift away from archaeological details toward anecdotal subjects, which first became evident in the 1880s, produced popular paintings that lent themselves to sentimental readings.

The artist adopted an unusually extended format in this composition, which recalls the photographic panoramas that were prevalent in Europe and the United States in the early nineteenth century. The snapshotlike quality of his late works has been noted.[1] In *A World of Their Own*, the young woman gazes directly at the viewer, as if she were looking into the lens of a camera. Alma-Tadema, an early enthusiast of photography, purchased a Kodak camera shortly after it was introduced in 1888.

A World of Their Own was immediately purchased by the Cincinnati art collectors Charles Phelps Taft and his wife, Anna Sinton Taft, whose later bequest established the Taft Museum. Their collecting and philanthropy were supported by an inheritance from Anna's father, David Sinton, who had made a fortune in the iron industry and real estate. The Tafts bought most of their art in Europe and the United States between 1900 and 1910.[2] The collection comprised both portraiture and landscape, interests that find expression in *A World of Their Own*.

KLC

1. For the influence of photography on Alma-Tadema's work, see Russell Ash, *Sir Lawrence Alma-Tadema* (New York: Harry N. Abrams, 1989), pl. 22, and related text.
2. For the history of the collection, see Ruth Krueger Meyer, "The Taft Collection: The First Ten Years of Its Development," in *The Taft Museum: A Cincinnati Legacy* (Cincinnati: Cincinnati Historical Society, 1988), pp. 3–16.

48.

HOPEFUL
1909
OPUS CCCXCIV
Oil on panel
13³/₈ × 5⁷/₁₆ in. (34 × 13.8 cm)
Sterling and Francine
Clark Art Institute

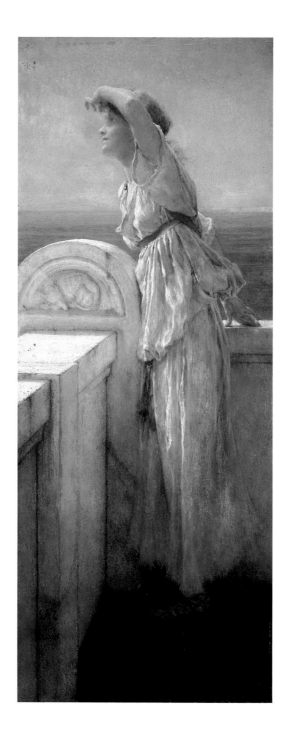

The theme of a woman searching for a sign of her lover's return recurred in Alma-Tadema's works from the mid-1880s onward. In addition to *Hopeful*, compositions such as *Expectations*, 1885, and *Hero*, 1898 (both, location unknown), focus on a single figure; whereas *A Coign of Vantage* (cat. no. 43) and *At Aphrodite's Cradle*, 1908 (private collection), depict groups of women. In fact, the figure in *Hopeful* mirrors the one in the upper right corner of *At Aphrodite's Cradle*.

Hopeful has no specific classical or mythological reference, unlike *At Aphrodite's Cradle*, which illustrates a verse from the *Odes* of the Roman poet

Horace, and *Hero*, which is based on the legend of Hero and Leander. Instead, *Hopeful* is a general image of fidelity, a theme that is underscored by the relief of a dog, the traditional symbol of fidelity, in the lunette on top of the cornerpost.

The brilliant blue of the Bay of Naples and the Mediterranean sky provide striking contrast to the cool white marble terrace. Elevated settings, such as this, allowed Alma-Tadema to experiment with a variety of vantage points. Here, the woman is seen from a conventional viewpoint rather than the dramatic angle used in *A Coign of Vantage*. The artist typically eliminates the middle

ground and offers an uninterrupted view to the horizon.

Hopeful was executed in 1909 as a gift for Queen Alexandra. Alma-Tadema also gave her the watercolor *Impatient*, or *Expectations* (cat. no. 46), which has a similar theme. *God Speed!*, 1893 (location unknown), which shows a woman leaning over a balcony and showering flowers on an unseen figure, has been interpreted as a lovers' farewell; it was acquired by the Prince of Wales, later King Edward VII, who often visited Alma-Tadema's London residence.

KLC

112

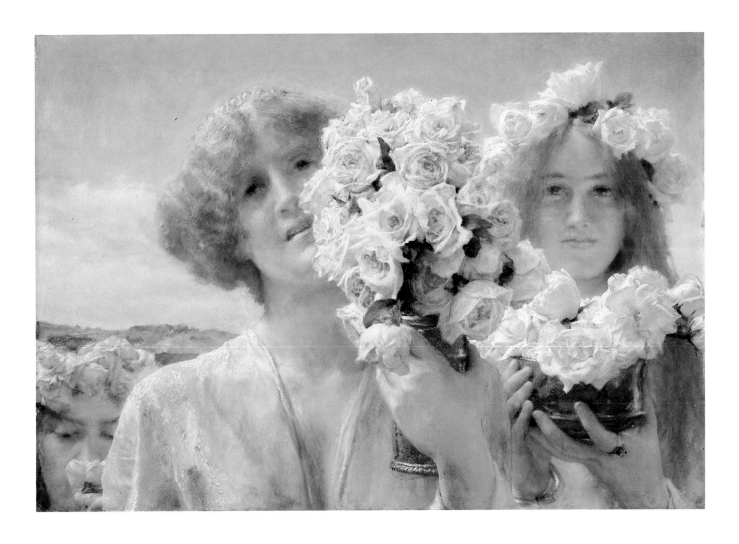

49.

SUMMER OFFERING

1911
OPUS CCCCIII
Oil on panel
16 × 22 in. (40.6 × 55.9 cm)
Museum of Fine Arts
Brigham Young University
Provo, Utah

Formerly considered to be an idealized portrait of the artist's daughters and his wife, Laura, *Summer Offering* is now recognized as a less personal subject.[1] Anna and Laurense Alma-Tadema were middle-aged women in 1911 and were physically very different from the figures in this picture. The central figure can be identified from a photograph as Marion Tatershall, one of Alma-Tadema's favorite models at this time. The figure on the right is recognizable as the model in other paintings.[2]

There is an enigmatic quality to this picture. The two foreground figures seem about to traverse the picture plane to present their gifts to the viewer. The tight cropping creates a sense of immediacy that involves the audience intimately with the composition. Each of the three women carries roses of a different variety. The artist has obviously studied them closely in nature because the blossoms are carefully individualized. Two of the women appear radiant and vital; they carry vibrant bunches of pink and white flowers. The woman who wears a wreath of wilted yellow roses is distinct from her companions. Walking behind them and crowded into a corner of the composition, she dreamily inhales the aroma of a faded bloom.

Laura Alma-Tadema died two years before this picture was painted. Although *Summer Offering* is not a portrait of the three Alma-Tadema women, it may reflect the artist's lingering grief for Laura, who died at the height of summer, in August of 1909.

JGL

1. Vern G. Swanson, *Alma-Tadema: The Painter of the Victorian Vision of the Ancient World* (New York: Charles Scribner's Sons, 1977), p. 131.
2. Vern G. Swanson, *The Biography and Catalogue Raisonné of the Paintings of Sir Lawrence Alma-Tadema* (London: Garton and Co., 1990), p. 273.

COMPARATIVE CHRONOLOGY

	POLITICAL & CULTURAL EVENTS	ALMA-TADEMA CHRONOLOGY
1836	John Constable paints *Stoke-by-Nayland* (Art Institute of Chicago)	Birth of the artist, then Lourens Alma Tadema, in Dronrijp, Friesland, Holland
1837	Victoria ascends British throne; ruler until 1901	Family moves to Leeuwarden
1838	Joseph M. W. Turner paints *The Fighting Téméraire* (National Gallery of Art, London)	
1839	Queen Victoria marries Prince Albert of Saxe-Coburg-Gotha Daguerreotype developed Births of Paul Cézanne and Alfred Sisley	
1840	Births of Claude Monet, Pierre-Auguste Renoir, Auguste Rodin, and Emile Zola	Death of his father, Pieter Tadema
1843	John Ruskin publishes first of five volumes of *Modern Painters*	
1844	Turner paints *Rain, Steam and Speed* (National Gallery of Art, London)	
1845	Jean-Auguste-Dominique Ingres paints *Contesse d'Haussonville* (Frick Collection, New York) Charles Baudelaire writes his first Salon review	
1848	Pre-Raphaelite Brotherhood founded Karl Marx and Friedrich Engels issue the *Communist Manifesto*	
1849	Gustave Courbet paints *The Stone Breakers* (destroyed)	Paints first commission, the oil portrait of the three Hamstra children (private collection, The Netherlands)
1850	Charles Dickens publishes *David Copperfield* Jean-François Millet paints *The Sower* (Museum of Fine Arts, Boston) Roman Republic ends	Draws *Tête-à-Tête* (cat. no. 1)
1851	Louis Napoleon declares himself emperor of France, as Napoleon III Crystal Palace built by Joseph Paxton in London for the Great Exhibition of the Industry of All Nations George Caleb Bingham paints *The Trapper's Return* (Detroit Institute of Arts)	Exhibition of paintings and drawings in the gallery in Leeuwarden Draws portrait of G. N. Van Der Koop (cat. no. 2)

1851	First edition of *New York Times* is published	
1852	John Everett Millais begins painting *Ophelia* (Tate Gallery, London), completes it in 1854	Moves to Antwerp to attend Academy of Fine Arts
1853	Ottoman Empire declares war on Russia	
1854	Rebellious uprisings against Queen Isabella in Madrid	
	Japan opens diplomatic and trade relations with the West	
1855	Accession of Alexander II as czar of Russia	Paints *The Massacre of the Monks of Tamond* (cat. no. 3)
	Paris World's Fair	
	George Inness paints *The Lackawanna Valley* (National Gallery of Art, Washington, D. C.)	
1856	Gustave Flaubert publishes *Madame Bovary*	Paints *The Declaration of Love* or *The Alm* (location unknown) and is expelled from academy
	Birth of Sigmund Freud	
1857	Frederick E. Church paints *Niagara* (Corcoran Gallery of Art, Washington, D. C.)	Stays with Professor Louis de Taeye until late 1858
	Irish Republican Brotherhood founded	Meets Egyptologist Georg Ebers
	Currier and Ives found color-engraving firm	Joins the Cercle Artistique in Antwerp
	Millet's *The Gleaners* (Musée du Louvre, Paris) exhibited at Paris Salon	
	Charles Darwin publishes *On the Origin of Species by Means of Natural Selection*	
1858		Introduced by de Taeye to the history painter Hendrik Leys
1859		Joined in Antwerp by mother and sister
		Enters studio of Baron Leys; assists in painting six frescoes in Antwerp town hall
1860	Abraham Lincoln elected president of the United States	
1861	American Civil War begins	*Education of the Children of Clovis* (location unknown) exhibited in Antwerp to great acclaim
	William I becomes king of Prussia, appoints Otto von Bismarck prime minister	Elected member of Antwerp academy
1862		Wins gold medal at exhibition in Amsterdam with *Venantius Fortunatus Reading His Poems to Radagonda VI: A.D. 555* (Dordrechts Museum, Dordrecht)
		Goes to London for the first time to attend Great Exhibition, visits British Museum where he sees Elgin Marbles
1863	Napoleon III establishes the Salon des Refusés	Death of mother, Hinke Dirks Brouwer Tadema, in January
	Edouard Manet paints *Le Déjeuner sur l'herbe* (Musée du Louvre)	Marries first wife, Pauline Gressin, in September they take honeymoon trip to Florence, Rome, Naples, and Pompeii
	Baudelaire writes *Le Peintre de la vie moderne*	
	Slavery abolished in the United States	
1864	James Abbott McNeill Whistler paints *The Little White Girl: Symphony in White, No. 2* (Tate Gallery)	*Pastimes in Ancient Egypt 3,000 Years Ago*, 1863 (Harris Museum and Art Gallery, Preston, England), wins gold medal at Paris Salon

	POLITICAL & CULTURAL EVENTS	ALMA-TADEMA CHRONOLOGY
1864		On first trip to Paris, meets Jean-Léon Gérôme, Alfred Stevens, and Rosa Bonheur
		Birth and death of only son, Eugène
		Meets Belgian dealer Ernest Gambart and receives commission for twenty-four paintings
1865	Manet's *Olympia*, 1863 (Musée d'Orsay, Paris), violently attacked by critics at Paris Salon	Moves to Brussels
		Paints first full-scale Roman work, *Catullus at Lesbia's* (location unknown)
	Abraham Lincoln assassinated	Paints *The Death of Galswintha* (cat. no. 4)
	American Civil War ends	Birth of daughter Laurense
1866	Winslow Homer paints *Prisoners from the Front* (Metropolitan Museum of Art, New York)	*Preparations for the Festivities* (cat. no. 5) shown at Exposition Générale des Beaux-Arts in Brussels in October with such success that he is made knight of the Order of Leopold
		Paints *Entrance to a Roman Theater* (cat. no. 6) and *Tibullus at Delia's House* (cat. no. 7)
		Meets Frederick Leighton in Brussels
		In London in May; he and wife are guests in Gambart's home when it is severely damaged by a gas explosion
		Paints *Lesbia Weeping Over a Sparrow* (cat. no. 8)
1867	Deaths of Baudelaire and Ingres	Exhibits twelve pictures at the Paris Exposition Universelle, wins second class medal with *Pastimes in Ancient Egypt 3,000 Years Ago*
	Emperor Maximillian executed in Mexico; Mexican Republic is reestablished	Birth of second daughter, Anna
		Paints *A Sculpture Gallery in Rome at the Time of Augustus* (cat. no. 9)
		Paints *Tarquinius Superbus* (cat. no. 10), which completes initial Gambart commission
1868	Mary Cassatt settles in Paris	Visits Italy in winter 1867–68
		Flowers (cat. no. 12) exhibited at Royal Academy in Amsterdam
		Paints *The Siesta* (cat. no. 11)
1869	First U. S. transcontinental railroad completed	Receives second commission from Gambart (forty-eight paintings)
	Suez Canal opens	Made knight of the Dutch Lion by King Willem III for contributions to Netherlandish art
	Birth of Mohandas K. Gandhi	Made knight first class of the Order of Saint Michael of Bavaria
		Death of first wife, Pauline, in May
		His two paintings in Royal Academy summer exhibition are strongly criticized by John Ruskin
		Paints *An Exedra* (cat. no. 13)
		Goes to London in December to consult physician; meets Laura Theresa Epps
1870	Prussia invades France	Moves to London with two daughters and his sister
	Monet and Camille Pissarro flee to England	Changes name to Lawrence Alma-Tadema
	Third Republic proclaimed in France	Meets Edward Poynter

1870	Deaths of Dickens and Alexander Dumas	Takes on several students, including Laura Epps
	James Tissot settles in England	
	Heinrich Schliemann begins excavations at Troy	
1871	Franco-Prussian War ends	Buys Townshend House in London and begins extensive renovations
	Birth of Marcel Proust	
	Alfred Sisley in London	Marries Laura Epps on July 29; they honeymoon in the Netherlands
	Jean-Baptiste Carpeaux in London	Elected member of Royal Academy in Munich
		A Roman Emperor-Claudius (cat. no. 14) praised at the summer exhibition of Royal Academy in London
1872	Paul Durand-Ruel exhibits impressionist works in London	Begins assigning opus numbers to his pictures
	Cassatt exhibits for the first time at Paris Salon	*Death of the First-Born* (Rijksmuseum, Amsterdam) voted Picture of the Year by Pall Mall Magazine
	Monet paints at Argenteuil, Pissarro at Pontoise	
	Homer paints *Snap the Whip* (Metropolitan Museum of Art)	
1873	French stock market crashes; six-year depression follows	Becomes British citizen on January 25
	Death of Napoleon III in England	Made a chevalier of Legion of Honor, Paris
	First color photographs developed	Paints *A Picture Gallery* (cat. no. 15)
	Monet constructs a floating studio on the Seine at Argenteuil	Elected associate of Royal Society of Painters in Watercolor after success at its summer exhibition
1874	First impressionist exhibition; thirty participants include Edgar Degas, Berthe Morisot, Cézanne, Renoir, Monet, Pissarro, and Sisley (Cézanne's works are mocked)	Elected honorary member of Royal Academy of Berlin
		Visits Holland
	Births of Winston Churchill and Gertrude Stein	Recently completed Townshend House is damaged by explosion of a barge on Regent's Canal
1875	Deaths of Jean-Baptiste-Camille Corot and Georges Bizet	*A Sculpture Gallery* (Hood Museum of Art, Dartmouth College, Hanover, N. H.) and *A Picture Gallery in Rome* (Towneley Hall Art Gallery and Museum, Burneley, Lancashire) exhibited at Royal Academy in London
	Thomas Eakins paints *The Gross Clinic* (Philadelphia Jefferson Medical College)	
		Tours the Continent for five-and-one-half months
		Begins collecting photographs of antiquities and ancient architecture
		Paints *The Tragedy of an Honest Wife* (cat. no. 16) and *A Sculpture Garden* (cat. no. 17)
1876	Second impressionist exhibition; nineteen artists participate	Elected associate of Royal Academy in London
	Alexander Graham Bell invents telephone	*An Audience at Agrippa's* (Dick Institute, Kilmarnock, Scotland) is highlight of the Royal Academy exhibition
	Monet forms friendship with John Singer Sargent	
	Renoir paints *Moulin de la Galette* (Musée d'Orsay)	Spends the winter of 1876–77 in Rome
	Whistler begins decorations for the Peacock Room (now in the Freer Art Gallery, Washington, D. C.)	
	Homer paints *Breezing Up* (National Gallery of Art, Washington, D. C.)	
1877	Third impressionist exhibition; eighteen artists participate	Awarded medal at Royal Scottish Academy

POLITICAL & CULTURAL EVENTS	ALMA-TADEMA CHRONOLOGY
1877 Thomas Edison invents phonograph	Exhibits seven pictures at opening exhibition of Grosvenor Gallery, London
Cassatt invited to join impressionists; she subsequently stops exhibiting at Paris Salon	Paints *Sculptors in Ancient Rome* (cat. no. 18), *Architecture in Ancient Rome* (cat. no. 19), and *Spring in the Gardens of the Villa Borghese* (cat. no. 20)
Death of Courbet	
Queen Victoria proclaimed empress of India	Spends summer at the Rocklands in Hastings
Grosvenor Gallery opens in London	
1878 Paris World's Fair	Visits Italy and France; director of excavations at Pompeii conducts dig in his honor
Frederick Leighton named president of Royal Academy	Ten pictures in Exposition Universelle, Paris; *Death of the First-Born*, 1872, wins gold medal
Eadweard Muybridge begins publishing multiple exposure photographs; project continues until 1881	Elected member of Royal Academy of Stockholm
John Ruskin condemns Whistler's *Nocturne in Black and Gold: The Falling Rocket*, 1874 (Detroit Art Institute); Whistler sues Ruskin for libel	Made an officer of Legion of Honor, Paris
1879 Fourth impressionist exhibition; fifteen artists participate	Elected member of Royal Academy of Madrid
Odilon Redon publishes his first album of lithographs	Elected full member of Royal Academy in London
Death of Honoré Daumier	Begins designs for Sir Henry Irving's production of Shakespeare's *Coriolanus*
Births of Joseph Stalin and Albert Einstein	Paints *On the Road to the Temple of Ceres: A Spring Festival* (cat. no. 21) and *My Sister Is Not In* (cat. no. 22)
Edison develops filament for electric light bulb	
Henry James publishes *Daisy Miller*	
1880 Fifth impressionist exhibition; eighteen artists participate	*Ave Caesar! Io Saturnalia!* (cat. no. 23) exhibited at Royal Academy in Berlin
Death of Flaubert	Paints *A Harvest Festival* (cat. no. 24)
Fyodor Dostoyevsky publishes *Brothers Karamazov*	*On the Road to the Temple of Ceres* (cat. no. 21) and *My Sister Is Not In* (cat. no. 22) entered in summer exhibition at Royal Academy, London
1881 Sixth impressionist exhibition; thirteen artists participate	Elected member of Imperial Academy of Vienna; awarded Prussian Order of Merit and Order of Frederick the Great
Czar Alexander II assassinated	
Death of Dostoyevsky	*Sappho and Alcaeus* (cat. no. 26) exhibited at Royal Academies in London and Berlin
Birth of Pablo Picasso	
First performance of operetta *Patience* by Gilbert and Sullivan	
1882 Seventh impressionist exhibition; eight artists participate	Retrospective exhibition of his work at Grosvenor Gallery includes 185 paintings and drawings
Courbet retrospective exhibition held at Ecole des Beaux-Arts in Paris	Visits Italy
Death of Darwin	Draws the etchings *The Archer* (cat. no. 27) and *The Lovers* (cat. no. 28)
Births of Franklin Delano Roosevelt and James Joyce	Paints *Between Venus and Bacchus* (cat. no. 29) and *The Oleander* (cat. no. 30)
Manet's *A Bar at the Folies-Bergère* (Courtauld Institute Galleries, London) exhibited at Paris Salon	Purchases former London residence of James Tissot at 17 Grove End Road, Saint John's Wood
1883 Durand-Ruel exhibits impressionists works in London, Berlin, and Rotterdam	Goes to Rome and Naples for three months
Deaths of Marx and Richard Wagner	Paints *Shy* (cat. no. 31) and *Xanthe and Phaon* (cat. no. 32)
Birth of Walter Gropius	

1883	Whistler's *Arrangement in Grey and Black, No. 1: Portrait of the Artist's Mother*, 1871 (Musée du Louvre), exhibited at Paris Salon	
	Death of Manet	
	Monet settles in Giverny	
1884	Société des Vingt founded in Brussels	Begins renovating new house
	Manet memorial exhibition at Ecole des Beaux-Arts (catalogue introduction written by Emile Zola)	Paints portrait of Alice Lewis (cat. no. 33)
	Georges Seurat begins work on *A Sunday Afternoon on the Grand Jatte* (Art Institute of Chicago)	Begins designs for music room in New York home of Henry G. Marquand; completes project in 1887
	Albert Pinkham Ryder paints *Toilers of the Sea* (Metropolitan Museum of Art)	
	John Singer Sargent paints *Madame X* (*Madame Pierre Gautreau*) (Metropolitan Museum of Art)	
1885	Eugène Delacroix retrospective exhibition at Ecole des Beaux-Arts	*A Reading from Homer* (cat. no. 34) exhibited at Royal Academy summer exhibition
	Death of Victor Hugo	Paints *The Triumph of Titus: The Flavians* (cat. no. 35) for William T. Walters of Baltimore
	Invention of gaslight	
	Birth of D. H. Lawrence	
	Degas and Paul Gauguin meet at Dièppe	
	Sargent settles in London	
	Sir Edward Burne-Jones elected associate of Royal Academy	
	Sargent begins painting *Carnation, Lily, Lily, Rose* in Frank D. Millet's garden in Broadway, England; completes it in 1886	
1886	Eighth and final impressionist exhibition; Gauguin participates	Paints portrait of Mrs. Frank D. Millet (cat. no. 36)
	Vincent van Gogh arrives in Paris and meets Pissarro and Gauguin	Family spends summer in Broadway with the Millets, thereafter shares many holidays with them
	Symbolist Manifesto published by Jean Moréas	Family moves into house at 17 Grove End Road
	Degas's work shown by Durand-Ruel in New York	
	Zola publishes *L'Oeuvre*	
	Exhibition of Seurat's *A Sunday Afternoon on the Grand Jatte* causes scandal	
	Statue of Liberty unveiled	
1887	Golden Jubilee of Queen Victoria	*The Women of Amphissa* (cat. no. 37) is entry in Royal Academy summer exhibition
	Birth of Le Corbusier (Charles Edouard Jeanneret)	Thirteen pictures shown in Royal Manchester Institute Jubilee Exhibition
	Pissarro exhibits pointillist works with Société des Vingt in Brussels	
	Théâtre Libre founded by André Antoine	
	Grosvenor Gallery closed	
1888	George Eastman markets first Kodak camera	Five paintings shown in opening exhibition of New Gallery
	Wilhelm II becomes kaiser of Germany	Seven pictures shown in Glasgow International exhibition
	Institut Pasteur founded in Paris	
	Birth of T. S. Eliot	

1888	Gauguin paints *A Vision after the Sermon: Jacob Wrestling with an Angel* (National Gallery of Scotland, Edinburgh)	
	van Gogh paints at Arles; cuts off his ear	
	The Nabis begin to meet regularly	
	Arts and Crafts Society forms in London	
1889	Paris World's Fair; Eiffel Tower built	*The Women of Amphissa* wins medal of honor at Exposition Universelle, Paris
		Paints portraits of Mrs. Ralph Sneyd (cat. no. 39) and John Alfred Parsons Millet (cat. no. 40)
1890	Japanese art exhibited at Ecole des Beaux-Arts	Paints *Promise of Spring* (cat. no. 41)
		Visits Georg Ebers at his summer home in Tutzing, Bavaria
		Elected honorary member of Oxford University Dramatic Society for his collaborations on theatrical productions
1891	Henri de Toulouse-Lautrec designs his first poster	Theatrical collaboration with Sir Herbert Beerbohm Tree and Sir Henry Irving
	Edison builds kinetoscope, the first movie projector	
1892		Becomes a charter member of Japan Society
1893	Chicago World's Fair	*A Sculpture Garden* (cat. no. 17) is most popular British entry in World's Columbian Exposition in Chicago
	Société des Vingt dissolved	
	Sir Edward Burne-Jones resigns from Royal Academy	
	Edvard Munch paints *The Scream* (Nasjonal galleriet, Oslo)	
1894	Aubrey Beardsley designs the lithograph *Salomé with the Head of John the Baptist* (Princeton University Library, N. J.)	
	Millais made director of the National Gallery, London	
1895	Leighton exhibits *Flaming June* (Museo de Arte de Ponce, Puerto Rico)	Paints *Unwelcome Confidence* (cat. no. 42) and *A Coign of Vantage* (cat. no. 43)
1896	Death of Leighton	Fifty-one of his paintings exhibited by Royal Society of Artists in Birmingham
	Millais elected president of the Royal Academy	*Whispering Noon* (cat. no. 44) shown in Royal Academy summer exhibition
1897	Diamond Jubilee of Queen Victoria	*Whispering Noon*, one of his three entries, wins Great Gold Medal at Exposition Internationale des Beaux-Arts in Brussels
1899	International Women's Congress established in London	Knighted by Queen Victoria on her eightieth birthday; honored at lavish banquet for 180 fellow artists and friends
1900	British Labor Party founded	Paints *A Flag of Truce* (cat. no. 45) for Artists' War Fund; he and his family help organize exhibition of 330 works of art to benefit the fund
		Visits Italy to research Etruscan sites for Sir Henry Irving's production of *Coriolanus*
1901	Death of Queen Victoria	His set designs applauded at opening of *Coriolanus*

1901 Theodore Roosevelt elected president of the United States	Paints *Impatient*, or *Expectations* (cat. no. 46)
1902 Death of Ernest Gambart	Attends dedication of Assiut and Aswan dams in Egypt with Sir John Aird and other dignitaries, including Winston Churchill
1903 Picasso paints *The Old Guitarist* (Art Institute of Chicago)	Invited to join British Committee for 1904 Saint Louis World's Fair
1904 Death of George Frederick Watts	His three pictures in Saint Louis World's Fair are extremely popular with Americans
1905 Henri Matisse's *Portrait with Green Stripe* (Statens Museum for Kunst, Copenhagen) exhibited in first fauve exhibition Controversial exhibition of impressionist works in London George Luks paints *Wrestlers* (Museum of Fine Arts, Boston)	Awarded the newly instituted Order of Merit by King Edward VII Paints *A World of Their Own* (cat. no. 47), the only opused work completed this year
1906 Picasso begins *Les Demoiselles d'Avignon* (Museum of Modern Art, New York); completes it in 1907	Receives Royal Gold Medal from Royal Institute of British Architects and is made honorary member
1907	Delivers lecture "Marbles: Their Ancient Application" to Royal Institute of British Architects
1909	Death of second wife, Laura Paints *Hopeful* (cat. no. 48)
1910 Constantin Brancusi sculpts *The Kiss* (Montparnasse Cemetery, Paris) Death of Edward VII of England; George V ascends the throne	Organizes memorial exhibition of Laura's paintings
1911 First Blaue Reiter exhibition in Munich	Resigns from Royal Academy Committee due to poor health *Summer Offering* (cat. no. 49) shown in Royal Academy summer exhibition Enters seven pictures in exhibition to commemorate coronation of George V (last major exhibition of Alma-Tadema's work during his lifetime)
1912 Marcel Duchamp paints *Nude Descending a Staircase No. 2* (Philadelphia Museum of Art) Giacomo Balla paints *Dog on a Leash* (Museum of Modern Art)	Accompanied by daughter Anna, visits spa in Wiesbaden, Germany, for treatment of chronic disorder; dies there on June 28th at the age of seventy-six In his memory, the Royal Academy mounts retrospective exhibition of 213 works
1913 Armory Show, New York	

NOTE: The primary source for biographical information was Vern G. Swanson, *The Biography and Catalogue Raisonné of the Paintings of Sir Lawrence Alma-Tadema* (London: Garton and Co., 1990).

Alma-Tadema, Lawrence. "Sir L. Alma-Tadema's Reply." *Journal of the Royal Institute of British Architects*, 3rd ser., 13 (June 30, 1906), pp. 441–43.

————. "Marbles: Their Ancient Application." *Journal of the Royal Institute of British Architects*, 3rd ser., 14 (Jan. 26, 1907), pp. 169–80.

Amaya, Mario. "The Roman World of Alma-Tadema." *Apollo*, n.s., 76 (Dec., 1962), pp. 771–78.

"The Archaeologist of Artists." Review of *Lorenz Alma Tadema: His Life and Works*, by Georg Ebers. *Nation* 43 (Sept. 16, 1886), pp. 237–38.

Ash, Russell. *Sir Lawrence Alma-Tadema*. New York: Harry N. Abrams, 1989.

Beck, Hilary. *Victorian Engravings*. London: Victoria and Albert Museum, 1973.

Belcher, John. "The Royal Gold Medal, 1906. The Presentation to Sir Lawrence Alma-Tadema, O.M., R.A., F.S.A. [H.F.] Monday, 25th June 1906." *Journal of the Royal Institute of British Architects*, 3rd ser., 13 (June 30, 1906), pp. 437–40.

Dafforne, James. "The Works of Lawrence Alma-Tadema." *Art Journal* (New York), n.s., 14 (1875), pp. 9–12.

Dircks, Rudolf. "The Later Work of Sir Lawrence Alma-Tadema, O.M., R.A., R.W.S." *Art Journal*, Christmas suppl. (1910).

Dolman, Frederick. "Sir Lawrence Alma-Tadema, R.A." *Strand Magazine* 18 (Jan., 1900), pp. 602–14.

Ebers, Georg. *Lorenz Alma Tadema: His Life and Works*. Translated by Mary J. Safford. New York: William S. Gottsberger, 1886.

Gaunt, William. *Victorian Olympus*. Rev. ed. London: Jonathan Cape, 1975.

Gosse, Edmund. *Laurence Alma-Tadema. R.A.* London: Chapman & Hill, 1883.

Gosse, Ellen. "Laurens Alma-Tadema." *Century Magazine* 47 (Feb., 1894), pp. 483–97.

Hook, Philip. "The Classical Revival in English Painting." *Connoisseur* 192 (June, 1976), pp. 122–27.

Maas, Jeremy. *Victorian Painters*. London: Barrie and Rockliff, Cresset Press, 1969.

McKenna, Ethel Mackenzie. "Alma-Tadema and his Home and Pictures." *New McClure's Magazine* 8 (Nov., 1896), pp. 32–42.

Mappin Art Gallery. *Sir Lawrence Alma-Tadema, O.M., R.A., 1836–1912*. Exhib. cat. by Anne L. Goodchild. Sheffield, England: Mappin Art Gallery, 1976.

Metropolitan Museum of Art. *Victorians in Togas: Paintings by Sir Lawrence Alma-Tadema from the Collection of Allen Funt*. Exhib. cat. by Christopher Forbes. New York: Metropolitan Museum of Art, 1973.

Monkhouse, Cosmo. "Laurens Alma-Tadema, R.A." *Scribner's Magazine* 18 (Dec., 1895), pp. 663–81.

Reynolds, Graham. *Victorian Painting*. London: Studio Vista, 1966.

"The Royal Gold Medallist and his Pictures." *Journal of the Royal Institute of British Architects*, 3rd ser., 13 (June 30, 1906), pp. 444–45.

Spielmann, M. H. "Laurence Alma-Tadema, R.A.: A Sketch." *Magazine of Art* (Nov., 1896–April, 1897), pp. 42–50.

Spiers, R. Phené. "Archaeological Research in the Paintings of Sir Lawrence Alma-Tadema." *Architectural Review* 33 (March, 1913), pp. 45–48.

Standing, Percy Cross. *Sir Lawrence Alma-Tadema, O.M., R.A.* London: Cassell and Company, 1905.

Starkweather, William. "Alma-Tadema: Artist and Archaeologist." *Mentor* (New York), 12 (April, 1924), pp. 28–42.

Swanson, Vern G. *Alma-Tadema: The Painter of the Victorian Vision of the Ancient World*. New York: Charles Scribner's Sons, 1977.

————. *The Biography and Catalogue Raisonné of the Paintings of Sir Lawrence Alma-Tadema*. London: Garton and Co., 1990.

Wood, Christopher. *Olympian Dreamers: Victorian Classical Painters, 1860–1914*. London: Constable, 1983.

"The Works of Laurence Alma-Tadema, R.A." Parts 1, 2. *Art Journal* (London), n.s. (Feb. & March, 1883), pp. 33–37, 65–68.

Zimmern, Helen. "The Life and Works of Alma Tadema." *Art Journal* (London), n.s., special no. (1886).

————. *Sir Lawrence Alma Tadema, R.A.* London: George Bell and Sons, 1902.

Photographs supplied by the lenders except for the following: courtesy Russell Ash, London, fig. 4; Arthur Evans, Clark Art Institute Photo Facility, cat. nos. 5, 36, 37, 39, 40 49; Metropolitan Museum of Art, New York, fig. 5; Owen Murphy, New Orleans, cat nos. 31, 44, 46; Michael Puig, Houston, cat. no. 4; Del Ramers, Elkins Park, Pa., cat. no 10; courtesy Vern G. Swanson, Springville, Utah, figs. 3, 6; Uffizi Gallery, Florence, Italy, fig. 1; courtesy Walters Art Gallery, figs. 2, 7–10.